How to Photograph
SPORTS & ACTION
Robert McQuilkin

HPBooks

Robert McQuilkin

Robert McQuilkin is an expert sports photographer who has received more than 48 national and international awards for his work. He has written five other books, including **Outdoor Photography, The Photo Seminar** and **Comfort Below Freezing**. He is a contributing editor for several sports and photography publications, and his photos and photography-related articles have been published in more than 100 magazines. His work has also appeared on magazine and book covers, posters and advertisements. Wilderness Photography Seminars was founded by McQuilkin in 1977. He is the photo advisor on the board of Expedition Research Inc.

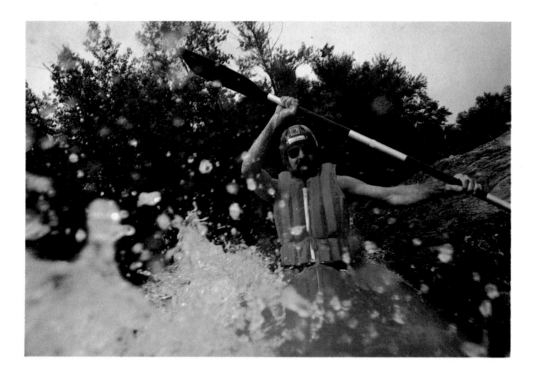

Executive Editor: Rick Bailey
Editorial Director: Theodore DiSante
Editor: David A. Silverman
Art Director: Don Burton
Photography: Robert McQuilkin, unless otherwise credited

NOTICE: The information contained in this book is true and complete to the best of our knowledge. All recommendations are made without any guarantees on the part of HPBooks. The author and publisher disclaim all liability incurred in connection with the use of this information.

Published by HPBooks, P.O. Box 5367, Tucson AZ 85703 602/888-2150
ISBN: 0-89586-145-3 Library of Congress Catalog No. 82-81487
©1982 Fisher Publishing, Inc. Printed in U.S.A.

1 Getting Started . 4

2 Photographic Technique . 23

3 Getting the Most from Your Equipment . 50

4 Photographing Sports . 77

5 Beyond the Picture . 93

6 Closing the Gap with the Proper Equipment 118

7 Creativity . 129

8 Competing in Your Sport . 140

9 Marketing Your Photographs . 145

 Appendix . 156

 Index . 158

1
Getting Started

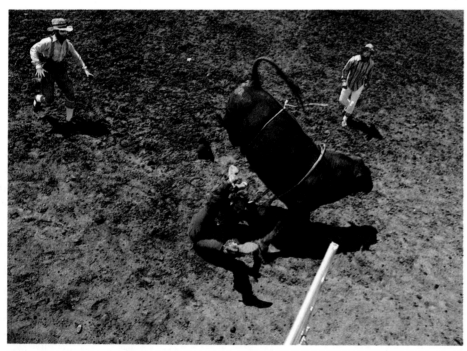

Don't plan on chance saving you. Know where to be *before* the action starts, so you can get a shot like this.

The gate burst open, the bull charged, the cowboy riding him flew off. Unfortunately, his boot caught on the cinch strap and he pivoted under the enraged 2000-pound bull. The bull kicked the cowboy's hat off just before he landed, and the cowboy shut his eyes so he wouldn't have to see what was going to happen next.

I kept my eyes open and released the camera shutter so I would have a record of what happened. When a friend saw the picture several days later, he said, "You sure happened to be in the right place at the right time for that one." I got madder than that bull and snorted, "I did not

happen to be there—I *planned* to be there!"

STRATEGY

Chance did not put me where I was when the cow puncher got punched. It was preconceived strategy—and it worked. One of the first things a photographer should learn is that half the job takes place *before you leave the house*. Race drivers believe this, too.

I enjoy watching drag races. Before each race, the drivers heat the tires on the dragsters by racing their engines and blowing off the line, with back tires screaming. The cars run much better after

their tires are warmed up. I also work better if I take the time to get "revved" up first. The more I practice and spend time working with the "sport" I have chosen, the more I learn about it and the better I can perform.

PRESHOOTING PREPARATION

There's a special building in every community where everyone can "rev up." It's the local library. There you can become acquainted with the sport you want to photograph. You wouldn't attempt to compete in a sport you've never heard of, but regrettably many people try to photograph sports they don't know anything about.

You can find all the information you need about any sport in the library. There are books and magazines covering most. Read them.

With some types of photographic subjects you can walk in cold and come out with something hot. But generally, you must know the rules of the sport—what is going to happen next, where to position

STEP VS. STOP
You'll notice in this book that the word *step* is used instead of *stop* or *f-stop* when exposure is discussed. This is standard ANSI usage because exposure depends on *both* exposure time and lens aperture, not just lens aperture as *f-stop* and *stop* imply. If this bothers you, read *stop* or *f-stop* instead of *step*.

yourself, and what direction to aim your camera and lens to catch the best action.

In baseball, for example, if there is only one runner and he's on third base with one man out, you'll know that this situation calls for the next play to be at home plate, not first—if you've done your homework. You must visualize the action *before* it takes place or you'll never get there in time, regardless of the camera you have or the focal length of your lens. Sophisticated equipment is no substitute for knowledge of the subject and good judgment.

I once witnessed a low-altitude malfunction at a skydiver's club. I was by no means an ace skydiver, having only seven jumps to my credit at the time, but I instantly recognized the "Mae West" when I saw it—one line over the top of the parachutist's canopy caused it to spiral out of control. To someone unfamiliar with the sport, this may have appeared to be a typical descent because high-performance parachutists often maneuver in similar style. In this case, however, it was an inexperienced student hanging from the partially inflated canopy. He was hesitant to cut away—release the main chute and use his reserve chute.

The problem with riding a partial chute down is that it can collapse without warning. If you cut away, the two parachutes can become entangled, and neither will open. I hated to think about what I would record, but instinctively reached for my camera.

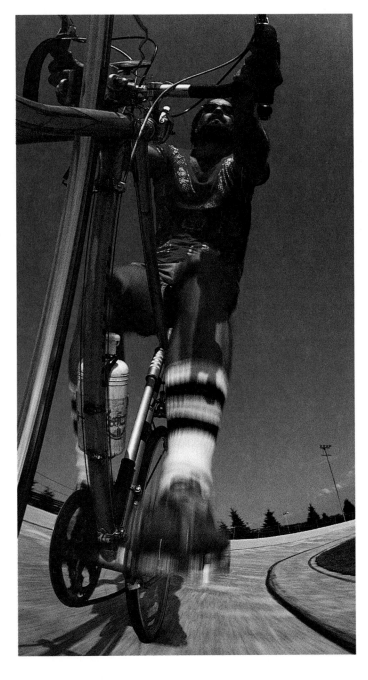

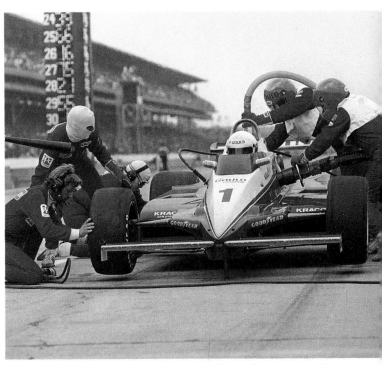

Above: Get to where the action is, regardless of the sport. This was shot from the pit area, and captured the excitement of the moment. Photo courtesy *Stock Car Racing Magazine*.

Left: Don't do what everyone else is doing. Develop your own approach to capturing the sport on film. This is an example of what you can do if you let your imagination take over.

DON'T DO IT!

In this book I often explain what you *shouldn't do,* based on my experience. Sometimes I do dangerous things. This is not to be interpreted as an endorsement of craziness. Any "stunts" should be calculated, and should not be attempted without careful planning and proper safety precautions.

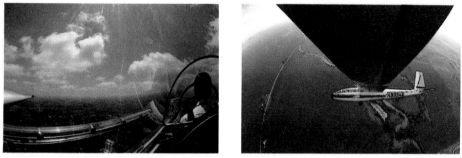

Avoid cliché photos by trying a unique setting. The shot at left was taken from inside a glider cockpit. You can see the reflections from the canopy. Or, use a lens other than a standard 50mm. For the shot at right, I mounted a 16mm lens and remote control on my camera and taped everything to the glider's wing.

Finally, he released his main. The reserve didn't open. After what seemed like minutes, his reserve finally popped but failed to inflate. At about 1000 feet above the runway, his reserve chute spread out, slowing the fatal fall. Fortunately, I did not have to take any pictures of the results.

Had I not been familiar with the sport, I wouldn't have recognized the severity of the situation, nor would I have been prepared to document it.

Picture Ideas—Check picture books and magazines devoted to the sport you are interested in. These will show you the best angles or unique views, and give you an idea of what lenses you'll need for your camera.

These publications also display the best of what photographers are offering. I am not suggesting that you copy the styles or shots exactly, but seeing them should stimulate your creative juices. From there, your own perspective will emerge. Once you've seen what you feel are superior images, you'll begin to think in those terms. You may come up with angles or combinations you might never have considered otherwise.

For example, once I noticed a sailboat in a magazine advertisement. The photographer must have been looking down at the boat from the mast. I turned the page and thought nothing more about it. Three months later, the idea surfaced upside-down: Why not attach the camera to the front hub of a bicycle and shoot up at the bike and its rider? The bicycle image was not a duplicate of the sailboat photograph, and it was fresh because most people had not seen it before. You can see the result on page 5.

Clichés—Another benefit derived from studying what has been published on a subject is learning what shots have been overdone. All clichés were fresh at one time. Because sports are often repetitive, you must be creative when photographing them. Avoid shooting banal viewpoints by knowing what has been done. Use a different approach when possible.

Observe—After you have learned all you can about the sport in the library, observe it *without your camera*. The disadvantage of watching the world through a viewfinder is that such a point of view narrows your field of view.

When I show up at a sporting event I have never photographed before, I leave my camera gear in the car. If you have time to attend the sport as a spectator, you will be ahead in the long run.

Sit back and observe—but watch like a hawk studying the whiskers of a field mouse. Note where the action occurs most often; where the crashes happen; the toughest turns; good camera positions close to the competitors; remote-camera possibilities; how you can get up close; what lenses you should use from which positions; problems you may have getting from point A to point B; how best to deal with crowds, and so on.

Participate—Now that you know what is *supposed* to take place based on your library research, see if it all happens according to the book. The unexpected often occurs. The best way to become fa-

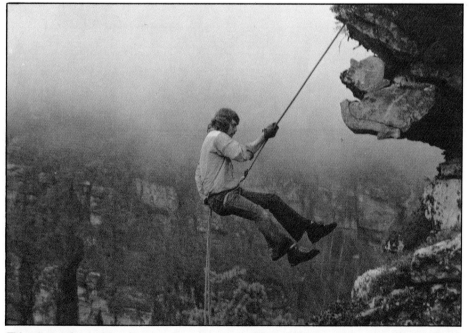

This shot, taken with a borrowed camera and a 50mm lens, brought me my first national photo contest award.

miliar with any sport is to jump right in. Photographers filming an event they have experienced themselves have a definite edge over non-participants.

PREPARATION

Imagine the embarrassment I faced when I rushed through the dressing room at my racquetball club, ripping off my clothes, pulling others on, trying madly to get on the court before the clock started. It was my first important challenging match. When I reached in the bag for my gym shorts while running for the door, I found . . . nothing. If you don't like to get caught unprepared, plan ahead.

When you are ready mentally, then start on your equipment. Specialized equipment is not required for successful pictures. You can take good photographs with even the most basic camera, although sophisticated equipment is easily affordable for almost everyone. When I started, I borrowed my father's Nikon and 50mm lens and made a picture that won fifth place in a national photo contest. It is *how* you use your equipment rather than what you own that scores.

Basic Equipment—The minimum required to cover most sports adequately is a 35mm single-lens-reflex (SLR) camera, which allows you to change lenses; a 135mm (short telephoto) lens, and a 28mm (moderate wide-angle) lens.

If all you have is a camera and standard 50mm lens, you don't have to sit home. You can still produce beautiful images. Pictures made with a 35mm rangefinder, a 126- or 110-format camera or even an instant camera are acceptable, too. But if you want to make enlargements to hang on your wall or to sell your photographs later on, you'll need the 35mm format, an SLR and several lenses. I'll discuss how to expand your equipment inventory later.

What To Take With You—After you have analyzed the sport and scouted the location, you'll know what lenses you may need. Always take more film than you think you'll shoot. I usually figure out how many shots I want and then double that number. *Always* take extra batteries for everything that uses them, such as electronic flash, motor drive, light meter and electric socks. Lens-cleaning fluid and tissue will save you from using your T-shirt.

Extras—If foul weather is imminent, protect your equipment and yourself adequately. See Chapter 3 for more on this. When it's going to be an all-day event, I usually bring a few sandwiches so I don't go hungry or lose precious shooting time looking for food. Note: If you are crazy enough to carry your sandwiches in the same bag as your equipment, you deserve to get mustard on your lenses.

Get There Early—Don't question this advice—just do it.

Lists—The best kind of preparation is to make a list. Start it the minute you decide to shoot an event. Any time an idea comes to mind, add it to the list. When you are filming, many spontaneous opportunities will arise. A note will keep you organized and help you remember to cover the essentials.

My "want list" of photographs for the 1980 Road America Can Am included pit shots, the ninth turn, classic cars and the starting lineup. Little did I know I'd be standing next to the straightaway, three feet from Paul Newman. Make sure you get the essentials of the event, and every now and then you'll get a surprise.

MAKING CAMERA OPERATION SECOND NATURE

Can you change your lens with your eyes closed? You may need your eyes for more important matters than mounting lenses.

I was filming some wild rams high in the Rockies several years ago after spending three hours closing in on them. I shot a few frames with my 200mm lens and decided to go to the 500mm lens. I knew the rams would stick around because they hadn't sensed me yet. I knelt down and made the change as quickly and silently as possible. I stood up slowly and focused the big lens on . . . nothing.

I could see for at least a mile in every direction and thought I was within earshot so I could tell if the rams moved, but nothing was there except a few wildflowers and mountain peaks 50 miles away. I have no explanation for their getaway, but as a result, I now keep my subject in view while changing lenses.

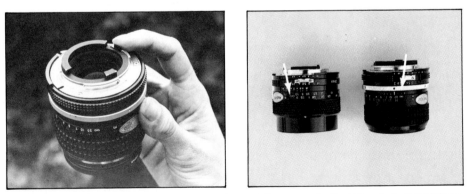

Become familiar with *every* part of your equipment. For example, the Nikon breechlock lens in the photo at left has an automatic aperture lever that fits into the breech on the camera. You'll find different levers and controls on other makers' lenses. In the photo at right, note the infinity symbol (∞) on the distance scale of the two lenses. On the lens at left, the ∞ is on the left; it's on the right on the other lens. This means that they focus in opposite directions. As a result, if you work with both lenses, your focusing technique will not be automatic—you'll have to remember which lens you have mounted on the camera, and think about which direction you have to turn the lens focusing ring.

Left: Holding the camera wrong slows focusing and aperture adjustment, and hinders steadiness. Right: The solution is easy. Turn your hand over. With the palm facing up, you can hold the camera and lens steadier and make adjustments faster. This is particularly important when using a telephoto lens.

Changing Lenses—The bayonet-mount lens is the most common lens-mounting system today. The easiest way to get used to changing the lens is to locate the aperture lever on the end of the lens that attaches to the camera body and note where it is in relation to the bayonet slot on the camera breech. Finger them together while still peeking. Then shut your eyes and try it a few times by touch. Soon you'll be getting them together easily.

Some models use screw-mount lenses. Although there is no reason why you can't use such equipment for sports photography, I do not recommend it. In a situation where you have to change lenses fast, you will find this almost impossible.

"Auto" Focus—If you think about focusing when you focus, you're making it tough on yourself. You should do it spontaneously. Use your lenses enough so you don't have to think about which way to rotate the barrel to move the focus out and which way brings it back in.

For some reason, different manufacturers produce lens-focusing controls that rotate in opposite directions. My Nikkor lenses, for instance, turn clockwise from up close to infinity. I have used other lenses that do the opposite. This difference is significant. I cannot use the others even though they have a Nikon mount because I have learned to follow-focus instinctively, moving in and out automatically with the subject. With the others, I have to think about rotating the barrel in the opposite direction.

Starting out with lenses of different types will prevent you from learning to focus instinctively because each time you change the lens, you have to unlearn everything you learned with the other lens. Make sure all your lenses work the same way. Then practice until operating them is *automatic*.

The most common focus method used by novice photographers is to simply twist the lens back and forth at random until the subject finally looks "good." This technique may be fine for scenics or shots of Granny on the front porch, but it won't do for sports.

Practice focusing. When you know which way to turn the lens barrel, don't stop practicing. Keep at it until you no longer need to even think about rotation but automatically move with the subject. This is called *follow-focusing,* and is covered in greater detail in Chapter 2. It's the greatest operational skill a sports photographer can develop. And you'll never need an auto-focus camera.

Many of today's cameras have automatic-exposure control. Under the right conditions, this feature can be a great asset. But if your camera does not have such a feature, I'll show you where to get one free: Look at what's holding this book—that free control is attached to the end of your arm.

Correct Handling—To make camera handling second nature, the first step is to learn how to hold the camera correctly. Most beginners hold the camera with the right hand and operate the focus and aperture with the left hand, palm facing out. The problem with this technique is that the hand must be moved to the aperture control to change the setting. And to focus, the hand must be moved forward again. As a result, simultaneous focus and aperture manipulation are impossible.

The solution is simple: Turn the hand over. With the palm facing up, you can focus with the thumb and index finger. Aperture adjustments can be made with the second or third finger. The real advantage is that you can perform both functions at the same time.

"Sensing"—Under most lighting conditions, you won't have to adjust the aperture more than a

Karate requires a lot of practice—to participate in or to photograph.

step or two either way. Modern 35mm cameras have an arrow or other display along one edge of the viewfinder. With practice, you can see it with your peripheral vision rather than actually focusing your eyes on it.

From there, it's just a matter of sensing when the setting has to be adjusted, while still keeping your eyes on the action. Make minor adjustments as the lighting changes.

WHERE TO START

There are difficult and easy sports to film, just as there are difficult and easy sports to play. For example, few aspiring karate students would attempt to learn their sport by first entering a black-belt combat tournament.

Inexperienced photographers should not tangle with karate fighters either because most meets are held indoors under poor lighting conditions, opponents move about unpredictably, the action is very fast, events end quickly, and backgrounds are usually cluttered. There are easier ways to start fighting or shooting.

Confined Action—Begin with sports that have confined areas of action. I don't necessarily mean a game of Chinese checkers, although if you have trouble keeping checker players in focus perhaps this *would* be a good place to begin. Many action sports follow predictable patterns—you know where the action will take place. In climbing, for instance, the rappeller (a method of descending by sliding down the climbing rope) has no choice other than to follow the rope down.

Sometimes even knowing that is not enough. Several years ago, while John Patten and I were climbing in Colorado Springs Canyon, we spent the night on a pinnacle called "The Maiden." The next morning I wanted to get a picture from below of John rappelling off this famous rock. He dropped "free fall" about 5 feet away from the face of the

After you have the rope in focus, the climber will be, too—and you can count on the two staying together.

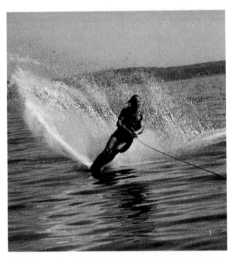
When you're in the tow boat, waterskiers don't get out of focus because they're always at the end of that rope—unless they go under. A word of warning: Remember that it's easy to soak your equipment on such rides.

rock. When descending this way, the rappeller loses control of his rotation because the rope twists as it moves through the hardware, spinning him during the fall.

John was about halfway down, spiraling slowly in mid-air, 200 feet above the ground and in no mood to pose for pictures. I hollered up to him, "Hold it right there." Obligingly, he stopped his descent but continued to rotate. Jokingly, I continued, "Now face the wall and stop turning." As I recall, he wasn't amused.

Water skiing is another good example of a sport with a predictable location. Skiers stay at a constant distance from the boat under normal conditions. When filming from the towboat, once you get the skiers in focus, the focus shouldn't change. Of course, that doesn't take into account a wipe-out, which is most spectacular at the moment of release, while the contorted body is still in the air, and in one piece.

Predictable Location—Don't limit your education to sports in which the person is attached to an umbilical cord. Toboggan runs or Alpine slides are fast sports, but the racers are confined to the track. You can predict where they will be when they appear. If they are not on the track, locate them in your viewfinder—you may get some unexpected action shots.

Other roaming-type sports with predictable patterns also make good starters. Cross-country skiing is easy. Unlike jumpy karate participants, cross-country skiers tend to go in a straight line. Although the skiers are not confined to one area, you generally know where they will be next. Unless they are angled toward or away from you, their line of travel will remain relatively constant. Then get them in focus once and simply follow with the camera until you have the background or composition you want, and shoot. To keep them in focus, use a small aperture (large f-number).

GALLERY OF SPORTS PHOTOS

You can produce photos similar to these and others throughout the book. Most are made without any specialized equipment or difficult photographic techniques. The only limitations are your photographic skills and your imagination. Photographic skills you can read about in this book; imagination is something you have to develop on your own.

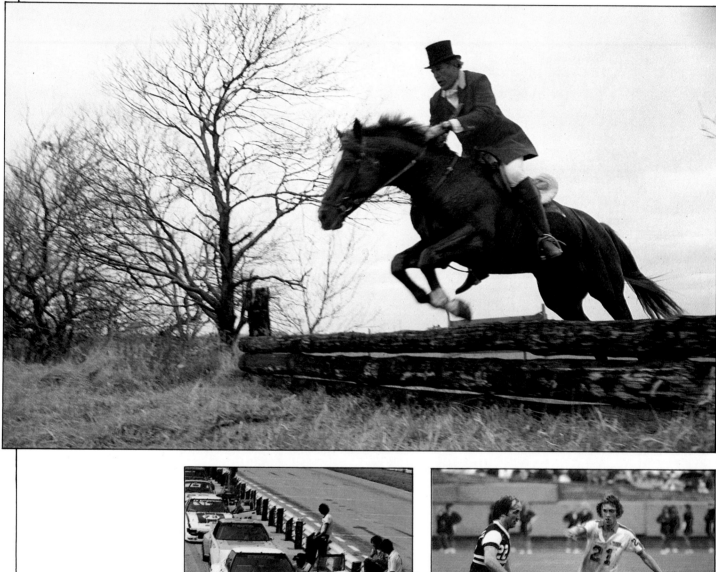

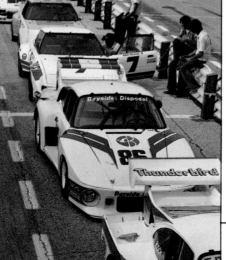

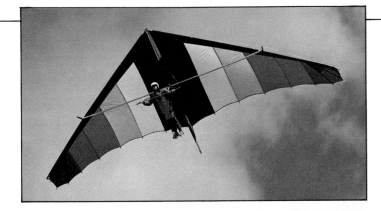

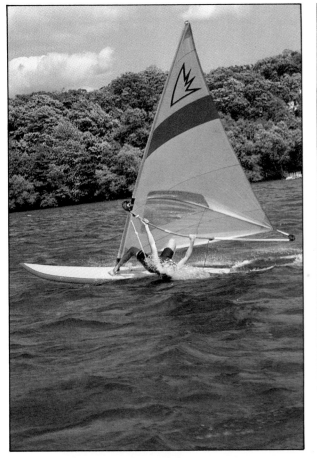

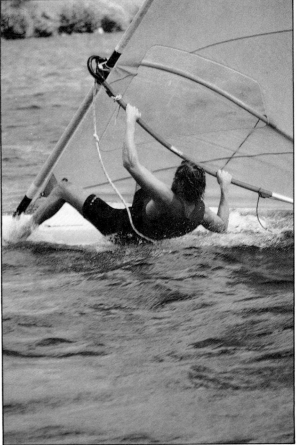

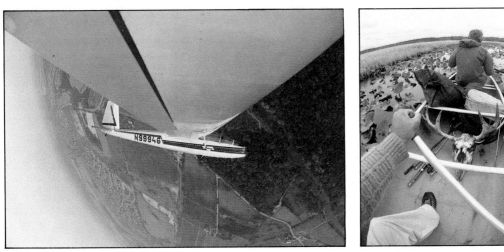

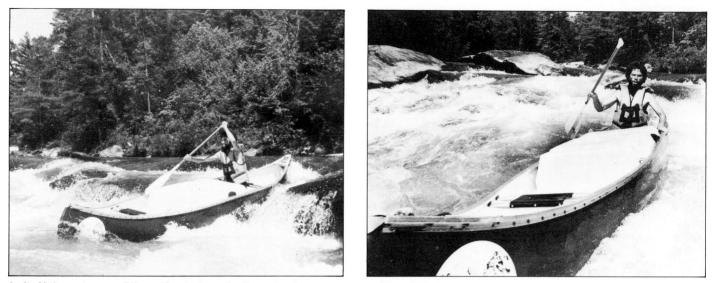

Left: If the outcome of the action looks safe, it creates less suspense and interest, or *dramatic effect,* than when there is an element of danger. **Right:** The canoeist hit a rock. Will he make it?

Why Golf?—The sport in which individuals whack little balls and follow them around is a great training sport for shutterbugs. One reason is that golf is always available. Every other sport in town could be rained-, sleeted-, snowed- or hurricaned-out, but not golf. You can count on golfers being on the golf course against all odds.

Another reason is that most of the action—walking after the ball, looking in the weeds, golf-cart crashes—is incidental to the sport. The only significant action is the "whacking" part. Luckily for the inexperienced photographer, during this play the golfer's feet never move—intentionally, that is.

Finally, the photographer always gets a generous number of start-over focus chances before any contact with the ball is actually made. Can you imagine asking a black-belt kung-fu expert if he would mind "kicking that fellow's teeth again?" In golf, you get as many tries as you like without even asking.

Little League—After mastering golfball beaters, it's time to progress to Little League baseball. Actually, Little League is one of the best places to develop action shooting skills. The motions of the tykes are identical to their big

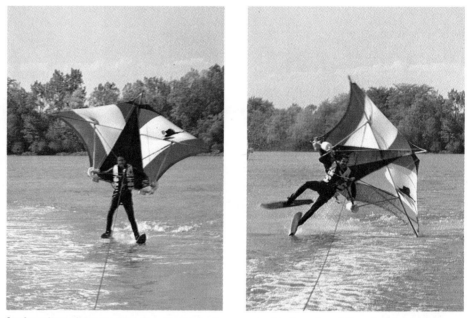

Again, when all goes well, the element of suspense is absent and the shot is of average interest. But potential disaster intrigues the viewer.

brothers at the major league stadium. Shooting at their games will give you a feel for where most of the action occurs, the best shooting locations, lighting angles and changes and, most important, it allows you to develop follow-focus techniques.

WHAT MAKES GOOD SPORTS SHOTS?

Once I took two pictures of the same canoe and the same paddler going over the same set of rapids.

I've sold one of them half a dozen times and the other will probably never sell. Why?

In the first picture, everything is under control. The canoe is upright, the paddler is doing what he should, and everything is bound to turn out all right—so the viewer thinks. But it doesn't. The second picture shows the next instant when the boat hit a rock, tipped sideways, and jolted the canoeist. That's suspense. Looking at the picture, you can't tell if he

hit the cameraman, flipped upside-down, drowned, or did all of them.

A picture that hints of the possibilities but leaves the conclusion up to the viewer has suspense. Tantalize without telling the whole story, and you captivate your audience.

Suspense—All sports fans are romanticists in a sense. We want the athlete to make it, particularly if he is the underdog. One type of suspense is built by catching the moment *before* defeat or victory, while he is still hanging on the crest of destruction—"he might make it, but he might not." After that, this element of chance no longer exists, and the moment of suspense is past.

Human Drama—Human drama is a strong attraction in sports photographs. We empathize with those who win and those who lose. The runners in the middle of the pack go by unnoticed, and so will your pictures of them. The individual who falls, the one who comes from behind and the victor, all stand out from the crowd. Concentrate on the extremes rather than the middle of the road.

The tendency, of course, is to concentrate on the leader of the pack. Keep that lens moving with the front runner. It requires concentration to divide your attention

with the also-rans, but they are just as much a part of the event as the ones on the other end. And, they are often overcome with as much emotion. Don't let the tears of joy steal your attention from the tears of defeat.

Emotion—For me, emotion is one of the most dramatic and difficult elements of sports to photograph. But it is the essence—the heart of it. Show the feat *and* the internal feelings, and you will have a compelling portrait of life—not of a sport, but of a person and a contest. You will have touched the very substance that embodies humanity. Our lives are driven by emotion, and the athlete often displays the gutsy, unclothed expressions that many of us feel but have learned to hide.

We run into a problem here of *trespassing.* The only way to capture feelings is to move in on the subject. Emotion is shown with various parts of the body, but primarily with the face.

Faces communicate without words. The only way to use faces in your pictures is to move in on them. The ethical question remains: Should you record a person's loss or disgrace, focus on his feelings, disrobe his heart to the public eye? There is no simple answer.

Naturally, every situation requires a different response. I caution you to be sensitive when photographing "hurt." Often a standard 50mm lens requires you to be too close in such instances. Use your judgment and determine if a long lens would be less intrusive.

I remember shooting at a climbing seminar in which the participants were all husky college football players. One guy couldn't rappel. His arms and legs were shaking and some of his friends were laughing. But he couldn't back off the ledge. Eventually his fear showed itself around the edges of his eyes and ran down his hard, leathery cheeks. It was a classic, but his embarrassment was too great for me to record it, so I didn't.

Your conscience should be your guide. When possible, in victory *or* tragedy, let the soul of the participant say it. Such an image can give life to the dreariest subject.

Action—It may seem elementary to say that *action* is what separates most ordinary subjects from intense ones, but some photographers misinterpret that word. It is not enough just to have the subject moving. The action must *show.* Many methods can be used to portray motion, such as panning to blur the background or freezing the subject in mid-air.

Emotion alone can carry an image and is usually spontaneous. The hardest part is spotting it and documenting it before it ends. Many photographers miss crucial expressive moments by relaxing when they think the action has stopped. Is it ethical to display a person's emotions? You'll have to answer that yourself.

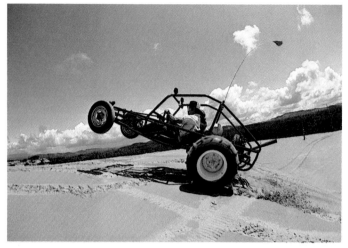

Decisive moments must be anticipated. When I saw the dune buggy speeding by, I knew it wouldn't stay on the ground much longer, so I was ready for this instant.

The best way to show detail is to move in close and isolate one part of the subject. How close you are to the subject is not as important as how you isolate the subject from its surroundings.

Besides the obvious techniques, you can effectively use internal elements of the picture to promote the sense of movement. Diagonals, especially zig-zag lines, can give the feeling of violent action, even if everything in the picture is stationary.

I took a picture of a skier standing below the Matterhorn. Nothing in the scene moved, but the picture promises action so loudly that it works. How? I used a 16mm fisheye lens that distorted the background, making it seem to go uphill. The skis, aiming diagonally toward the front corners of the picture, were stretched out of proportion by lens distortion and appeared to be jutting out of the image.

The action wasn't in the picture, but you knew it was coming. Remember, the photograph doesn't always have to have *motion,* but without *action* it's as dead as wooden skis.

Detail—The one component most often missed in photo coverage of any subject, including sports, is *detail*. Close-up, specific shots are what sell photo stories, not only to an editor but to readers and viewers as well. The way to give a complete photographic image of anything is with close-ups.

Move in on the hands, feet, important parts, connections. Show how the rope is held, how the harness is buckled, what it looks like inside the cockpit—everything the spectator can't usually see from the sidelines.

Head shots are essential to all sports photographs. Without heads, most games could not be played. Every other part of the athlete's body can be blurred, out of focus or hidden, as long as the head shows. Taken a step further, every part of the face can be out of focus as long as the nearest eye is sharp. Keep the subjects' heads in view and don't fire until you see the whites of their eyes.

Peak Motion—A freestyle skier hangs for a moment at the peak of his jump before plummeting back to the powder. A diver hangs motionless for an instant at the height of his ascent. A skydiver slows from 120mph to 11mph in nine-tenths of a second.

Peak motion in many sports is the apex of the act and well worth shooting. The more peak action you can discover in sports, the more visual excitement you will exhibit in your photographs. To accurately predict when it will occur demands complete familiarity with the sport—but you already know this.

Composition—Some folks don't think composition is an important element of sports photography. Let me assure you that it is.

I tested this theory with two almost identical pictures showing a canoe crossing a misty lake. In the first, the canoe was slightly off to the left, heading toward the center. In the second, the canoe had crossed through the center of the picture and was heading out the right side—a basic compositional taboo.

I submitted both pictures to dozens of magazine editors across the country. The first shot has been published more than 15 times; the second has never been purchased. Don't kid yourself—compositional rules evolved be-

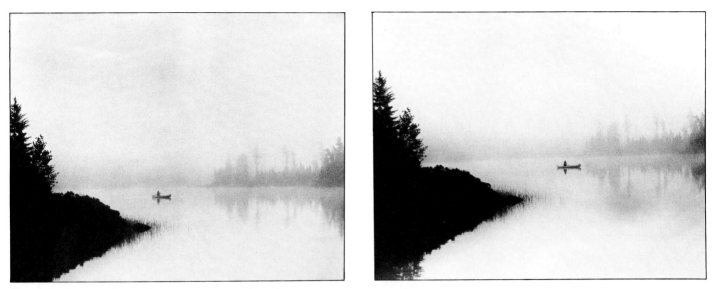

These are the two pictures I put to the test, as described in the text. One has been published more than 15 times—the other has never been accepted. Before reading the explanation, try to figure out why one is preferred over the other.

cause they work visually, not just with isolated topics. In Chapter 5, I discuss rules and tips for good composition.

DEVELOPING A QUICK-FOCUS TECHNIQUE

The ability to focus as fast as you can aim your camera is one skill that will improve your sports shots more than any other. I discuss many focusing techniques in the next chapter, but you should be aware that competence depends on *practice*. There is no shortcut.

Once, a young fellow wanting to see the photo exhibit at the Museum of Modern Art apparently approached the building from the wrong street, and could not locate the entrance. On the corner, he spotted an elderly gentleman carrying a vintage rangefinder camera, and thought, "Ah, this man should be able to direct me." Mentioning that he, too, was a photographer, he asked the gentleman how to get into the museum. The older man looked at the youth and said, "Practice, practice, practice."

Happily, it doesn't take enormous amounts of time or capital to practice shooting, if you do it right. The best place to start is at home with an empty camera.

Several times a day, pick up your camera, aim, focus and fire. Keep the camera available, and anytime you can—while visiting with friends, sitting around the table, during TV commercials—pick it up and "play" with it, even for only five minutes a day. If done consistently, this will help you become more comfortable and at ease with your photographic equipment.

Home Practice—Begin your practice sessions by setting the focus on infinity. Look through the viewfinder and move the camera around, stopping arbitrarily on any object. You can "shoot" light switches, chair legs, chandeliers, table legs, door knobs, real legs, or anything stationary. As you stop on the object, snap it into focus with as few twists as possible. Gradually you will become more adept at "feeling" the right and wrong rotation directions. Focus on near and far objects, constantly trying to cut down on focus time.

Live Practice—When you feel that you have good control over the legs in your house, try your hand at some faster things. Focus on the dog or cat or follow a person's hand as it moves during conversation. Aim out the window at passing cars, neighbor-

hood kids on their bicycles, the garbage man or anything else that moves.

This will force you to freeze the action and lay the foundation for follow-focusing. It is important to squeeze the trigger during this practice so you learn to coordinate your shutter timing with precise focus. Again, practicing with an empty camera won't cost you anything.

The Test—When you feel that your eyes and hands work in unison, put some film in the camera and test the results of your labors. One of the most sensible arrangements is to *practice while getting paid* for practicing.

Photograph sporting events in your local area for profit. Most local clubs and community teams rarely get publicity or photographic coverage. Attend one event and get action shots of individual players. At the next game, bring a contact sheet and 8x10 prints of a few of the best shots and show them to the members. Most people are vain enough to pay $5.00 for an action shot of themselves doing what they enjoy doing.

Typically, these teams will not have an opportunity to purchase action shots from any other source. Several team members are

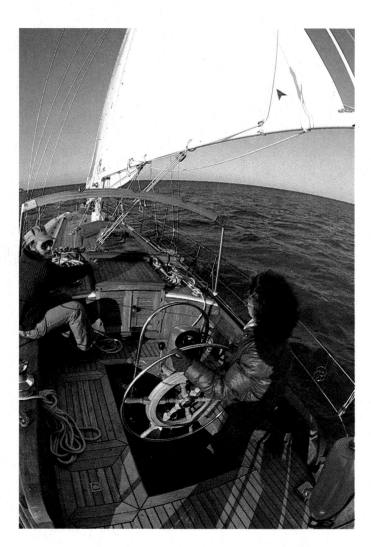

One reason you may want to use a wide-angle lens in some situations is that it offers good depth of field, and doesn't require precise focusing. When necessary, preset the lens, point and shoot. At left, I used a 16mm; above, a 35mm.

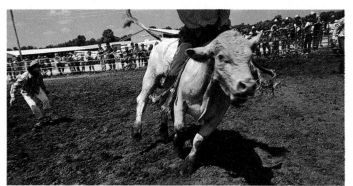

I was in bigger trouble than the rider of this mean-looking critter when I decided to get out of the way. Do you see the several things wrong with this picture?

usually delighted with the prospect, which often tips the first domino. This in turn pays for your practice session and the next few as well.

You can find other suggestions of ways to earn money with your camera in HPBooks' *How to Make Money with Your Camera* by Ted Schwarz.

AUTOMATIC EXPOSURE WITH A MANUAL CAMERA

People who own simple cartridge-type cameras think they have it easy. They assume they are the only ones who get to point-and-shoot. I'll show you a way to automate your manual 35mm camera to make it faster and easier than a 110 camera—without purchasing any accessories. The results with your 35mm camera, of course, will be far superior.

Wide-Angle Lens—First, use a wide-angle lens, either 24mm, 28mm or 35mm. The advantage of a wide-angle lens is its great depth of field. Using Tri-X film on a clear day, with an aperture of *f*-16 on your 28mm lens and a 1/500 second shutter speed, you can set the lens at ten feet and have a zone of focus from three feet to infinity. If the subject is not closer than three feet, it will be in focus.

This might get you in trouble, though. I was using this technique to film bulls and their riders at the DuPage County Rodeo several years ago. Most of the animals seemed to deliberately go in the opposite direction I wanted them to. Finally, one brute singled me out and started closing the gap between us. As he did, the image got better and better through my 24mm lens. As if I were watching

a thriller on the big screen, I couldn't pull my eyes away.

Unfortunately, the scene was in my viewfinder instead, and I was in a pen with a mad bull rather than in a theater. The beast was so close to me that the rider was no longer in my finder. I continued to shoot. By this time I could see the individual hairs on the bull's nostrils, and saliva trailing out of his mouth. I figured that was close enough but when I put the camera down, I had a big surprise coming.

Because the wide-angle lens distorts your perception of distance, it makes objects seem farther away than they actually are. The six feet that separated me from the stampeding bull through my lens suddenly became two feet in reality. Never before had the people screaming in the grandstand witnessed a photographer jumping higher than the bull.

Moral: When you are close to the action, respect it—and remember the distortion properties of the wide-angle lens.

Another Benefit—With its wide angle of view, the wide-angle lens also enables you to make quick shots before you get the camera up to your eye. Then, if there is time to focus precisely and make other minor adjustments, you can take a back-up shot. At least you will have the original image if you don't get another chance.

Shutter Speeds—Next, choose the shutter speed that will stop the expected action. To film hikers, 1/125 second is usually sufficient. Motocross bikers generally require 1/250, and airplanes 1/500. Naturally, a faster speed also freezes the action, but by picking the slowest possible speed for each subject, you gain the greatest depth of field due to a smaller lens aperture.

Meter Readings—Outdoor light is usually stable and predictable. Lighting will also be even if the sky is overcast. Most subjects will require the same exposure because no shadows exist under overcast sky.

On clear, sunny days, the only major change in lighting usually occurs in shaded areas. For a correct reading of the area in shadow, move in close and meter just that location. Set the reading manually on your camera or use the exposure-hold button if your camera has one. Move back to your original position and make the exposure.

When you can't get close to the shady area, place your hand in light similar to the area you want to photograph and meter on it, making sure the camera doesn't cast an additional shadow. Remember to set your camera back to automatic, or the previous meter setting. Generally, all areas in sunlight will require the same aperture setting.

Lighting fluctuates on transitional days when the sun is going in and out of clouds. On such

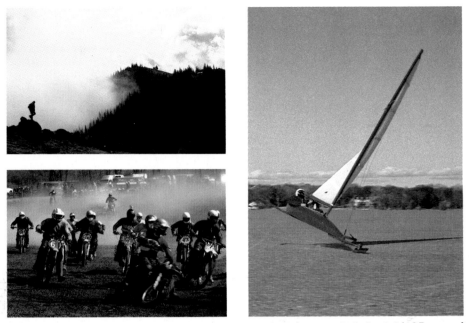

To stop action on film, you'll generally need to use a shutter speed of about 1/125 second for hikers, 1/250 second for motocross and 1/500 second for ice boats.

occasions, take one reading in full sunlight and another under the cloud cover. Change your settings as needed during the shooting session. I usually make meter adjustments as the light changes rather than when I shoot, so my camera is always ready.

Besides the "automation" these techniques provide, you get more than just simple freedom. Learning to keep ahead of your camera's operational mechanics is the way to better images. The more you have to think about working your gear, the less involvement there is between you and your subject. When the mechanics are automatic, you can devote all of your attention to creative execution.

FIVE REASONS TO BEGIN WITH B&W

Staring up through the snow, I heard my ski partner say, "You're doing great! If you don't fall, it means you're not trying hard enough." If you are going to learn to ski or photograph, expect a lot of mistakes along the way. It means you are doing what you should be doing—learning from mistakes. But unlike pulling yourself out of the snow, every trip-up in photography costs money. By starting off with b&w film, you will find advantages other than just economy.

Cost Factor—First, of course, is the cost savings. When comparing negative materials, every penny spent—or wasted—on b&w film would be about four cents in color. If you shoot 20 rolls of film before you weed out all the idiosyncratic bugaboos—before you get consistent results—it would cost . . . well, you figure it out.

A benefit of using b&w is that you can make *contact sheets* of the negatives on standard 8x10 sheets of photographic paper. This shows all the images on the roll the same size as the negatives. These give you better perspective of your progress as a photographer. Overall approach, shot sequence, repetitive faults, picture flow, composition, areas of omission are all visible on the one tell-tale piece of photographic paper.

Contact sheets are not necessary when shooting with slide film because the final image is a positive, and you can view it directly. They can be ordered for color negatives, however. You can make b&w contact sheets yourself even

without a darkroom by aligning the photographic paper with the negatives in a dark room in your house, placing a sheet of glass on top of the "sandwich" and turning the light on for a few seconds. Then run the paper through developer and fixer. Of course this is not going to be as good as a proof made under controlled lighting conditions, but it should still provide you with usable results.

Speed—Another advantage of b&w used to be its speed, or sensitivity to light. Fast (ASA 400) b&w film can work well at film speeds of 800 or more. But today's high-speed color slide films can also be used at high speeds. They can be shot at higher than their rated ASA speeds and then *push-processed,* to work under low-light situations without flash. The advantages of faster films are obvious for the sports photographer who will usually take all the shutter speed and depth-of-field he can get.

Latitude—The greatest advantage b&w offers the beginner is *latitude.* This refers to how "forgiving" film is. For example, if exposure is off as little as 1/2 step with color slide film, it may show up; precise metering is critical for most pictures. However, when using b&w film under normal lighting conditions, you could be off a full step in either direction and still get acceptable results. This gives a leeway of two *f*-stops—quite a boon to the photographer who feels like he is caught in the middle of a technician's nightmare. Don't abuse it; it is not a license to be sloppy. Always strive for precision and quality in your photographic technique. In the beginning, if you're not sure of yourself, use b&w film.

Darkroom Tricks—Additionally, b&w images can be rescued in the darkroom. Poorly exposed film can be corrected during processing—up to a point. No solution can save completely botched photography. Some printing papers, used to bring out tones and contrast, produce very dramatic prints—sometimes looking more dramatic than the actual scene. Compensation for under- and overexposure problems is another darkroom tool.

Cropping for compositional enhancement is another advantage. Slides are usually presented full-frame, but with prints, you only have to show what you want. Dodging, burning-in and other print manipulations are simpler with b&w because exposure time is the only critical consideration. With color film, you have other considerations. Again, this should not be used to cover up for poor technique or mistakes, but as a method to extend your versatility and the usefulness of your equipment and film. Darkroom techniques can also be used as a way to produce surreal images, or to express your artistic interpretation. You'll find more information about darkroom work in Tom Burk's *Do It in the Dark,* also published by HPBooks.

Seeing In B&W—With b&w film, you have to concentrate on values other than color—such as contrast, balance, texture and form. Many of these components are often overlooked by people who see only in color.

One of the hardest traits to develop is seeing in black and white.

Contact sheets show more than individual pictures: You can see picture flow, in-camera cropping, focus and exposure. Inconsistencies are evident at one glance. This is only part of an 8x10 sheet. The marking you see indicates my choice of frame to be printed, and the cropping I want. Such markings serve as instruction for the person who makes the prints.

This is a strip from another contact sheet. Each exposure was made at a different aperture setting—and each negative will produce an acceptable print.

We are so overwhelmed by color that it is easy to skip over other equally important elements. Subtract color from a picture and suddenly the other important parts become evident. We see that lines, shadows, mass areas, competing forms, detail and texture play major roles in visual communication. Master them in b&w where they are essential and then use them effectively to intensify color.

SETTING UP
YOUR EQUIPMENT

Trying to use a camera right off the store shelf for sports photography would be like taking a factory Chevy to the Grand Prix. But unlike auto racing, camera modification does not take a lot of money or a crew of mechanics.

Ditch The Case—Begin by ditching the "ever-ready" leather case, which is often sold with the camera as part of a package. If you are going to buy a new camera, don't buy this type of case. It was designed to match the tourist's motif. Wrestling with buttons and twisting a cover before each shot will keep you on the sportshooter's bench the rest of your life. For cosmetic protection, there are a few tricks.

Wear—The outside edges of the camera usually show wear first. Worn corners won't affect the quality of your pictures, but may affect the resale value of your camera. To prevent *brassing*—an archaic term passed down from the days when camera exteriors were actually made of coated brass—cut narrow strips of duct tape or similar heavy-duty adhesive tape and line all the exposed edges.

I keep three or four layers of duct tape on the base plate of each of my cameras. This is not just to protect that area; it gives me immediate access to little pieces of the miracle tape. I use it for everything, such as fastening loose sync cords, to keep a fixed focus or aperture in position or taping the remote trigger so it doesn't slip.

When there are several layers of the stuff on the bottom of each camera, it is always available when you need it most and when you are least likely to have any. Put the tape strips on the camera back when the camera bottom has exposed electrical connections for a winder or motor drive.

If you're worried about the looks of your camera, or you just want to have the tape handy, check with your local photo dealer (ask for *gaffer's tape)* or hardware store *(duct tape).* If you want to match the black finish of your camera, and can't find black tape, have your hardware dealer order it from Kendall Inc., Boston MA 02021. It is thicker than ordinary duct tape and does not leave a sticky residue. Another way to protect the exposed camera body is to use self-adhesive Mylar, which is available at most hobby shops. It comes in 8x10-inch sheets.

A neater and perhaps more permanent method of protecting chrome bodies is to paint the outside edges with fingernail polish, clear lacquer or varnish. As it wears off, you can retouch it. And when you sell the camera, you can easily remove the coating with acetone.

Eyelet Rings—Most eyelet rings that connect the shoulder strap to the camera are inadequate for heavy use. They are traditionally the weakest link in the camera system. Replace these with heavy-gauge rings that require at least two complete revolutions for connection.

Clipping your neck strap directly into the eyelet rings will wear grooves in the top edges of the camera body. Avoid this abrasion by using leather neck-strap protection shields. These are available at your photo retailer or you can make your own by cutting small circles out of a piece of leather.

Punch a hole in the middle and insert the circle over the eyelet before you fasten the ring. You can also make the protectors out of rubber or soft plastic.

Camera Strap—Comfort, not often associated with sports, is a pleasure we photographers can bask in. Splurge on a wide, fully adjustable strap that won't dig into your neck the first time you use it. Make sure it can be adjusted short. It should also be long enough to put the camera at your

When carrying more than one camera, adjust straps high and low so one camera will fit below the other on your chest. You can then carry a third and fourth body hanging from each shoulder, if necessary.

navel. You can easily carry two cameras on your chest, one above the other. Your dealer has a variety of these straps.

Once you have the exterior of your camera protected, begin making the functional alterations, some of which will also serve as additional protection.

Front Lens Element Protection—The active outdoor photographer probably abuses the lens of his camera more than most other photographers. Dust, water, snow, mud and sometimes even rocks fly at the glass. One solution is to keep a filter on the front of every lens you own. My filters are never removed unless I break one.

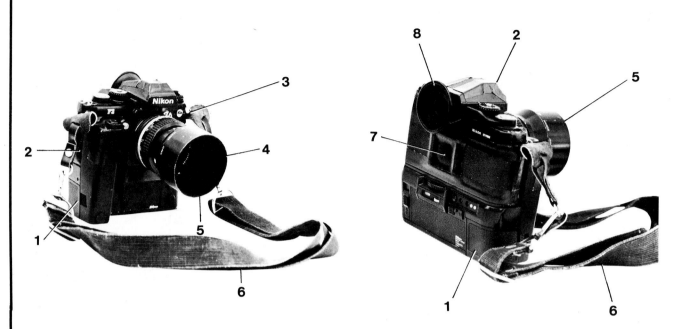

BASIC EQUIPMENT FOR THE SPORTS PHOTOGRAPHER

1. Batteries—be sure to change them at least once a year. There are batteries in the camera body to power the camera controls, and for the motor drive. If you change batteries on your birthday, you're most likely to remember to do so each year.
2. Put duct tape on exposed camera edges to protect them from wear. Outside edges get the most abuse.
3. Replace standard eyelet rings with heavy-gauge rings and neck-strap protection shields.
4. Keep a clear filter mounted on every lens. This will protect the lens from dirt, fingerprints and physical damage.
5. A lens shade provides a shield from extraneous light. Some lenses have a shade built in.
6. A wide neck strap is a must for your comfort.
7. Place tape where your hands or nose touch metal—especially if you're going into frigid temperatures.
8. A rubber eye cup cuts extraneous light going into the viewfinder. This can prevent inaccurate exposure metering.
• Several layers of duct tape on the base plate are handy for protection of the camera and situations that call for some kind of fastener.
• Paint chrome edges with fingernail polish to protect them.
• Seal all exposed screw heads with Loctite.

You can use three types of filters for this purpose. *Ultraviolet* (UV) filters cut down on atmospheric haze. *Skylight* filters give a slightly warming effect with skin tones and also cut atmospheric haze. And *clear glass* filters have no effect on the image at all. Because none of these alter color or light input significantly, you can use them without worrying about changes in your photographs. They're the cheapest insurance you will find.

The first filter I broke was due to my own stupidity. I wanted to change lenses but didn't have a jacket pocket or camera bag to put the unused lens in. So I tried to stuff it in my shirt pocket. If I had a smaller pocket, I wouldn't have attempted this; if it were larger, all would have been well.

But it was just inbetween and I went for it. Nothing but the tail-end of the lens fit in the pocket, so I leaned back to keep it in place. All I wanted was one picture. You can imagine the rest of the story. A concrete slab stopped the lens, front-end first. Nevertheless, I gladly replaced the $10 filter rather than a $200 lens—and learned my lesson.

Lens Shade—The next item is as important as the filter. A lens shade helps you maintain good image contrast and saturated colors when you shoot outside by blocking extraneous light from entering the lens. Whether you are shooting directly into the light source or not, the shade keeps out unwanted light, even on cloudy days.

The lens shade also gives added protection to the most vulnerable part of your camera equipment, the lens. But be careful. Some wide-angle lenses, such as 15mm or 20mm, cover such a broad field of view that a lens shade may cause *vignetting,* or image cutoff. Take your camera with you and

try the shade on the wide-angle lens before buying the shade. The field of view just might include part of the lens shade. Special lens shades for wide-angle lenses have cutouts where they overlap the image area. And some lenses come with built-in shades.

A while back I photographed a caving expedition. I had never crawled in such a place before, and learned a lot of dark lessons. The first thing I discovered was that hard hats get in the way of photography—so I pitched mine. There were six other cavers in the group and I decided that made for enough light without my carbide-lit hardhat. Mistake number one.

I had a backpack full of equipment, a flash and battery pack on one shoulder and two cameras on my chest when I spotted a nice silhouette at the end of a dark tunnel. Because I could see the light I decided it was safe enough to walk toward it carefully.

Halfway there, my shins hit a large boulder and I flipped flat on my face. Two $1000 cameras kept my sweater from getting dirty where I landed on the rocks. Infuriated by my own ignorance, I got up and heard a lens shade rattle. When I picked up the shade, I saw that it was mangled, but neither the lens nor the filter was scratched. Today, I still keep lens shades on all my lenses—and I don't walk in dark places anymore without a light.

Rubber Eye Cup—A rubber eye cup mounted on the viewfinder does more than protect the rear of the camera from abrasion. Light entering through the viewfinder eyepiece decreases image brightness and can affect the reading of the camera's internal light meter. When the eye cup is not needed, it can be folded back out of the way. Then, it protects the back of the camera.

ADDITIONAL ACCESSORIES

Your camera should be fully protected from abuse already,

Both of these pictures were made with the same lens at the same angle and time of day. The only difference is that the one on the right was made with a lens shade.

with varnish, duct tape, a lens shade and filter over the lens, for example, but additional accessories can enhance its efficiency. Check your local camera dealer for these and other accessories. I often cruise through camera shops whether I need anything or not, just to see if they have something I don't have but perhaps should.

Soft Shutter Release—If you own a camera with a mechanical shutter button, install a soft shutter release. This is a pressure-sensitive button that screws into the existing shutter button and gives it hair-trigger reaction. It allows you to make quicker shots by being able to push the shutter release faster. And in the winter, you can operate the camera while wearing mittens.

Sports Finder—Some camera systems with interchangeable prism heads offer a sports finder, sometimes called *speed finder*. This replaces the prism head and permits

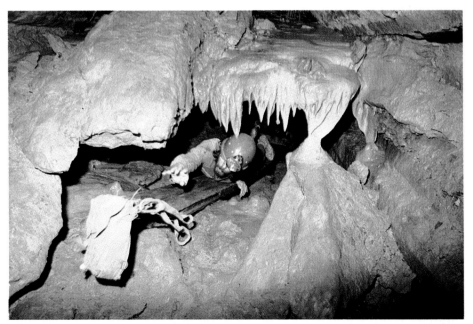

Caving (spelunking) is treacherous for both people and camera equipment. Humidity, mud and restricted passages are three reasons.

full-frame viewing from about six inches away. It facilitates rapid aim-and-shoot photography. It will also give you peripheral vision in the finder so you can see what is not yet in your picture-taking frame.

Grips—Many sports photographers like to use a modified gunstock grip when shooting with a long-focal-length lens. You can make your own by cutting a platform in the top of a rifle stock on which to mount the camera. Then drill a hole through the back to accept a cable release instead of a trigger. This makes it easier to support the extra-long lenses, which tend to cause camera shake. Commercial grips are available at retail camera outlets.

Other people prefer the commercial pistol grip with a remote trigger. The Novoflex grip has a lens-focusing mechanism geared to a separate trigger. The contraption is held like a machine gun, with one hand operating the focus and the other pushing the shutter release.

Batteries—It's unfortunate that so much camera equipment is powered by batteries because batteries eventually fail. I think the marriage of batteries to camera operation is like the old cliché about women: "You can't live with them and you can't live without them."

The best way to live with batteries is to change them at least once a year. Although some will last more than a year, you shouldn't depend on it. Overextending battery usage leads to problems: They may fail at the height of action—or worse, they may leak inside your camera. If you leave them in your equipment for an extended period, you run the risk of repair bills.

Change the batteries in your camera, motor drive, flash, hand-held light meter and other accessories at the same time once a year and you'll stay happy. You'll never forget if you make it a habit to do it on your birthday.

One more precaution: I loosen the battery compartment cover when I'm not using my camera. Then, if the camera power switch is accidentally left on, it won't drain the batteries. Be careful not to lose the cover.

Screws—Unpainted screws on the camera body may corrode or rust if you often work in damp weather. One solution is to dab watchmaker's oil on all the external screwheads from time to time. The oil is available at some jewelry stores.

Vibration—A worse problem for the sports photographer—or anyone who travels a lot with photo gear—is that screws loosen from the vibration of airline flights and automobile trips. Minimize problems by sealing external screws with fingernail polish. Aside from preventing corrosion as I mentioned earlier, it also helps keep the screws from working loose.

Because fingernail polish chips off easily, Carver Penwell, a well-known Chicago camera repairman, suggests the use of a more permanent substance, such as LocTite, which is available at most automotive stores. Dab screwheads with it, using a toothpick.

Screws can be broken loose as needed for future repairs.

Battery Compartment Cover—One screw head that gets stripped more than any other is the cap on the battery compartment. Use a penny to remove the cover when checking or replacing batteries. Quarters and nickels are too fat and round off the edges of the notch. Dimes are too thin.

Caution—It is easy to get caught up in gadgetry with delusions of better pictures emerging from possession of more sophisticated equipment. Good pictures result from what is in your head, not in your camera bag. Spend time with what you have. Get to know it inside and out. Above all, practice, practice, practice.

This pistol-grip telephoto lens has one trigger for focusing and another one for firing the camera.

Photographic Technique

You won't believe this, but I'll tell you anyway. *It doesn't take unusual equipment to make good pictures.* I wish I could convince more people this is true.

The first thing I am asked when people see a picture they like is, "What camera did you use?" I have a standard response. I pull out a well-used 110-format camera and say, "This is my baby. *It's* the one that deserves all the credit." Sometimes I don't even admit my lie.

Good photographic technique creates great pictures, not expensive cameras. Spend your time developing photographic skills, such as focusing. Then go to your photo dealer and talk to him about bigger and better camera bodies. In the meantime, concentrate on the basics.

HOW TO IMPROVE FOCUSING

Nobody likes fuzzy pictures. What most people don't realize is that unsharp pictures are not only caused by *poor focusing* technique, but also by *camera motion.* Both of these problems have traceable roots—improper equipment usage, a misunderstanding of film properties or lack of skill. The first step to improvement is learning what matters and what doesn't.

Misconceptions— Many people put too much faith in *depth of field.* I heard someone tell his buddy who apparently was taking too long to focus, "C'mon, c'mon,

Critical focus is more important when using long-focal-length, or *telephoto,* lenses because the depth of field is shallow.

23

Note how disturbing the picture is with the far eye in focus. When photographing someone's face, the focus must be precise and should be on the near eye.

just get it close. You've got enough depth of field to take up the slack.'' Although this may be true with some wide-angle lenses, don't use it as a general rule.

When photographing a bicycle race, for instance, focusing on the group of bicycles is not enough. You must single out one racer. And it takes more than just having one bike in focus, or just the racer. It must be specifically the racer's head if that is what you choose as your main point of interest.

Many situations call for even further distinction, such as the subject's nearest eye. Always pick your focus as a point rather than a broad zone.

Eye Fatigue—Tired eyes create more focusing problems than most of us realize. According to some researchers, our eyes become fatigued when forced to focus on one point for more than 1-1/2 seconds. They need movement and get it by moving, refocusing and blinking. In addi-

tion to these voluntary movements, the eyes make minute subconscious motions. When you take more than a few seconds to focus on any object, you halt this process of natural movement, diminishing the focusing accuracy of your eyes.

Speed-Focus—The first step to improve your focusing speed and accuracy is to develop a *speed-focus* using the three-motion, two-second technique. Set the camera lens on infinity or move the focus out until it is *behind* the subject. Most of my subjects fall within a quarter turn of the infinity setting, so I like to leave my lens set at infinity. This eliminates the first step of focusing beyond the subject. Next, bring the focus to just in front of the subject, stopping at that point. Then focus precisely by turning the lens focusing ring the other way.

Those three motions are all it takes for any subject. Additional twisting and turning wastes time

and tires your eyes. If you practice until you don't have to think about what you are doing, you will be able to focus more accurately, resulting in more good images.

Moving-Focus—Once you perfect this technique, you can vary it. The most difficult objects to focus on are those *approaching* the lens. Anything traveling at a right angle to the lens is easy to keep in focus. Objects moving away from the lens are not often photographed because few viewers care about the tail ends of things.

Subjects moving at any angle toward the lens are common and the toughest challenge. If you are used to twisting and turning the lens barrel until the subject is in focus, you will never get the shot. By the time you have the subject sharp in the viewfinder, it will move out of focus before you release the shutter.

The only method that works is to focus behind the subject, or start with the focus on infinity,

and bring it forward at a faster rate than the moving subject. Overtake the subject with the focus and then stop just in front of it. At this point, instead of refocusing the lens on the subject, let the subject move into the critical focus point, and then release the shutter. The speed of this technique is unrivaled when the lens is preset on infinity because you only need one motion to put your subject in sharp focus.

I stumbled onto this approach while sitting on top of the Schlithorn in the Swiss Alps. A bird kept making dives at us, hoping for another bread crumb. I was having no luck focusing in on the high-speed dive-bomber.

Every time I shot, I could sense I had misfocused slightly—not much, but just enough to irk me. Finally, I set my cameras down and thought the process through rationally. The moving-focus idea struck home, but it took me most of the afternoon to perfect the technique. Much to the distress of my climbing partner, the sun had nearly set before I finished "playing with those blasted birds." We had to bivouac just below the summit, but I got the picture I was after. That shot graces my stationery now. But more important, I discovered a technique I have used ever since.

Follow-Focus—A refinement of the moving-focus technique is called *follow-focus*. It does not involve any trick twists, but requires enough practice so you can *instinctively* adjust the focus with the changing position of the subject. This cannot be accomplished without automatically knowing which direction to rotate the lens focusing ring for focusing. The key ingredient is practice.

For instance, I *know* my lens focusing ring twists clockwise to infinity. Therefore, when a subject moves away from me, I instinctively twist the focusing ring to the right to "catch up," rather than having to use the more typical "back-and-forth" approach until

Zones of sharpness vary with lens and aperture. The picture at left was made using a 28mm lens at *f*-8. Depth of field is from 4 feet to infinity. The picture at right was taken with a 16mm lens at *f*-8. Everything from a few inches to infinity is sharp. Usually the subjects' heads should be sharpest.

the image is sharp. With enough practice, you won't have to think about this process.

The next step is to be able to follow-focus a moving subject to keep it sharp throughout its movement. You can't do this if you don't instinctively know which way the lens focus moves.

Open-Eye Focus—An essential ability for the sports photographer is focusing with both eyes open. When you close one eye to focus, you're playing with Pandora's box. Most sporting events last several hours. Keeping one eye closed for long periods of time is tiring.

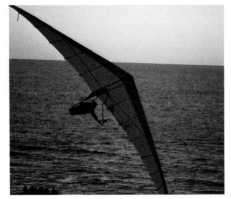

Above: You should be able to *follow-focus* to do good sports photography. Hang gliders don't seem to move very fast unless they are close. I was using an 85mm lens, and thought the glider was going to crash into the hill I was standing on. (It didn't.)

Left: Focusing is most difficult when working with a subject moving toward the lens. Use the *moving-focus* technique or *pre-focus* on a certain area and wait until the subject enters that area before releasing the shutter.

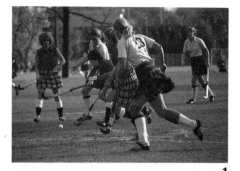

More detrimental, however, is that you cut out much of your viewing field when you close one eye. By learning to focus with both eyes open, you can follow the action with your peripheral vision and anticipate objects about to enter the camera's viewing frame.

You can train yourself so you can use both eyes while you are looking through the finder. First, concentrate on the eye that is looking through the viewfinder. Then, concentrate on seeing areas outside that narrow field with the other eye. You will then be able to use both eyes at the same time. This enables you to keep the camera up to your eye for longer periods and gives you wider vision at the same time.

THREE MORE METHODS

Professionals use three methods of shooting without focusing to give them flexibility in their photographic technique—*zone focus, non-focus* and *subject focus.*

Zone Focus—This approach involves a deliberate attempt to get objects between two specific points in sharp focus. You do this by controlling depth of field with your lens aperture. For example, you may want objects between 4 feet and 8 feet in focus. Focus 1/3 the way between those distances and stop the lens down until those distances are sharp, using the

1. *Open-eye focusing* enables you to see action not visible in the camera viewfinder. This helps you to see where the ball is heading so you can be prepared for the moment it becomes visible in your viewfinder—and might also protect you from getting hit.

2. When you must locate the camera where you can't look through the viewfinder, use *zone focusing.* This is best done with a wide-angle lens because of its greater depth of field. Preset the lens based on where the subjects will be located. Here I set the 28mm lens at 3 feet and held the camera over the edge.

3. A good way to focus on an oncoming subject is to prefocus on a spot in front of it and let the subject move into that spot. This is called *subject focus.* Release the shutter when the subject becomes sharp.

4. Use *hyperfocal focusing* to get two subjects equally sharp. See the text for details.

depth-of-field preview feature on your camera. If your camera does not have this feature, consult your camera manual.

Non-Focus—Wide-angle lenses are particularly helpful here because of their tremendous depth of field. With proper lens and exposure settings, you may not have to focus the lens at all. When there is enough light to use the lens at a small aperture, the area of acceptable sharpness should be about 3 feet to infinity. Set the lens distance scale to show good focus at 6 feet, the hyperfocal distance. Then just point and shoot. Experiment to be sure this works for you.

However, non-focus should be *planned.* Do not use it as an alternative to good focus technique.

Subject Focus Or Prefocus—The third way to focus without actually focusing when the subject is traveling in a predictable pattern, is *prefocusing.* Simply focus on a specific location on the ground or track and release the shutter when the subject moves into that area.

Head Focus—The point of focus is always critical when you are using a telephoto lens. An easy way to get around having to refocus at the last instant with a long-focal-length lens is to move your head and camera forward or backward together. Of course, the success of this type of focusing depends on the lens you are using and the distance you are from the subject.

HYPERFOCAL FOCUSING

A lens has a specific point of best focus. What happens when your shot includes two subjects at different distances and you want them both to be as sharp as possible? Because depth of field extends twice as far behind the point of focus as it does in front of it, if you focus half-way between the two objects, the front one may not be sharp.

One solution is to focus on the near object and let the distant one

go out of focus. The aperture setting affects this distance. A better way is to focus between the two so each one falls within the range indicated on the depth-of-field scale on your lens.

But because depth of field does not extend equally to both sides of the focusing point, it is best to use *hyperfocal* distance. You can do a lot of calculations to find the hyperfocal distance, or do it the easy way: When the lens is set at infinity, hyperfocal distance is the near limit of the depth of field. This varies with the *f*-number. Set the lens to infinity and note the near limit of depth of field, at the chosen aperture. Then refocus to that distance. Everything to half that distance will now be in focus.

As with other techniques I discuss in this book, you should practice this until you feel confident using it. You can then use hyperfocal distance as a standby setting of the focus control.

EQUIPMENT

Equipment plays an important role in focusing. Lens movement and smoothness vary, not only among manufacturers, but also from lens to lens. You want smooth action and easy, rather than stiff, lens focusing-ring movement.

Optics Test—Here's a simple test to make sure your lens is not the cause of poor focus. Remove the lens from the camera and *backsight* it. To do this, set the lens on infinity and place the back of the lens against a piece of paper from a magazine or book. Hold it up to a light source and look through the lens. If the lens elements are properly aligned, the print on the page should be sharp. If your lens fails this test, have it checked by a camera-repair technician.

Focusing Screens—Some manufacturers offer optional focusing screens for the viewfinders of their cameras. The screen I prefer is *split image/ground glass.* The center split image focusing aid—also called a *biprism*—is easy

to use, which is nice for folks who should wear glasses but don't. The ground glass outside the center can be used for faster focusing with long-focal-length lenses.

These accessory screens can be replaced by the user in some cameras. To change them in other models, you must take the camera to an authorized repair facility. For more information, read your camera instruction book. Carl Shipman's up-to-date series of camera manuals, published by HPBooks, cover Nikon, Pentax, Olympus, Minolta and Canon SLRs, and indicate what screens are available and how to have them changed.

"Blind" Photographers—If you don't have 20/20 vision, I suggest you use contact lenses or a diopter-corrective eyepiece. When you try to focus while wearing glasses, you can't get your eye close enough to the viewfinder to see the full frame. Side lighting resulting from that space between your eye and the back of the camera also makes it harder to see and focus, depending on the situation.

Some manufacturers offer lens-correcting diopters that screw into the eyepiece of the camera and correct for near- or far-sighted vision. Or, you can have one custom-made by your optometrist.

You can also improve the viewing image by using a rubber eyecup and a faster lens. The eyecup blocks stray light, making the finder image brighter. A fast lens—with larger maximum aperture— gives you a bright viewfinder image, which makes it easier to focus.

Some of the newer telephoto lenses feature shorter rotation of the focusing sleeve, which makes focusing quicker. This focusing method is called *rear focusing, internal focusing* or sometimes *internal rear focusing.* Conventional telephoto lenses often require two or three complete revolutions of the sleeve to make this focus change. The new lenses require as

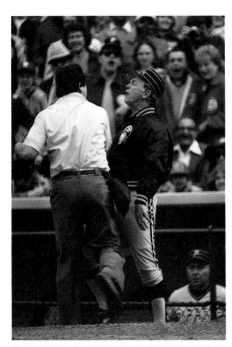
This picture is misfocused. Unfortunately, I was focused on the ump's back, even though my main subject was the coach. The expression on the faces behind them are great—maybe I should have focused on them.

little as a quarter turn. Ask your dealer for information.

STABILIZING EQUIPMENT

As I said earlier, everyone blames unsharp pictures on focusing blunders. However, many of these "out-of-focus" pictures are the results of *camera motion.* An easy way to judge whether a picture is unsharp due to focus or motion is to look for *misplaced focus.* If the mole on the runner's left earlobe is sharper than his near eye, you can assume the picture was not properly focused.

Check lens sharpness with this simple optics test. See the text for details. This is only a general check for major element misalignment. The only sure test is to use the lens.

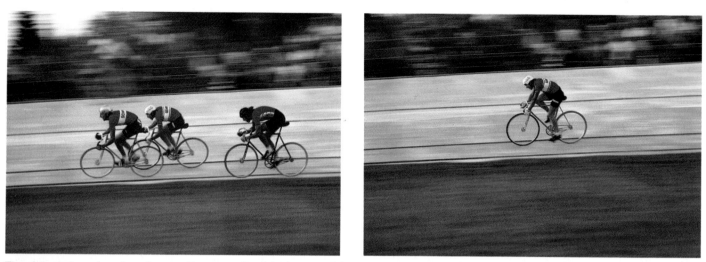

The picture above is not as sharp as the one on the right, because I did not *pan,* or move the camera with the subjects' movement, at the correct speed. The image at right was shot with the same focus setting, but is a little sharper because the subject's head and the camera were moving at the same speed. To pan properly, mount the camera on a monopod or tripod for smooth, even movement. I discuss panning later in this chapter.

However, if nothing in the picture is sharp, you can probably trace the problem to camera motion. Camera motion sometimes shows up in photos done under poor lighting conditions or with long-focal-length lenses.

Don't handhold the camera at a speed slower than 1/60 second unless it is absolutely necessary, because you cannot be sure of the results. If possible, lean against something for support to get more camera stability at slower shutter speeds. I try to use 1/125 second as my minimum speed just to be on the safe side.

Rule of Thumb—Here's a good rule of thumb when using a telephoto lens. For best results, do not handhold the camera at a shutter speed slower than the reciprocal of focal length of the telephoto lens being used. For instance, with a 200mm lens, don't handhold below 1/250 second, and with a 500mm, do not handhold at less than 1/500 second.

Naturally, there will be situations where this guideline must be ignored but, generally, when you must work with a slower shutter speed, use additional support such as a monopod or tripod.

Tripod—The first choice for camera support is the *tripod.* This offers the most stability if you have the space to set it up. A tripod is good for use with long lenses but can also be used for panning, remote triggering, and as a hands-free stand when you are using more than one camera. In Chapter 4 I'll tell you what features your tripod should have.

Monopod—If you can't use a tripod because of space, mobility, weight or other restrictions, the next best thing is the *monopod,* which has only one leg. It is also called a *unipod.* The advantages of the monopod are many: It's light and sets up quickly; it takes up very little space while in use; it can be moved around quickly; it gives adequate support for long-focal-length lenses. The better models have swivel heads to allow vertical and horizontal exposures. Some also have feet that extend out from the bottom, making them self-standing. A monopod is one of the mainstays of the sports photographer. Mine goes with me to every event.

Use a tripod when you can.

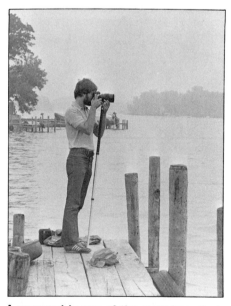

A monopod is one of the most important tools you can own. Buy one that collapses small enough to fit into your gadget bag. This makes it convenient enough to carry all the time.

There are several other alternatives if you can't use a tripod or monopod.

C-Clamp—The C-clamp is extremely useful. It fits in the palm of your hand and will attach to almost anything you can think of. I always carry one and have used it to clamp my camera to ski tips, ice axes, fence posts, and even to a glider wing.

I wanted to mount one camera above a glider's wingtip and one below, shooting remotely from the air with the ground turning below as a backdrop. Darryl Lonowski, general manager at Windy City Soaring in Chicago, warned me that there would be little aerodynamic stress on the camera resting on top of the wing, but the camera hanging underneath the opposite wing would triple its weight during certain maneuvers.

Because the wings are made of lightweight aluminum, all I could use to attach the cameras was gaffer's tape. This was no problem for the upper camera, but I wasn't sure I wanted to trust $2500 worth of camera equipment taped to the underside of the wingtip with all those G-forces tugging at it.

We were trying to rationalize the potential loss when Darryl asked to see my C-clamp. He whittled two small blocks of plywood with his pocket knife, gouged a hole through them, and used the clamp to secure the whole contraption to the tie-down ring under the wing. Gaffer's tape kept it from vibrating loose. The camera never budged, even under the stress of Darryl's wild flight patterns.

Bean Bag—On a suitable work surface, one of the most stable and easiest systems to use is a bean bag. Just plop the bag on the table, crease it and cradle the lens in the gouge. The bag can then be shaped for the proper angle or positioning. Because bean bags don't allow much camera rotation, they are best suited for relatively stationary points of view.

Footstrap—Another useful support system is the Hold-Steady strap, available at camera stores. One end fastens to the base of the camera and the other is secured around your foot. You then stretch it tight. This results in greater versatility because you can walk around and then simply snap the camera up into place for pictures. You can also make your own out of two neck straps.

Natural Support—When nothing else is available, don't overlook natural supports. Look for a wall, fence, guardrail, telephone pole, your friend's shoulder, or anything stable you can rest your camera on. Protect the baseplate of the camera with gaffer's tape if you plan to use one of the rougher surfaces.

Holding It Right—Make sure you handhold your camera correctly. Stand at a right angle to the scene you are photographing. Rather than facing the action dead-on, you should have your left shoulder toward the action. Then turn your left palm up and set the base of the camera firmly on the heel of your hand.

Tuck your elbow down onto your side so you have solid connection from your wrist to your waist. When you move the camera, rotate from the waist, always keeping your lead arm in solid contact with your body. This "archer's stance" will give you more stability than the typical "opera glass" stance with your elbows in the air.

When you need more support, drop down on your right knee and place your left elbow on your left knee, with your palm still facing up to hold the camera. This direct support gives considerable stability, even with relatively long-focal-length lenses. A variation of this is to sit down with both knees up and prop your elbows against your knees.

You can get even more stability by lying prone with both elbows on the ground and shooting straight ahead. Many of these posi-

I trusted $2500 worth of equipment to the care of a C-clamp and duct tape fastened to the underside of this wing. You can see the end result on page 6.

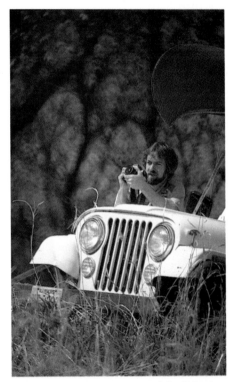

When you need a support and don't have a tripod or monopod, use anything you can find. Caution: With *any* lens, slow shutter speeds usually require support.

tions are similar to those of marksmen who need a sturdy hand to aim at a target.

PITFALLS AND HOW TO AVOID THEM

There is nothing wrong with economy, but false economy is worse than waste because you are blind to it. Two typical penny pinchers that you should *avoid* are

short-loading and short-shooting film.

Short-Loading—When you short-load film, you are loading the roll of film with just the leader engaged, in order to "cheat" and get up to 40 frames out of a commercial 36-exposure cassette.

It doesn't make sense. What you may lose will never offset the few cents per frame you save on those additional exposures. Sooner or later one sprocket may tear and the film will fail to advance. As a result, you may get the 40 exposures you wanted— but all on one frame.

The only secure system of loading film is to advance the film with the back open until *both* the upper and lower sprocket perforations are engaged in the sprocket wheel. Then close the back and advance the film twice to clear the exposed film. Some cameras have a safe-load indicator that indicates when the film is advancing properly.

My friend John Swider always short-loads his film. He tells this story about the once-in-a-lifetime picture he took of his sister carrying the Olympic flag in the 1976 Olympics. The picture was exposed on the 40th frame and he claims he never would have gotten it if he hadn't short-loaded the film.

I pointed out that if he had only used 36 exposures, he would have already reloaded and been able to get 30 more pictures of his beautiful sister. I couldn't convince him. Even when I tried to win him over

by writing in a magazine about the folly of his technique, his only comment after seeing it in print was, "I bet I've saved ten rolls of film in my life doing it that way." I don't think I'll ever hear about the rolls that come back blank.

Short-Shooting — Short-shooting consists of saving film by shooting fewer frames than the situation calls for. Not many people waste film on subjects of little interest to them, but many photographers waste subjects of interest by *not* shooting a lot of film on them. Film is one of the smallest expenses in this hobby, so when you find a fantastic subject, don't economize by taking few pictures. *You* always lose.

ASA Hazards—Did you ever pull a roll of film out of your camera and stare at it in horror as you realized it was exposed at the wrong film speed? Camera companies have tried their best to solve the problem but so far nothing seems to be foolproof. Some cameras have little slots on the back door where the film box top can be placed as a memory aid. I have seen individual attempts with blazing red signs taped to the back of the camera saying CHANGE ASA, but nothing really works every time for everybody.

The solution I found is to carry two camera bodies, one for b&w film and one for color. Because I have standardized my film use to one color film—Kodachrome 64—and one b&w film—Tri-X—I

never need to change the ASA because I never change film types.

If you do expose a roll of b&w film at the wrong ASA, and do your own darkroom work, you can sometimes alter development time to salvage the roll. You can also do this with E-6 process films and color negative films. If you do not have your own darkroom, tell the processing lab what the problem is and ask if they can salvage your film. There is no recourse with Kodachrome films.

Back Lighting—Back lighting is a problem for many photographers. Although some of the most dramatic pictures are lit with back or side light, when exposure is incorrect, the results can be disastrous. Depending on the effect you want, there are two easy solutions.

To *silhouette* foreground objects, set the shot up so the light source is behind them. Direct the camera meter toward the light source and use that reading for your exposure setting. Because the difference between the light behind and in front of the subject is great, basing exposure on the background light underexposes the foreground. The result is that the foreground reproduces dark, showing little detail.

In most cases, however, you want detail in shadow areas. For the proper exposure of the main subject, you must meter the foreground light and base exposure on that reading. To do this, move close and take a reading directly from the subject. If that is inconvenient, take a reading off the palm of your hand. Your hand must be close enough to the lens to block extraneous light, and must be in the same light as the subject. Be sure it is not in the shadow of the camera. Set your camera manually with that reading and make the exposure.

Shutter-Speed Dilemma—One of the toughest decisions you must make is choosing a shutter speed that will stop motion. Unfortu-

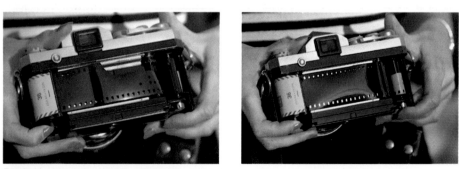

Don't load just the leader. The film might tear or not feed properly. Make sure upper and lower perforations are engaged before closing the camera back. Then watch the rewind knob and be sure it turns when you advance the film. If it doesn't, open the camera back and see why the film is not feeding properly.

nately, there are too many variables for me to give you definite guidelines. The only solution is *practice*. A few of the factors that dictate shutter speed are the lens focal length, film speed, the angle of approach, subject motion, panning action, vertical versus horizontal motion and actual speed versus perceived speed.

In addition, the subjective element of *taste* governs whether the final image should be frozen, partially blurred, or streak-blurred. The only way to know what you want is to experiment until you get what you like.

Instant Reject—Generally, the two most boring angles in photos are taken with the standard 50mm lens and from eye-level. The solution is simple: Don't shoot from eye level and don't use a 50mm lens! This is not an unbreakable rule, as I mentioned earlier. After all, one of my photos shot with a 50mm lens has received recognition in competition. But this rule should be followed until you learn when it should be broken. Try to expand your creativity by finding a viewpoint the millions of Instamatic users haven't discovered yet.

Second Life—Some day your camera will fail. Cameras get old and die, just like everything else. If you are serious about sports photography and are dependent on a single camera body, your time is marked. However, with a backup, you can continue to shoot when the first body fails. If you have two bodies, you can shoot with b&w and color film at the same events and you don't have to change lenses as often. You can also use the extra body for remote triggering to get a different angle of view.

Ultimately, an extra body will provide more flexibility in almost every shooting situation. But be aware that you can make b&w prints from color materials, so you don't have to shoot with a separate camera *specifically* set up for b&w

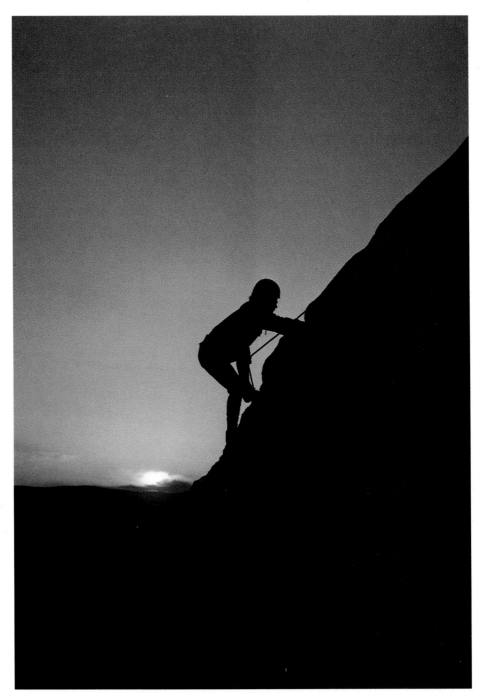

When metering for a silhouette, aim your camera toward the light source and meter it. In this case, the sky is the source. Then compose and shoot. I *wanted* the mountain and mountain climber to be dark, so I directed the camera to the sky to get my reading, which was *f*-5.6 at 1/250 second. Then I set the aperture manually. Had I not done this two-step procedure, my camera would have metered partially on the mountain. The result would have included some detail that I didn't want.

prints—although original b&w images will be superior to b&w prints made from color slides or negatives.

Exposure Check—A simple system to check exposure could save you a lot of film. On a sunny day, with your aperture set at *f*-16, you can get good exposure by using a shutter speed that is the approximate reciprocal of the ASA. For example, with Tri-X on a sunny day, the correct exposure for sunlit subjects would be *f*-16 and 1/500 second, or the equivalent—see the accompanying table. With Kodachrome 64, correct exposure is *f*-16 and 1/60, or any combina-

tion of settings that result in the same exposure.

The exposure meters in today's cameras use the same batteries as the camera's electronics. Some automatic cameras have a mechanical override that allows you to take pictures without batteries. But without batteries, the meter does not work, so you must be able to figure out the correct exposure yourself. Knowing which *f*-stop and shutter-speed combinations are equivalent may save your shots some day when those reliable batteries die just when you need them.

Screaming Pictures—Looking in the early scrapbooks of almost every sports photographer, you'll see products of what I call the *non-committal-spectator-shooting* syndrome. The photographer finds it hard to leave his seat and "jump in"—but it's really the only way to get good pictures.

Most pictures taken from the bleachers look like just that. You get impact when you get up and stick your nose in the fast lane. The closer you get to the action, the louder your pictures will "scream." You may feel uncomfortable shooting at close range at first, but after doing it for a while, you'll get used to it. Keep this in mind: Whether they admit it or not, people are usually flattered when someone wants to take their picture. Don't worry about moving in on them.

FACTORS TO REMEMBER

Good composition comes naturally to *few* photographers. Most of us have to *learn* the principles. One problem with sports photography is that you can often get caught up in the action and forget about composition, even though composition is important.

Drill yourself constantly with the basic compositional rules discussed in Chapter 5. Ask yourself if the internal elements are balanced, if the subject is moving toward the center, if lines and patterns complement each other or

SUNNY-DAY APERTURE/SHUTTER-SPEED EQUIVALENTS							
For ASA 64							
f-32	*f*-22	*f*-16	*f*-11	*f*-8	*f*-5.6	*f*-4	*f*-2.8
1/15	1/30	1/60	1/125	1/250	1/500	1/1000	1/2000
For ASA 400							
f-32	*f*-22	*f*-16	*f*-11	*f*-8			
1/125	1/250	1/500	1/1000	1/2000			

These settings represent possible aperture/shutter speed combinations for correct exposure on a sunny day using the listed film speeds.

You can get accurate exposures in back lighting by taking a light reading off your hand, held eight inches in front of the lens, or use grass or a patch of soil. Be sure the light you are metering approximates that falling on your subject. If this procedure hadn't been used here, the little fisherman's face would have been underexposed.

the subject rather than distract from it. If you continually brainwash yourself before every picture you take, eventually this will become automatic.

Close In—A photo editor once told a group of his photographers, "If your pictures aren't good, you're not close enough." Although it's a bit simplistic, this advice is important.

Most pictures, especially action shots, could be improved by moving in and cutting out the extraneous elements. Tight shots not only create a sense of involvement for the viewer but also reduce the chance of compositional error by eliminating everything that doesn't contribute to the picture. Closing in on the action allows emotion to show through.

Ecstasy And Agony—A columnist in one of the photo magazines stated that the real story of sports is in the ecstasy and agony of winning and losing, and in the pictures that go beyond the action to capture emotions. Focus on the emotion and human drama as well as the ball, and you will be several steps ahead of the next photographer.

Variety—To prevent your pictures from becoming stagnant and routine, add variety. Don't shoot picture after picture with the same lens from the same position. Move around to every different location you can find, preferably where no one else has been. Even

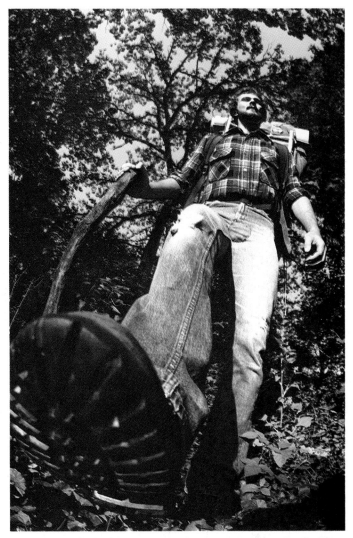

Sometimes it is hard to keep the horizon straight when the whole world is tipping. I shot half a roll before I realized that because I was leaning with the boat, it would look vertical in the pictures. Then I tried to level the horizon, standing on a narrow railing as the boat pitched.

Everyone is tired of the average picture, shot at eye level with a 50mm lens, as in the photo below. Pick an unusual angle or lens—or both—for more impact. I was on my back, using a wide-angle lens on my camera, for this effect. I told the hiker to step on my face and released the shutter just before I got squashed.

with the same lens, move around. Back up and take overviews, get close for details. Variety is what keeps pictures interesting. You'll never get it by standing in one place or using one lens.

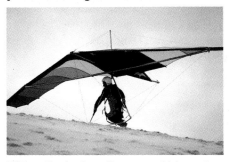

Tilting the horizon line can add impact or dilute it. This was a steep hill that didn't look very impressive after I tilted the camera to keep the horizon level.

Level Heads—The horizon *should be* horizontal. With few exceptions, the ground must be level in your frame. Generally, when your feet are flat on the ground, this presents little problem. However, any time you get vertical action such as motocross, hang gliding or skateboarding, where you are moving the camera up and down rapidly, it's easy to misalign the horizon. A crooked horizon often distracts the viewer from the action—the world tipping over is always the fault of the photographer. But you can use such an element to your advantage, too, if you plan properly.

For instance, I was photograph-

ing a hang glider pilot methodically plodding his way up a sand dune while carrying his glider on his back. Because the only thing that showed in my frame was the sand dune and the sky behind the glider, I could choose my own

You will never get any good pictures sitting on your front porch. Roll up your sleeves—and pants, when necessary—and jump into the activity.

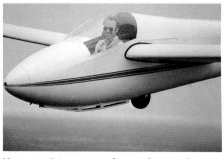

If your pictures aren't good enough, get closer. The wings of the plane I was in actually overlapped the glider's wings when I made this exposure.

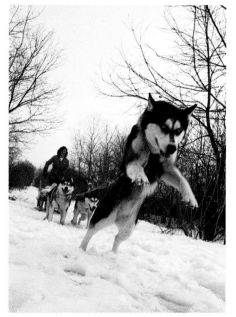

For this shot, I wanted to use a fast shutter speed and small aperture for sharp action and good depth of field, but it was a cloudy day. I had to compromise. The lead dog wasn't the most important element anyway, and being out of focus, it adds a feeling of movement to the picture.

angle of gradient by tilting the camera at different levels.

It was interesting to note that in one picture where I kept the hill level with the picture frame, the strain of the hang glider's climb is diluted to a flat parking-lot effect.

The horizon is more important than you may have imagined. It's not easy to keep the horizon horizontal if you're sitting in an airplane banked at a 90° angle, standing on a yacht heeled over farther than you believed was possible, or leaning precariously from a rock wall on a climbing rope. But you have to keep the horizon straight or you'll get us all dizzy when we look at your pictures.

If you're going to be in a situation where *you* won't be level but your *camera* must be, use a cross-grid focusing screen that gives a reference point in your viewing screen. Or you can buy an accessory level that fits into the camera's flash hot shoe and indicates when you should realign the camera.

Don't allow the horizon to cut the picture in half. It should appear in the top or bottom third of the picture. It will look stilted if it slashes through the middle. You can easily move the horizon by changing the lens or shooting angle.

Thinking Crooked—Reverse the "level" principle to enhance the action. When I used a super-wide 16mm lens while shooting from the bow of a beautiful teakwood yacht on Lake Michigan on a gusty day, I could see the entire mast and three sails in the finder. As the boat heeled over, I tended to keep the mast vertical in the frame because it looked "correct" that way. But resisting the temptation and keeping the horizon level exaggerated the impact of the action.

Smiling Stiffs Vs. Setups—Posed subjects would look better dead, in my opinion. However, there is a difference between smiling stiffs and *spontaneous setups*.

In most organized sports and competitive events involving more than one person, setup shots are not possible. But you have

For the shot I wanted, I asked this motocrosser to come over the hill again—but that's different from posing. I didn't ask him if I could take his picture. Rather, I asked him to continue his sport.

more freedom with many of the popular individual outdoor sports. It's one thing to sit a person down, tell him to look at the camera and smile—and another to ask a kayaker to run a set of rapids again, a skier to jump at a little different angle, or a dog sledder to charge by again.

I was at a ranch early one morning when a mist filtered the early morning light through the trees. An accomplished motocross racer came sailing over the crest of a hill with the blue sky and misty trees framing him from behind. It all happened so fast that I didn't have time to get my camera up, so I asked him to hop it one more time. The result was energetic action that was set up, but far from being posed. My advice is to get what you can on the run. If you have to ask for a rerun, shoot it as it naturally occurs—don't ever ask the sportsman to pose.

CONTROLLING THE BACKGROUND

Backgrounds are important because every picture has one. They are impossible to remove and will

This climber has a tree growing out of his head. In our minds, we accept this scene because we *know* the tree isn't really attached to him. But the camera and film record only what's there. When we are presented with this scene on film, it looks strange.

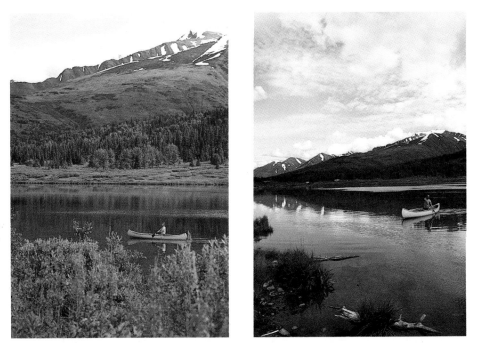

These were taken from about the same location. Notice how different the mountains look. The one at left was made with a 50mm lens, the other with a 28mm.

either enhance or detract from every picture. As a photographer, you must be aware of the background and use it to suit the subject.

When you first start taking pictures, you don't notice backgrounds because the mechanical operation of the camera is so overwhelming—and it seems tough enough just to get your subject framed in the finder. But as your pictures come back from the lab, you gradually begin to notice obtrusive telephone poles growing out of heads, tree branches poking out of ears, or sometimes a jumbled mishmash in the background that dominates the scene.

An Eye For The Background— The best way to begin developing an eye for backgrounds is to first look at everything *except* the subject. Start with the four corners of the frame and move your point of focus in, avoiding the main subject entirely. Later you won't have to put this kind of effort into it because the process will become automatic. The fast pace of sports photography requires that the photographer be able to see and compose backgrounds simultaneously with the foreground action.

Practice until your mind takes over. A *Sports Illustrated* photographer once said to an interviewer, "A guy who sells shoes is always

looking at people's feet. I'm always framing. Talking to you just now, I caught myself moving to get the line of benches curving behind your head." But there are dozens of ways to modify backgrounds without changing your position.

Lens Focal Length—Mountains are easy to move if you have a bulldozer *or* are a smart photographer. Any large background can be "modified" considerably with a simple flick of the wrist. Because telephoto lenses compress space, you can increase the height of your mountain simply by using a longer-focal-length lens and moving farther away so the foreground subject is still the same size. Or you can use the telephoto to enlarge the subject so only a small portion of the background is visible behind the subject. Telephoto lenses have a shallow depth of field, so this conveniently softens backgrounds automatically.

Shrinking—Diminish background size by using a wide-angle lens and moving closer to the subject. Wide angles reduce the apparent size of distant objects, so you can turn mountains into molehills.

Vanishing Backgrounds—Not only can you modify the background, but I'll show you several ways to make it disappear. The easiest, of course, is by using *depth of field,* which is easy to check if you have a depth-of-field preview button on your camera. If you do not have this control on your camera, manually stop down to the required aperture to see what will be in focus. Then set the lens back to its automatic setting.

On a bright day or with fast film, it may be impossible to open the lens aperture as much as you need. If this happens, use a *neutral-density* (ND) filter. This does not alter tones or the color of the light. It just cuts down the amount of light entering the lens. There are various ND filters that cut the light by different amounts. I like the ND 0.4, which reduces the light by about 1-1/2 exposure steps. It is also good to use when you need a slow shutter speed for panning effects.

Panning—During the exposure, you can pan, or swing, the camera with the movement of the subject and at the same time "lose" the background. It's the best way to

eliminate crowds that would otherwise compete for the viewer's attention, or hide the speeding subject. I'll talk about how to pan effectively later in this chapter.

Changing Your Position—This is a simple way to change or eliminate the background. You can lower your point of view and use the sky for the backdrop or raise your viewpoint above the subject and use the grass or plain ground.

If these approaches aren't possible, as unlikely as this may be, you can always depend on Mother Nature. A particularly dramatic way to "erase" backgrounds is to use a *strong back light* to mute the background.

If you have time, you can wait for a morning when a *heavy mist* shields your subjects from whatever clutters the background. There are many other ways to achieve similar effects. Backgrounds are under your control, so take command of them.

Streaking—Capitalize on the action. By panning with the subject at a slow shutter speed, you can fuse the background into a collage of streaks. Or you can zoom during the exposure at a slow shutter speed, or move close to the subject.

But first you must *notice* the background before you can change it.

Seeing Selectively—You don't always have to deal with backgrounds with an "all-or-nothing" attitude. Sometimes an objectionable background can be arranged to make the subject stand out more. Rather than simply getting rid of it, you can curve a branch overhead or use the angle of the mountain ridge to point or lead into your subject, gaining a stronger accent than you might have had otherwise. Think about using background elements when you can before categorically eliminating them.

The main thing is to notice the background and be aware of how it can help your subject. If used properly, the background can carry as much weight as the subject. But if ignored, it can steal the show.

Once you become aware of backgrounds and the different methods of changing and using them to your advantage, you'll be able to predict the result, which is often different from what you think you see through the finder. This is a major step toward becoming a better photographer.

You may already be aware of these principles but the key to good photography is your ability to apply them to your working situation to achieve the effect you desire.

STOPPING ACTION

Action is the password for sports. The key to sports photography is in the cameraman's ability to freeze the action or the *feeling* of action. The photo doesn't have to show the subject in mid-air. Because of artistic freedom, you can use your judgment as to how you can best portray the feeling of action. The situation may call for a blurred impressionistic view, suspended peak action, sequence movement, abstract motion, or high-speed stop-action.

Effective selection of the best combination depends on being familiar with both the sport and your equipment. Once this is accomplished, *experimentation* and *practice* will help you learn how to get the effects you want.

To acquire a skill, you must first be familiar with a few fundamental rules that you will later perfect. I will point out some basic techniques for capturing action. But the only way you can take advantage of the effects is to use the techniques until they become automatic.

Intentional Blur—You can produce a blurred image many ways.

A wide aperture creates a shallower depth of field, so the background is blurred. You can use this to your advantage by setting the subject apart from a distracting or busy background. Long-focal-length lenses do this naturally, particularly when you are focusing on a subject close to you.

Using a long-focal-length lens allows you to be seemingly much closer to the subject than you really are. There are two ways to eliminate background clutter. Either compose the shot so the subject fills the frame, or use the limited depth of field to your advantage to blur unwanted details. Or, use a plain background, as shown here.

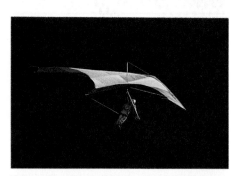

Take advantage of back or side lighting to black out the background. When you understand your craft, you can plan such results. For this shot, I waited until a glider flew into the shadow of the hill.

Subject movement results when you hold the camera still and, with a slow shutter speed, allow the subject's movement to be captured on film. If the shutter speed is too fast, it will freeze the subject; if it's too slow, the subject will not be recognizable. The speed I chose for the bucking-bronco image was 1/60 second. It was slow enough to blur the clown in the foreground and the kicking bronco but left them recognizable.

Camera movement is different from subject blur, but is equally effective. If you move the camera while photographing motion, this will heighten the feeling of activity. To do this, move the camera as you depress the shutter. Use a shutter speed of 1/15 second or slower.

I used this technique just before I was thrown off the track at the Indy 500. I wanted the effect of a race car screaming out of the pit area, and figured my best position would be to climb over the guardrail and lie down on the track. I set the shutter speed at 1/8 second and supported the camera with my elbows on the track. As the car hurtled toward me, I pressed the

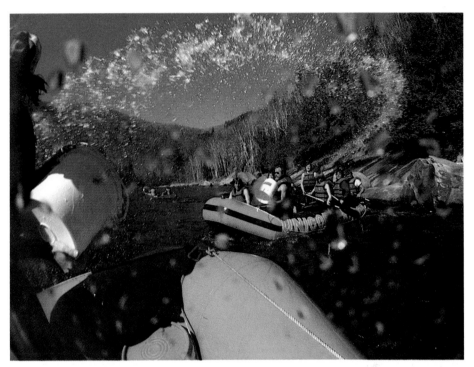

You can use the background or other picture elements to tie the scattered elements within the scene together. Here, the two rafts are linked by the curve of water that drenched me shortly after I made the picture. The camera was in a waterproof housing.

shutter and shook the camera. I intended to get several more shots, but track officials had other ideas.

Partial blur is almost impossible to predict. Although it is a pleasing effect, like other pleasures in life it's also hard to get. If a portion of the image is sharp, such as the head of the athlete with the rest of his body blurred, you can identify the subject and still get a feeling of speed. Totally blurred images are more impressionistic and harder to relate to.

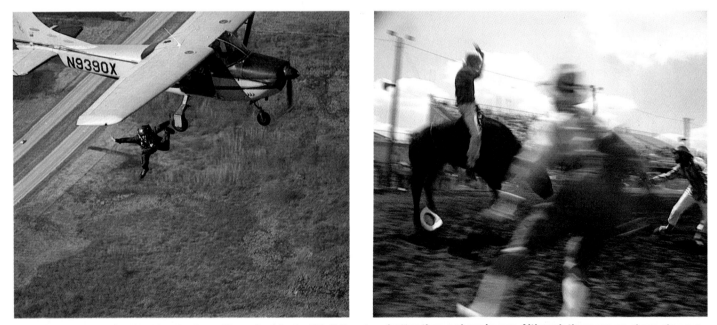

Sometimes you have to decide whether a blurred subject will tell the story better than a sharp image. Although there are no sharp elements in the rodeo shot, I think it tells the story.

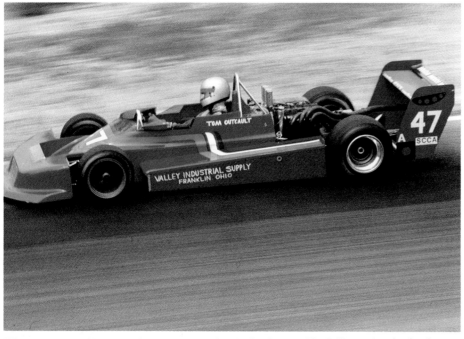

When you *pan* with the action, you can make the background look like a streak of colors or tones. You must keep the camera moving the same speed as the subject to keep the subject sharp. Practice is the key. It also helps to use a tripod with a swivel head. Photo by Candee Associates.

The only way to get partial blur is to experiment. Some shots work, others don't. Unfortunately, you can't tell until you get the film processed.

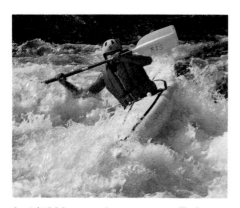

A 1/1000-second exposure will freeze almost any motion.

The only way to achieve a partial blur is through experimentation—and lots of film. You must use a shutter speed slow enough to blur the motion and have to rely on chance to keep the subject's head moving at the same speed as the camera during exposure. Because you cannot see through the viewfinder in an SLR during long exposures, you can't judge your success until the results come back from the lab. Make lots of exposures and keep your fingers crossed.

Freezing the action is sometimes more effective than a blurred image. But first you must know the correct shutter speed to use. As I mentioned earlier, because most moving objects travel at different speeds and shooting conditions cannot be predicted for these situations, I can't give you a set of rules. You must experiment, keep records for each sport, and hope this system works for you. Of course, you must try different approaches and be flexible. This will add creativity to your photographs and help you learn more about the capabilities of your equipment.

A shutter speed of 1/2000 or 1/1000, or even 1/500 second can effectively stop the motion of most sports. That is one way to stop action—use a shutter speed fast enough to freeze it. Sometimes, however, lighting conditions prohibit the use of such fast speeds. Then you can stop the action by waiting for the natural break, or peak, that occurs in most sports.

Peak-action shooting is a popular technique. With this approach, you use a *slower shutter speed* and catch the movement at its climax. There is a moment of minimum or no movement in most action sports. You can anticipate those moments when the pole vaulter reaches the peak of his ascent, when the basketball player's leap stops for an instant below the net, when the skateboarder hangs just before gravity wins out.

To capture these peak moments, you must be familiar with the sport so you can predict when they will occur. Timing is important. You must have fast reflexes so you can release the shutter just as the motion stops. *If you see it in your finder, you know you've missed it.* Because the mirror goes up when the shutter is released, your "blind spot" must overlap the peak action. Using a motor drive diminishes the chance of missing that split second.

Zooming is another effective way of showing speed in your photographs. Use a slow shutter speed and a zoom lens. Release the shutter while simultaneously zooming the lens in or out. This will produce streaks from the center out to the edges. For this reason, the subject must be dead center when using this technique. For best effect, be sure the lighting is contrasty, and the subject does not blend into the background. A friend once told me the first zoomed image he saw was unique and all the rest look like duplicates. I think he's right.

Showing motion in photographs made with a still camera is easy

with today's equipment. But you must still know how to use the equipment effectively. Never stop experimenting. Always keep records of what you did and how you did it, noting which results you consider successes.

PANNING

Moving the camera with the subject is an integral part of sports photography. Whether you use panning as a special effect or not, you will use it almost every time when action is going on around you. The only way to keep your subject within the frame is to follow the action. This is called *panning*.

Panning for effect is similar to handheld panning except that you use a slower shutter speed and a camera support. A monopod is suitable because it pivots on one axis and gives adequate support, but a tripod with a pan head can handle slower shutter speeds.

For maximum performance, have the camera level with the subject's course of travel. Then set the pan head on the tripod so the camera rotates smoothly and easily. Practice panning the camera a few times to get the feel of the required movement. It is possible to achieve a streaked-pan effect while handholding the camera, but the odds of keeping the subject sharp are against you because of the slow shutter speed.

A telephoto lens works best for panning. You should use a shutter speed of 1/60 second or slower to streak the background. Remember two points: Leave plenty of room in front of the subject in your frame or the subject will look like it's charging out of the picture. And, at slow shutter speeds, the image will not remain sharp unless you follow through with your sweep, continuing to pan with the subject after you release the shutter. A common fault is to stop panning as soon as the shutter is released. This is very much like the follow-through in golf or bowling—after the ball is released, you must continue the motion.

Experiment—Experiment so you know what to expect when you pan. I was filming a girl training a sled dog and tested some pan shots with various lenses and distances. With the dog and girl running past a 28mm wide-angle lens, even a 1/15-second exposure did not streak the background. The background became blurred at shutter speeds as fast as 1/125 second when I switched to a 135mm lens—just the effect I wanted.

Another variable I noticed was the distance between the girl and the background, which also made a significant difference. The closer she was to the background, the greater the streaking effect.

For the image to be useful—unless you are attempting an artistic or abstract effect—a portion of the subject must be sharp. For example, you may want the legs of

Once you've gotten this type of zoom shot out of your system, you'll try more original approaches. I'm not a big fan of this—but I've done it myself.

a thoroughbred racehorse blurred, with the horse's head and the jockey in sharp focus; or a bicyclist's head in focus with his feet and legs blurred. Every effect requires a different shutter speed and different movement of the camera. What you want is to be able to make accurate shutter speed/action choices.

Double-Axis Pan—One variation of panning is the double-axis pan. You can give both vertical and horizontal blur to an image by *dip-*

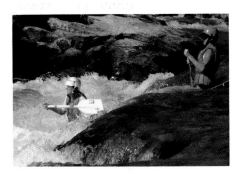

You should know the sport well to be able to anticipate peak action. I didn't have to know much here because I watched five canoes swamp before this one.

When using a wide-angle lens, you must use a very slow shutter speed to blur the background. This was shot at 1/8 second. There is some streaking, but at that shutter speed, the subject begins to blur as well.

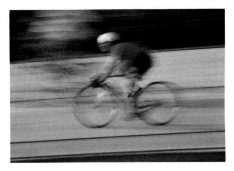

I created this effect by moving the camera vertically while panning horizontally. Doing this prevents any part of the picture from being sharp.

39

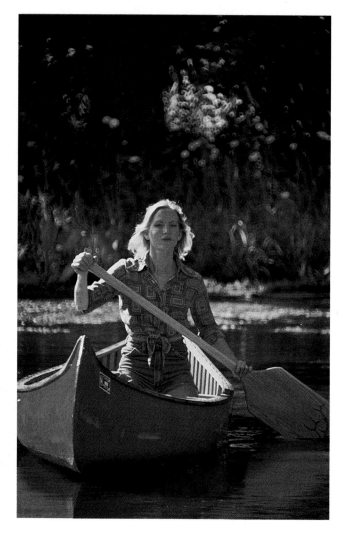

To get detail in the shadow area when shooting into the sun, take a meter reading of your shadowed hand and set the exposure manually. For more of a silhouette effect, close down the lens aperture one step, as illustrated above.

ping the camera while panning. For example, as you swing the camera on a horizontal plane, following the subject, move the camera vertically just before you release the shutter. I tried this technique while filming several bicycle racers. The result was jagged streaking rather than the more typical smooth, blurred background.

Variable-Speed Pan—You can pan at a faster or slower rate than the speed of the traveling subject. This distorts the subject by stretching or shrinking it. For example, if you pan at a faster speed than the subject is moving, this tends to elongate your subject, increasing the feeling of speed. Don't hesitate to experiment with your own twists and turns for greater creative impact.

OVERCOMING LIGHTING PROBLEMS

Fortunately, most sports are illuminated by the best light available—the sun. The advantages of natural outdoor lighting are numerous: One light source illuminates everything and the lighting is constant; it allows you to use the fastest motor drives; it is balanced for daylight film and is consistent, and it's available all year round, anywhere you go.

There are two drawbacks: It can't be moved, and as a single light source, it limits your shooting positions. The lighting is harsh on clear days, the angle is unappealing when directly overhead because of cast shadows, and it is frequently too dim on overcast days. But if understood and used properly, you can use it to your advantage.

Changes in lighting give outdoor pictures a distinct look. No two are ever lit exactly alike. Learn to exploit the sun's light and control it.

Time Of Day—You can't always pick the time of day when you'd like to shoot. Although competitive events are usually pre-arranged on a tight schedule, non-competitive events don't have that rigidity.

One *National Geographic* photographer says he only shoots between 6 and 9 in the morning and between 3 and 6 in the afternoon, and finds a local bar in which to entertain himself the rest of the day. I'm not sure what logic led to his success, but he claims the system is fail-proof.

Best Light—The angle of light is lower during the early morning and late afternoon and is warmer and softer than the midday sun. During those hours, it illuminates subjects at a more pleasing angle than from directly above, and creates modeling. The resulting long shadows show definition that would otherwise be lost in harsh midday light. The best conditions are when the sunlight is diffused through clouds, creating light shadows. An overcast day is especially good for photographing

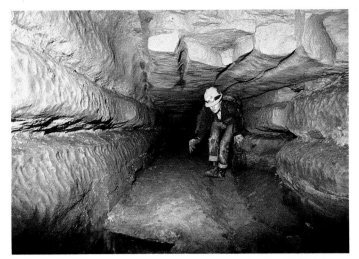

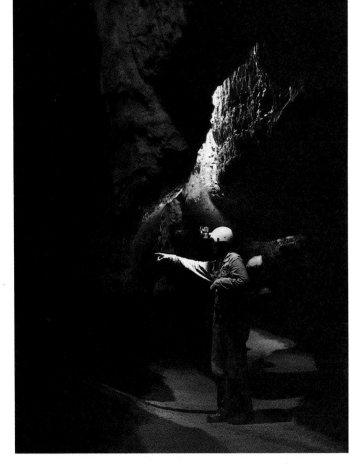

The only lighting in the photo at right was from the carbide lamps used to light our way. I used a flash for the other shot. Both show the activity, but which do you prefer?

people when detail would otherwise be lost in deep shadows.

Back Lighting—When shooting into the sun, *always* use a lens shade and *never* base exposure on meter readings from your shooting position—unless you want a silhouette, as discussed earlier.

One clever photography student had a solution to the problem: Avoid lens flare by standing behind the sun. If he meant you should stand with the sun at your back, he was right. I suppose if he meant what he said, he was correct, but that advice won't help earthbound photographers.

Most light meters average light—including extraneous light. As a result, back lighting can result in underexposed photographs. If you don't want silhouettes, hold your hand about eight inches in front of the lens, shielding the backlit light source, and take a reading. Make sure you are reading light similar to that falling on the subject. Take your camera off automatic and manually set the aperture to the correct setting. After the shot, remember to set the camera back to automatic. Otherwise, the rest of the roll may be incorrectly exposed.

I think this technique is more accurate than using the under- and overexposure compensating systems on automatic cameras. The reason you can get into trouble using only the compensating dial on your camera is that it just gives you basic steps, usually up to two steps in 1/3- or 1/2-step increments in either direction, without compensating for the light source. At best, those settings are guesswork. Using the technique I outlined, you can pinpoint the setting you need. This may be more than two *f*-stops on some occasions.

Transitional Lighting—A partly cloudy day is the toughest outdoor

CAUTION
Never look directly at the sun through any kind of optics. Permanent eye damage may result.

lighting to work with. The light is constantly changing. Keep your eye on the camera meter. Be aware of those times when you are in the sun and your subject is in the shade, and vice-versa. On heavily overcast days you may have to use faster film, especially when shooting in color. I always carry a roll of high-speed color film in my bag in case the weather changes.

Artificial Lighting—Indoor lighting requires more thought for good results. When using b&w film indoors, few alterations are necessary. Color is not as simple.

Color films are balanced for specific types of light, based on *color temperature*. Color temperature is a scale of values, in degrees Kelvin (K), that represents the relative amounts of red, blue and green light emitted by a light source. The color temperature of the lighting dictates the type of film required.

Artificial, or available, lighting is not set up with the photographer in mind. As a result, when shooting color film, you must use film balanced for either tungsten lighting or electronic flash. See "How to Get Better Color" on page 46. **Top Left:** I used electronic flash to eliminate much of the greenish cast from the overhead fluorescent lighting. **Above:** The rink lighting was sufficient for good exposure. It is obvious from the b&w examples that color temperature isn't a factor with b&w film.

For example, some stadium lighting has the same relative amounts of red, blue and green as daylight, about 5500K, so you can use regular outdoor film. Other facilities may use fluorescent lighting, which varies in color quality, and may create a green cast in your photos if you use daylight film without proper filtration.

A filter that can be used to correct this situation is called *FL-D,* for *fluorescent-to-daylight.* Be sure to experiment first, using the filter under similar conditions before taking those once-in-a-lifetime shots. You don't want to disappoint anyone—the photographer or subject!

Tungsten film is color balanced for incandescent light sources in the 3200K to 3400K range. High-speed color negative film, such as ASA 400, can be used satisfactorily with most indoor light sources. Some films must be filtered or matched to the light source for natural color rendition. Be sure to read the manufacturer's instructions that come with each box of film.

ELECTRONIC-FLASH LIGHTING

An alternative to existing indoor lighting is to use an electronic-flash unit. The main advantage of using a flash is the extremely short duration of the emitted light. With some units operating automatically, the pulse of light may be as short as 1/20,000 second. As a result, even at a shutter speed of 1/60 second, which is the flash sync speed of some cameras, you can freeze almost any moving object.

Available light is not positioned for the photographer's benefit. Portable electronic lighting *can be positioned* almost anywhere. Depending on the power of the unit, you can illuminate subjects at distances up to 80 feet. With a portable and controllable light source, you are not bound to any particular location and can shoot in any direction.

Creative use of flash enables you to produce special effects and multiple images. With special stroboscopic flash units, which flash repeatedly at a controlled rate for specialized uses, you can make dozens of exposures per second on the same frame of film. You need a dark background for this effect.

Warnings—Here are some things to keep in mind when using an electronic light source. Always carry at least one set of new batteries or an extra power source. Set the correct aperture for the distance of your subject and the guide number of the flash unit. Don't forget to set the correct flash-sync shutter speed, or slower, for your camera. To prevent *red-eye*—your subject's pupils look red—mount the flash on a bracket rather than on the camera's hot shoe. This gets the flash away from the camera lens. Purchase a flash unit with a maximum recycle time of three seconds so you are ready for the next shot almost instantly. Tape all sync-cord connections so they don't disconnect accidentally.

Go Natural—If possible, work with natural light. Although consistency is the strongest advantage of electronic flash, redundancy is also its greatest drawback. Flash pictures often look the same unless you make a special effort to use flash creatively, as discussed earlier. Use natural light for variety. Only when that fails

CALCULATED EXPERIMENT: Fifty photographers were running around at the Windy City Balloonport taking pictures of the mammoth bubbles drifting into the air. Then it dawned on me that my pictures were going to look like everyone else's. I wondered what it was like inside the balloon, and soon found myself creeping in through the mouth, down the esophagus, and into the voluminous stomach. I walked to the "top" of the balloon and photographed through the half-inflated belly as two pilots checked for line tangles.

should you go to the reliable alternative, electronic flash.

FILM CHOICE

There are many types and brands of film. Where do you start? Several things may dictate your choice.

Purpose Of Photography—Your first consideration should be: "What is the purpose of the images?" If they are to be color snapshots, viewed once and tossed into a drawer, pasted in a scrapbook or given to friends, *negative film* is probably what you need. If you want to make a slide show or plan to sell the pictures for publication, choose *slide film,* also called *transparency film.*

There are more color trans-parency films than color negative films, so if you need a variety of film speeds, shoot slides. If you plan to produce big enlargements from your images, use slide film. Slide film offers higher contrast than negative film. In a case such as water sports, where the water or water spray may diffuse the light, negative film would result in lower contrast images.

Even with high-speed color film balanced for indoor lighting, the house lights are seldom bright enough to allow you to use a fast enough shutter speed for high-speed sports activities without supplemental lighting. You can use an electronic flash unit to overcome other lighting effects, such as fluorescent or incandescent or even

daylight, by keeping the exposure short—at the camera's flash sync speed. As a result, the flash light becomes the main light source and is under your control.

Benefits Of Flash—At best, indoor lighting conditions are unpredictable and unreliable, and vary from one light source to the next. A flash is a predictable light source. When you understand how to use it, you can predict the results every time.

Shooting Conditions—When you have determined the end use of your work, you can narrow the choice even more. As I mentioned earlier, your main concern is the light source: Is it tungsten lighting, daylight or a combination of the two?

Weather conditions, such as a bright sunny day or an overcast one, may dictate the film speed you need. Or the type of sport may require a fast film. And, your decision will be based on your concept of what you want in the picture. Different film types vary in color balance, which will also influence you. For example, I find that Ektachrome emphasizes blue and green, and Kodachrome emphasizes red and yellow.

Film Characteristics—You must also consider film speed, grain characteristics, color, tonal range and acuteness. The best way to compare film characteristics is to shoot your own tests under identical conditions and compare the results. Then decide what you like. Once you have found certain film types you like, stick to them. As a result, you will know how they react and will be able to predict the results more easily.

When testing films, slide film is a better choice. With slide film, "what you see is what you get." The lab has no opportunity to fine-tune the final image before returning it to you. With negative film, the exposures could be slightly off and compensated for in the lab, so you would never know the difference. And when the prints are made, color balance is often left to the discretion of the lab technician or, worse, an automatic computer system. As a result, you may never know exactly what is on the film.

One And Only—Do some tests of different films. I suggest you then pick *one* type of b&w and *one* color film. Use them exclusively. It is important to use one film so you learn its strengths and weaknesses. Then you will know how that film will react under *all* conditions. The professional knows how his film and equipment perform under every condition and can predict the results. That separates the professional from the amateur.

Grain—The portion of the film that forms the image is the *grain*. It varies widely between film types

and manufacturers. Grain generally increases proportionately with the speed of the film, which is one reason to pick the slowest speed film possible. According to tests, Kodachrome 25 has the finest grain among the color slide films. Other conditions such as overexposure and processing technique can also affect apparent grain.

At times you may want a grainy look—for dramatic purposes, for example. But it is generally better to have a good, fine-grain original and make special-effect prints as you need them.

Color—To emphasize a specific color, you can choose a film rich in that color. For example, Fujichrome is known for its bright reds; Kodachrome for its rich, warm yellows, oranges and reds; and Ektachrome for its blues and greens. This is different from b&w films, where the differences are mostly related to speed, grain size and contrast that can be controlled somewhat with processing.

Sharpness—Some films are inherently sharper than others. The best way to judge this characteristic is to do some tests. Test films by shooting several types on a sunny day. Be as consistent as possible: Use the same camera body and lens so equipment variations won't affect the results. Mount the camera on a tripod and use a shutter speed of 1/250 second or faster, to avoid the possibility of camera motion. Use slide films and judge the results with an 8X magnifier such as the Agfa Lupe. Projecting the images is not a way to make accurate judgment of grain or sharpness, although this approach may be satisfactory if your only purpose in shooting the pictures is to show the slides projected the same way you are checking them.

Articles in photography magazines compare films and give the results of tests. Compare your results with those tests. It can be disheartening to invest a lot of money, time and energy in the finest optics and developing the sharpest skills, only to find that

the film you are using doesn't give the kind of results you want.

I have found that Kodachrome 64 and Tri-X are the best films for my needs. Kodachrome 64 offers vivid color, and both of them offer fine grain, good contrast and sharp image characteristics. I rarely use any other films.

Best Film—If I told you that one film has finer grain, deeper color saturation, produces sharper images and has colors that do not deteriorate as fast as other films, would you be interested? I asked editors of 18 national magazines what film they prefer photographers to use. Kodachrome 25 and 64 were preferred by 16 of them.

Kodachrome is slightly more expensive than other films, but if it keeps my customers happy, it's a fair trade-off as far as I'm concerned.

HELPFUL FILM FACTS

Now that you know how to choose film for your needs, here's how to care for that film so the images you make will appear on the processed film.

Cold—Did you know film lasts almost indefinitely if stored at 50F (10C) in your refrigerator? You can also freeze film. When storing film, leave it in its original container. Remember to allow the film to warm up for at least two hours before using it. Otherwise, condensation may form on the film. Don't open the box until the film is at room temperature.

Heat—Film is damaged by excessive heat. *Never* leave it on the car dashboard, in the trunk or glove compartment, near a heat vent in the house, on a window ledge, or any potential hot spot. Often when film is subjected to too much heat, the resulting overexposed-looking pictures are never traced back to the original cause. Then it happens again.

Moisture—An easy way to avoid moisture damage is to leave the film in the plastic canister before and after exposure. The canister provides excellent all-around protection.

To be sure you don't reload film that you've already exposed, tear off a piece of the leader.

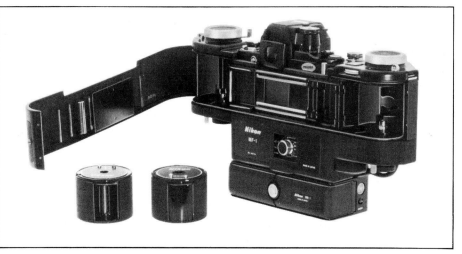

With this special magazine back, you can use bulk-loaded film for 250 exposures without changing cassettes. There is a model for 750 frames, too.

Once I was taking pictures of seals from a small boat. As I swung my day pack down into my lap, a roll of exposed film fell out of the open pocket and plopped into the sea. But I had put it back in the canister and it floated until I made a loop and picked it up. The film, dry as my sixth-grade history teacher, went back in my pocket.

Light Leaks—Sometimes, light can leak in through the felt trap of the cassette. After the film is exposed and rolled back into the cassette, the felt trap will not always block out the light. To avoid this possibility, make a habit of leaving a short strip of film in the trap rather than rewinding the film completely.

You can do this easily: Rewind the film in the normal manner. When you feel the tension ease up as you are rewinding, the film is off the take-up reel, but not completely wound into the cartridge. Give the camera rewind knob another half-turn. Then remove the film from the camera and return it to its canister. To avoid the possibility of trying to reuse that film as a fresh cassette, tear off a piece of the leader.

Oops—If you open your camera by mistake when there is film in it, don't discard the roll thinking all is lost. Simply close the camera back again and rewind the film as if it was at the end. Or advance it three or four times and continue shooting. You'll lose only a few pictures.

Bulk Loading—Many b&w and color films are available in bulk quantity, such as 27.5, 50, 100 feet or longer rolls. There are advantages to loading your own. Bulk-loaded film is about one-third the cost of commercially loaded films. You can recoup the initial outlay for the loader and cassettes in the first 100-foot roll you use.

For instance, a roll of Tri-X film costs about $3.00 and a 100-foot roll sells for $20. You get 720 exposures, equivalent to 20 36-exposure rolls, from a 100-foot roll. If purchased separately, those 20 rolls would cost about $60. Ektachrome 64 would cost about $50 in bulk and more than $100 if bought separately.

You also have more control over film length because you can load enough film for almost any amount of exposures you want—up to about 40 exposures.

A Lesson—A friend of mine told me that "the best things in life are always free." Before I responded, she gave me a kiss and said, "See!" I'm certain she was convinced she had overwhelming evidence, but I disagreed.

I told her about the time someone gave me a whole case of a new film. He asked me to try it and tell him what I thought of it. I forgot to open the box for several months. Finally, I tossed a roll in my film bag and forgot about it again. Some time later I was filming the famous Chicago-Mackinac Yacht Race for which I had pulled some heavy strings to get an envied position on one of the press boats. All went well until the last heat finally departed and our boat took off at full speed to catch the leading yacht.

As the pilot sidled up alongside the America's Cup contender, I carefully took aim and fired. The horrible click of my motor drive at the end of a roll of film was my first omen. I knew it was my last roll of film. Feeling in the bottom of my film bag, my fingers discovered one last roll—the free one, the new brand.

With fear and trepidation, I sent a prayer heavenward and loaded up. When the film came back from the lab, the transparencies were worse than I could have

Is this a familiar sight? It shouldn't be. You should always know when your camera is loaded. However, if you do accidentally open the camera back without rewinding the film, don't despair. Just close the back up again. The text tells you what to do.

imagined. My only color exposures of the lead boat came back green, overexposed and as grainy as a bowl of undercooked grits.

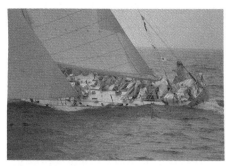

This is the best explanation as to why I don't accept free film anymore.

That's why I no longer trust or accept anything that comes free. Stick with products you are sure of and you'll almost never get burned.

HOW TO GET BETTER COLOR

There are many ways to be sure your color photographs will accurately reproduce the colors in the original subject. Some have to do with equipment and some with technique.

Accurate Meter Readings—The first step to getting good color is accurate exposure. Overexposed pictures wash out and lose much of their color; underexposed pictures become dense and lose color.

However, it is impossible to be accurate with faulty equipment. Use a gray card to test your meter. Compare the readings with other cameras you are sure are working properly. If you think there is a problem, have the camera checked by a camera repair center. Don't take chances.

Matching Film With Conditions—If you and your camera are both working properly, the next thing that will affect color is the combination of film and lighting. Each type of film is manufactured to be balanced for a certain type of light, or color temperature. The best way to get vibrant colors is to

match the appropriate film with the lighting conditions. When you shoot under incandescent light you have to use tungsten film, such as Ektachrome type B; with floodlamps, use professional film, such as Ektachrome type A. Outside shooting requires daylight film.

Naturally, there are other ways to get good color if the film is improperly matched to the light source. The light source can be filtered or you can fit a filter on the lens. Or, you can use an electronic flash to override the existing light. But the best color is achieved with the correct film for the lighting conditions.

Longevity—If you are worried about how long you can keep your color images, you should be aware that some films are more stable than others. For instance, when Ektachrome slides are stored under ideal conditions—cool, dry and dark—they will last 50 years without showing any change in color. However, under test projections, Kodachrome films last up to 100 simulated years.

Film Protection—Regardless of the type of film, several factors can cause color shift after you take the picture. Heat and moisture are the biggest problems. Don't leave film in the camera for weeks at a time. If you do not plan to use your camera for a month or more, and have a partially exposed roll of film in it, here are some things you can do.

First, you can take the film out and have it processed, regardless of how many unexposed frames remain.

Or, you can check the camera's frame counter and rewind the film as if you were going to have it processed. Make sure you leave the film leader out of the cassette, as described earlier. Then mark on the back of the film leader what frame you last exposed. Store the film in the refrigerator. When you are ready to take pictures again, reload the cassette as you would normally, and advance to the in-

dicated frame. Be sure to advance the film with the lens cap on so you do not get double exposures. If you have an automatic camera, set it manually on a fast shutter speed. Otherwise, with the lens cap on, the automatic camera will "think" it is dark out there, and will keep the shutter open. As a result, you won't be able to advance the film. It also drains the camera batteries.

Processing—Another way to ruin color after you shoot the film is by improper developing. Some people think all commercial processing is the same. I disagree. Some color labs do not practice good quality-control procedures, resulting in obvious color differences from lab to lab. And, some process all film at higher temperatures to shorten development times and increase production. Shortening wash and fixing steps will cause the film to deteriorate earlier and cause colors to fade within years.

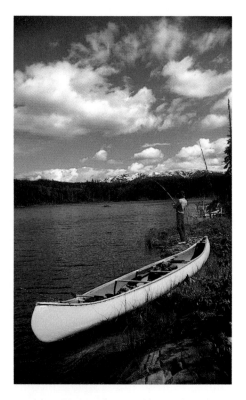

This shot was made with a polarizing filter to darken the sky and water, and emphasize the clouds.

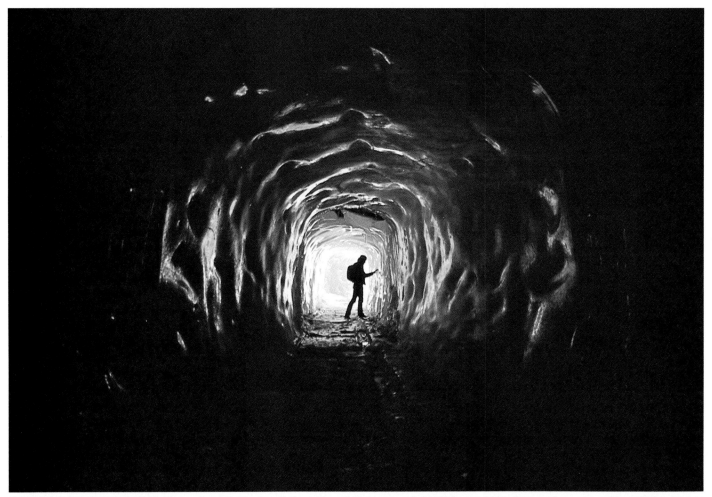

CALCULATED EXPERIMENT: Use natural light when it "won't work." No one would think of taking pictures in a cave without lights. But at the mouth of an ice cave in Austria, I decided to turn out the lights and see what I could see. The available light was intriguing, although it was pitch-black where I stood. Making use of my partner's silhouetted image provided the scale and compositional element I needed.

You can avoid some of the risks by using Kodak processing, which is available from most local camera stores. Although Kodak labs are not perfect either, experience has proven that they are reliable most of the time. Or, experiment with test rolls of film by sending them out to other labs to see if you are happy with the results. The best way to find out which labs you should deal with is to ask other photographers. Then send your own film out to see if you agree. Beware, however, that a lab's quality can fluctuate with the employees operating the machines.

Extra Color—To deepen color saturation when exposing transparency film, *underexpose* it by 1/3 step. The easiest way to achieve consistent underexposures is to change the camera film-speed setting. This procedure is often called *exposure compensation.* When using Kodachrome 64 film, for instance, I usually set the ASA at 80 instead of 64. This gives slightly richer colors, particularly to reds, yellows and greens. Caution: Care must be taken on overcast days and with dimly lit subjects where underexposure will make dark areas denser. When in doubt, bracket.

Some cameras have an exposure-compensation dial, which effectively creates the same effect as setting the film-speed dial to a different speed. Read your camera manual for instructions. Remember, however, that you must return the dial to the normal setting for the rest of the exposures on the roll. Otherwise, underexposed photographs may result. If you forget, explain to your processing lab what happened when you bring in the film. They *may* be able to alter the processing to salvage some of your images.

Another way to intensify colors is to use a *polarizing* filter. To intensify sky colors, the polarizing filter is most effective when used on sunny days and aimed at sky areas 90° to the sun. For other reflective surfaces, the best camera angle is about 55° from perpendicular to the surface. The polarizing filter does not add color but reduces reflections from colored surfaces, which makes them appear brighter. It is used most commonly to darken skies and

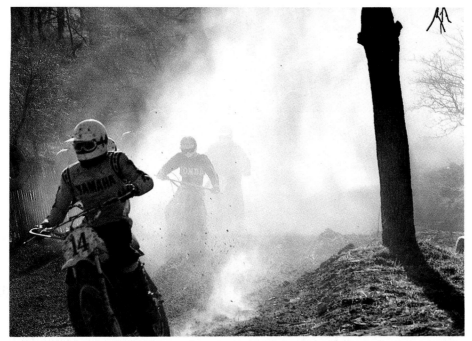

CALCULATED EXPERIMENT: I entered this picture, called "Dust Eaters," in a photo contest. Actually, the men on the motorcycles had plenty of clean air because they wore face-mask filters. I was the one who ate the dust. Sometimes you have to expose yourself to the elements, lie down in the mud and get bugs between your teeth to get the best pictures. Those shots won't come knocking while you're sitting in your lawn chair.

water, lighten clouds and intensify almost all colors. But it is ineffective on cloudy days and cuts exposure by about two *f*-stops.

CALCULATED EXPERIMENTS

After you make the routine, traditional shots, try some creative ones. Look for new perspectives. Do things the "wrong way." Part of the definition of *unique* is seeing things in your own special way. It's impossible for me to tell you how to do that. But I can explain how I came up with some different angles. These should spark your imagination. You'll find examples of this throughout the book, labeled "Calculated Experiment." But don't limit your thinking to only those labeled photographs. There are many others in the book, and all around you, that should get those creative juices going.

Darkroom Manipulation—Color can be altered and intensified in the darkroom with filtration. You can add or subtract color from a picture. But if you do, the entire print is affected by the change—unless you give different parts of the print different exposures and filtration, which can become complicated.

SAGE ADVICE

Every week *Sports Illustrated* magazine showcases the most interesting sporting events taking place around the world. They select the greatest athletes, the most challenging competitions and send the best sports photographers to highlight these moments on film.

Don Delliquanti, the magazine's assistant picture editor, told me they employ three categories of professional photographers: staff, contract and freelancers. They require all photographers to be versatile, know how to shoot in

both color and b&w, and be able to follow-focus with a long lens. Focus, exposure, composition and action are all essential.

He explains that their magazine is always looking for new talent, but it is extremely difficult to break into it. There are thousands of top-rate professional sports photographers who have never been published in the magazine and never will be. "Still," Delliquanti admits, "we are a weekly magazine and newcomers do get published."

Practice—Whether you want to become a professional, or just want to improve your technique, the best way to become adept at sports photography is to know your equipment and film, and get *lots of practice.* One of the best places to learn the ropes is through the local newspaper, which can be a student-produced school publication, a small community paper or a large city paper. Take on assignments for them, on a paid or unpaid basis, and get your results published. When you have a portfolio and printed samples of your published work, then, if you want to turn professional, it will be easier to go on to bigger and better publications. I'll discuss this more later.

Training—Training is most important. You must have a working knowledge of sports in order to anticipate the action and develop the reaction time of a well-trained athlete to catch the optimum moment.

Pressure—As in any sport, it is producing under pressure that counts in photography. Jim Sugar, the *National Geographic* photographer chosen Magazine Photographer of the Year in 1979, said that if he had all the time in the world, he could always do a good job. One of the marks of a pro is making the most of an assignment in as little time as possible.

Sugar's answer to high performance on tight schedules is being in top physical condition. For example, he'll photograph sculp-

CALCULATED EXPERIMENT: Go where no one else wants to. Every time the ball went near the home net at the Chicago Sting game, all the photographers would crowd to the sidelines. They didn't want the soccer net obstructing their view. I decided I did, and left the net in my view. It gave a unique perspective to an ordinary game.

ture from the rafters of a museum or chase all day after hang gliders. He is as serious about physical conditioning as he is about photography.

The University of Missouri, where the Photographer of the Year awards are presented, scheduled a special reception for the winners of the Photographer of the Year Competition. When the escort arrived to pick up Sugar at the hotel, he was nowhere in sight. No one could find him. Finally, Sugar arrived exhausted, dressed in his jogging shorts and tennis shoes. He runs ten miles a day and *nothing* interrupts his training schedule.

Technique—It is well within the ability of any serious photographer to take outstanding pictures with a good camera and a telephoto lens at a high school or college event. The best sports pictures are generally close-ups, so use as long a lens as you can, and get as close as possible to catch tension in the athlete's face. Be aware of changing lighting conditions. Backlighting or side lighting can easily change an ordinary photograph into one of distinction. Even if publication of your images is not your goal, you'll at least have photographs you'll be proud to show and hang in your home or office.

3
Getting The Most From Your Equipment

In every field you'll find people who excel not because of genius or superior skill but because they know how to get more out of their equipment. In photography, *knowing how to operate the camera* is more important than the kind of equipment you use.

A few simple camera accessories will help anyone take better pictures, although they are not required. Equipment customized to your own shooting style allows more freedom and efficiency, and permits you to be selective for each situation. In addition, you can increase its capacity to function where stock equipment might be inefficient.

PROTECTION AGAINST WATER

The first problem you'll run into outdoors is keeping your gear dry in bad weather. I don't know why so many photographers treat their cameras as if they were made of papier-mâché. The camera will not dissolve in your hands when the first raindrop lands.

Cameras are a lot like people. When it's damp out and *you* don't mind standing in it, chances are your camera won't suffer either. Naturally, it's wise to dry the exterior of the camera when you get indoors. Don't forget to keep a clear glass, ultraviolet or skylight filter on the front of each of your

Shooting near salt water calls for special protection. I failed to use a housing when I went out on this fishing vessel in Holland and ended up with the problems mentioned in the text. Don't let a shot as nice as this be one of the last from your equipment!

lenses at all times. And it's not a bad idea to keep plenty of lens tissue in a dry pocket to remove moisture and raindrops from the lens filter while shooting. But don't jeopardize your picture-making opportunities by running inside every time it sprinkles.

I was covering a major league soccer game at Kominsky Park in Chicago when it began to sprinkle.

Most of the professional photographers on the field kept shooting as if it were 95 degrees in Miami. One guy grabbed his camera bag and ducked into the dugout. Later I noticed him out on the sidelines again with his camera and lens mummified in plastic and gaffer's tape.

When the sun came back out, I made a minor aperture change

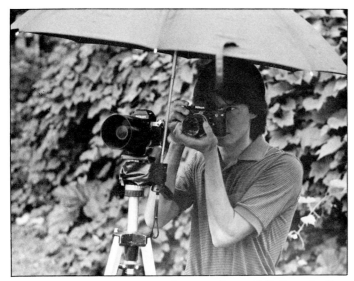

The umbrella-tripod marriage above works well, if there isn't a wind. A C-clamp or duct tape holds everything together.

Don't take this kind of a chance with your valuable photographic equipment.

and kept on shooting. Suddenly, an exciting scrimmage broke loose right in front of the group of photographers. Above the whirr of motor drives I could hear a string of expletives. When the play ended, I saw the rattled photographer ripping handfuls of plastic off his camera. Moral: If the rain is light, don't worry about it.

One exception to the rules about moisture is when you are shooting near the ocean. When salt is in the water, you can count on it being in the air, too. These conditions corrode and rust camera parts, inside and out. The camera must be protected.

Poncho—Protection from the elements starts with rain gear. A poncho works better than a raincoat because it fits loosely and covers a lot of equipment, such as camera bodies, hip pouches and daypacks. Access to anything is as simple as throwing the front of the poncho over your shoulder. A raincoat restricts movement, doesn't cover as much equipment, and is inconvenient because of zippers or buttons.

A poncho is convenient when you're using a tripod. Simply carry the camera attached to the tripod, with the poncho draped over the top. To use the camera, set up the tripod, stick your head under one end of the poncho, and hold the front part above the camera like a tent.

I was camping with a friend on the north shore of Rose Lake in Ontario one time when a nor'wester storm screamed in off the lake and began pelting us with raindrops the size of marbles. While we were trying to decide whether the rain would rip through the tent before the wind blew us into the lake, I interjected with, "This is a perfect time to take pictures!"

My tentmate looked at me half cockeyed, then figured I had contracted tent narcosis when I pulled out my new Nikon F-3 instead of the Nikonos. I stuck the F-3 on a tripod, draped my poncho over it and ran out into the squall. I got drenched, the camera stayed dry and the pictures looked great.

Umbrella—A simple technique when mobility is not essential is to use an umbrella. Choose one broad enough to cover your longest lens. It can be cradled under one arm, leaving both hands free. Canon makes an umbrella specifically for outdoor photographers.

Combination—Still another technique, which seems unwieldy to me, is the umbrella/tripod combination. My friend has a clamp on the neck of his tripod into which he inserts the handle of an umbrella. This makes the umbrella self-supporting, leaving his hands free to operate the camera. The disadvantage is that rain can blow underneath it. I visualize a heavy wind sweeping the whole contraption aloft, Mary Poppins style.

Plastic Bag—When you need more mobility in foul weather, use a plastic sandwich bag large enough to fit over your camera. Cut the two bottom corners of the bag, remove the neckstrap from your camera, slip the bag upside down over the top of the camera,

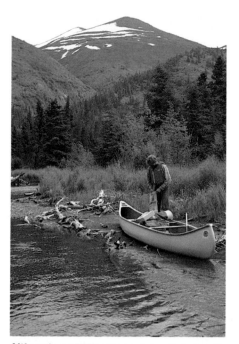

Although a plastic bag works, it is fragile and can be awkward to use. When we made this stop, I took all my pictures and returned to the boat before my friend even got his camera out of the bag.

Use a plastic sandwich bag for an inexpensive way to protect your camera in damp weather.

and clip the neck strap back onto the camera through the clipped corners. Wear the camera on your chest and slip the plastic up to make the exposures.

For a more secure system, don't clip the corners. Put the camera inside the bag and seal off the bottom with a rubberband or tape. Then screw the camera's eyecup into the viewfinder from the outside, catching the plastic in

between. Do the same thing with a lens shade on the front of the lens.

Then carefully cut or pull away the plastic covering over the eyepiece and lens, and you will have a tight seal around the rest of the camera. Be sure the bag you select is loose enough so you can manipulate controls from the outside. Then look for a rainstorm to play in.

COMMERCIAL ACCESSORIES

If you don't like to rig your own contraptions, you can buy several different types of products.

The Blimp—One such accessory is the Nikon Blimp. This not only shields the camera from water but also insulates it for use in damp winter conditions. A wide assortment of lenses can be used with the pouch. You operate controls through two sleeves on the side of the synthetic bag. It is not submersible, however.

Waterproof Bags—Airtight plastic bags are available for camera protection in a variety of styles and designs. Some are padded, and one model is surrounded by an inflatable shell. The obvious problem with these housings is that you must remove the camera before you can take a picture. The not-so-obvious disadvantage is that they can tear because they are made of vinyl.

I tied one to the cross brace in my canoe, which I breached on a rock in the middle of a set of rapids. The boat, the camera and I went under simultaneously, but I had no fear for the camera because it was in the trusty housing. I rescued myself first and the camera second, intending to deal with the canoe last.

But I had more pressing matters when I pulled the camera out of the water—it was soaked. The current had knocked the bag against a rock. The small cut resulting from the collision caused a leak. Somehow I should have known better than to trust soft plastic—now I don't.

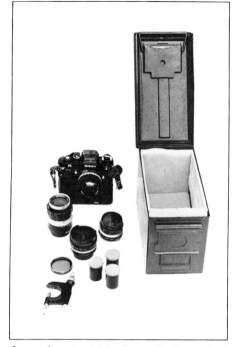

Ammo boxes, originally made to protect explosives from the elements, do the same for photographic equipment. This one is padded with foam rubber. Ensolite, available at camping stores, would be better for the interior because it is a closed-cell foam and doesn't absorb water like foam rubber.

Steel Boxes—For a tougher, nearly indestructible housing, many photographers use a 50-caliber Army surplus ammo box. Other sizes are available, but this one is large enough to hold two camera bodies, several lenses and dozens of rolls of film. Most surplus stores sell the boxes for about $5.00.

Make sure you get one with a rubber gasket or it won't be watertight. Convert the box for photographic use by lining the interior with a nonpermeable foam rubber such as Ensolite, available at camping stores. Use extra pieces of foam to separate individual pieces of equipment so they do not bang against each other.

These boxes can withstand abuse. While running the Chattooga River, I switched canoes and partners, and somehow my ammo box wound up in someone else's

Photo equipment worth about $3400 was in this canoe in an ammo box before the canoe was swamped. Moments after I retrieved the box, the canoe collapsed and buckled, as you can see here. This shot was taken with a camera stored in that trusty ammo box.

You may think you're high and dry, but when there's water around, somehow it's going to find a way to get onto or into your equipment. Be sure to wipe everything down thoroughly as soon as you can.

canoe. Naturally, *that* canoe swamped in the next set of rapids and became wedged between two sides of the channel with water tearing at it.

Fearing the canoe would collapse any minute, but wanting desperately to retrieve my ammo box, I waded out, standing on the edge of the suspended canoe and felt for the rope.

With water billowing over my head, I played tug-of-war with the river—for keeps—winner take all. I won. Moments after I got to shore, the 18-foot aluminum canoe collapsed, doubled in half and was sucked under by the current. The guy who dumped the canoe offered to pay for the cameras. I opened the box and there everything sat, bone dry, as if nothing had happened. I pulled one out and took a picture of the now landlocked, crumpled canoe.

SALT-AIR DAMAGE

The effects of salty air on camera workings are as subtle as termites creeping under the floorboards at night—undetected until it is too late. I didn't believe this until I discovered my camera body covered with green corrosion.

It all began when I fell in love with a Dutch fishing boat moored in a small inland harbor, fishnets draped about it. Using sign language, I asked the owner of the boat if I could come aboard to make some exposures. The fisherman's hands conveyed an invitation to ride out with him. When we pulled back into the harbor after he made his catch and I had my pictures, we shook hands and parted.

Both my camera and the two flounders he "forced" on me were damp and sticky, so I dried the camera and fried the fish. I thought my problems were over. About six months later I noticed rust on the screw heads of the camera and green corrosion inside the meter housing. Sure enough, that was the camera I had taken to sea with the old fisherman. I cleaned the outer parts, using watchmaker's oil on a cotton swab, but had to have the inside cleaned professionally in an ultrasonic bath. You can avoid expensive repairs by using a housing when you shoot under such conditions.

WATER DAMAGE

A camera that is *thoroughly* soaked in fresh water stands a slimmer chance of recovery. One camera repairman said, "The only

reason a person would want to pull a camera out of the water would be to throw it out farther." Actually, it's not that bad when dealing with *fresh* water. Several remedies may save a soaked camera.

Rust and corrosion are the result of mixing a camera with water. If a repair facility is not too far away, place the camera in a plastic bag, seal it and rush it in. If not, dry the camera as quickly as possible.

An electric hair dryer will work well if you don't have access to compressed air. Remove the lens and take off whatever external accessories you can. Be sure to remove all batteries from the camera. Open the camera back. Set the dryer for low heat and position the camera in front of it.

Caution: The camera's shutter curtain is extremely delicate and should not be touched. Avoid directing strong blasts of air directly at the shutter curtain during the drying operation.

Or, set the camera on the open door of an oven with the heat on low, about 110F to 120F (43C to 49C). Do not use this approach for the lens. Heat damage will probably be worse than the water damage.

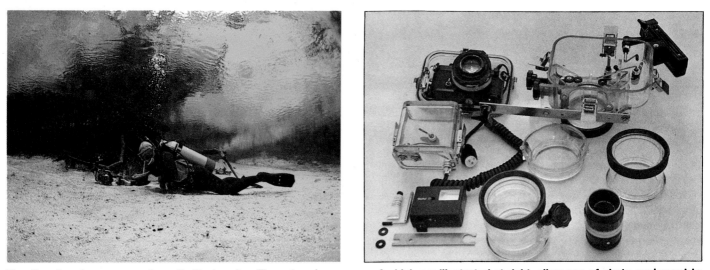

The diver is using a camera in an Ikelite housing. These housings, some of which are illustrated at right, allow use of photo equipment to about 300-foot depth, and provide good protection against water, sand, dust and salt—above or below the surface. I took the underwater photo with my camera in an Ikelite housing. Photo at right by Carl Holzman.

When heat and repair shops are not available, drain the excess water out of the camera, seal the camera in a plastic bag and freeze it. This retards or halts corrosion temporarily. One friend kept a flooded SLR in deep freeze for two months. The repair bill was under $100.

Barring these solutions, dry the camera in the sun or next to a fire. Then continue using it until it grinds to a halt. Of course, you should keep in mind that in the process, you may be losing some exciting shots.

Remember, repairs to a thoroughly soaked camera may cost more than a new body.

If the camera is dropped into *salt* water, there is a different procedure because salt water is extremely corrosive. According to Marty Forscher of Professional Camera Repair in New York, if you drop an electronic camera in salt water, "leave it there." He stated that you can never remove all the salt, no matter how well you clean the camera, and that the salt creates many problems with the electronics.

For any chance at saving the camera, get it to a repair shop fast. If that is not possible, flush the camera thoroughly in fresh water *immediately,* for about an hour, constantly changing the water.

Then follow the same procedures mentioned earlier.

UNDERWATER HOUSINGS

For more protection, buy an underwater housing. These are available for most cameras. One soft housing, from Ewa, is a thick plastic bag with a window for the lens and eyepiece in each side. An inverted glove-like compartment is sealed into the right side of the bag through which you can operate the controls. Because it is made of soft plastic, the bag will leak if damaged, so be careful.

This Ewa housing is watertight to about 30 feet. There is a built-in glove and an optical-glass port for the lens.

Also, trying to keep the camera between the two windows is maddening.

For *complete* protection and easier use, try one of the more than 270 different Ikelite underwater housings. The shells are made of unbreakable clear plastic with external levers geared to operate all functions of the manual camera.

You can use almost any camera and motor drive with these. At the time of this writing, no underwater motorized camera was available. So, remote pictures such as those taken from the deck of a kayak, the tip of a surfboard, or the runner of a catamaran must be made with a standard camera protected in such a housing.

One inconvenience with such a housing is opening the box and removing the camera to change film.

The Hydro 35 is a professional die-cast aluminum housing that accepts only the Canon F-1 and the Nikon F series cameras. It features water-refraction correcting ports and fisheye domes to accept extreme lenses. Hasselblad also offers a corrosion-resistant underwater housing for their 500ELM medium-format camera. Ask your camera dealer about these products, or write the manufacturer or distributor listed in the Appendix at the back of this book.

UNDERWATER CAMERAS

An alternate route for those who want the convenience and can afford a separate camera for wicked-weather shooting is the all-weather camera. The Nikonos has long dominated this market. This amphibious rangefinder 35mm camera was originally designed for underwater photography. It is now used in rain, snow, dust, sand and other situations generally not suited for 35mm cameras.

The original Nikonos Calypso had a shatterproof housing, zone focusing, no metering system and four lenses. The current Nikonos IV-A is the state-of-the-art in underwater camera equipment. It accepts the four original lenses from the Calypso—the 15mm, 28mm, 35mm and 80mm. The IV-A has a hinged back for easy film changing. Other features, such as an automatic metering system with aperture priority, make operation unbeatable above or below water.

Improvements—Two great improvements are the oversized viewfinder and flash sync. It used to be impossible to see through the tiny viewfinder while wearing an underwater mask, so divers had to guess distances—no easy task, considering water refraction makes everything appear much closer than it actually is.

On my first diving trip I borrowed a friend's Nikonos II at the last minute to record my aquatic adventure. A week later, when I processed the film, I learned how tricky guessing underwater distance can be. I had *13 rolls* of unsharp pictures to prove it. That shows how important it is to test new equipment before shooting photographs that are difficult to duplicate. Don't ever assume that everything is simple and the equipment will work the way you think it will.

You can see through the finder of the new model while wearing your mask. This eliminates the guesswork. With the Nikon SB-101 electronic flash, designed

for use with the Nikonos IV-A, flash photography is easier because the unit has a remote sensor for off-the-camera lighting and the camera synchronizes with the flash at any shutter speed. Sounds simple, but try it out before you head to the Bahamas.

Now There's A Choice—For a long time, the Nikonos had no competition. Now, however, you have a choice between a 110-format model and another 35mm camera.

The Minolta Weathermatic-A 110-format camera is for the

The Minolta Weathermatic-A is a 110-format camera. It is watertight to about 15-foot depth.

casual photographer. This camera is watertight to a depth of about 15 feet, and is housed in bright yellow, bouyant plastic. It is compact and relatively easy to operate. But the size of the negative is its main drawback. There are only three types of film available in this format. And, sharp enlargements larger than 3x5 from that size negative are sometimes difficult to produce.

If you want an inexpensive 35mm alternative to the Nikonos, look at the Fujica HD-S. The camera fills the gap between the Nikonos and the Weathermatic, although it cannot be used under water. It has a built-in flash and 38mm wide-angle lens, and features automatic exposure. Cautions: You must use zone

This is Fuji's HD-S all-weather 35mm camera. It cannot be used underwater, but can be used in rain, snow and extreme humidity. The camera selects shutter speed automatically. Below: Because there is no way to override the automatic controls, use a support in case the camera chooses a slow shutter speed. Here, lighting was ideal, so the camera's choice worked.

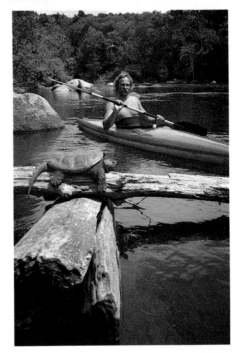

focusing, which is not the most accurate method. Also, this camera is fully programmed. It selects shutter speed and aperture automatically. You have no way of knowing what it chooses.

I used the Fujica on a kayak trip down the Wolf River in northern Wisconsin. When the sun was shining and I had enough time to calculate relatively accurate distances between myself and the subject, the camera worked like a charm. Later in the day, when the sun went down, I came across some good whitewater but had no way of knowing the camera's shutter speed selection or regulating it.

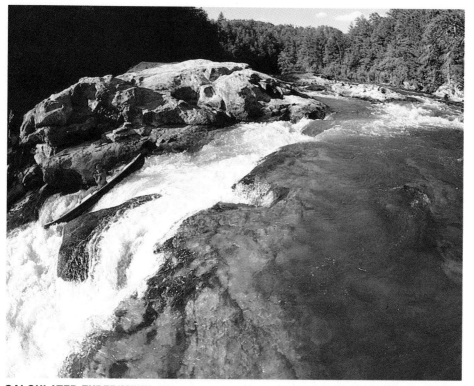

CALCULATED EXPERIMENT: When you mention white-water sports, most photographers think of using a telephoto lens from shore. That's why I pulled out my super-wide 16mm lens to shoot the Bull Sluice rapids on the Chattooga River. Not only did the image include the upper and lower sections of the river, but because of the type of lens I used, the rapids appeared much more severe than they actually were. When you can get away with distortion, take it to the limit.

It chose 1/30 second. The equipment is good, but don't push its capacities. Stick to ideal lighting conditions or use fast film exclusively.

PROTECTION AGAINST THE SUN

Rain is not the only outdoor troublemaker. Although the sun may not damage your camera, it can easily damage the film inside it, depending on the type of camera you have.

An example of the sun's raw power is illustrated by the solar panels on my neighbor's roof. The black boxes covered with glass become hot enough in the summer to almost boil water. If your camera is a black box, guess what happens? Granted, you may be more stylish with a black body camera, but remember you can "cook" your film with that chic equipment. Chrome bodies reflect more light away and allow the film

to remain at a significantly cooler temperature than all-black bodies, so keep that in mind when buying any kind of camera. However, even with a chrome camera body, you must still be cautious.

Film is very sensitive to heat, whether the film is in the camera or not. Any time you are working in extreme temperatures, find a cool place for your film. I usually put mine in a watertight plastic container and leave it in the cooler with other perishables. One trick is to purchase a commercial cold pack for camping and stick it in with the film. It lasts up to 48 hours and is not messy or wet.

Don't lay the camera down facing the sun, either. The lens may act like a magnifying glass and braze the inside of the camera like an acetylene torch. Many years ago a professional photographer received a set of pictures back from the lab with a white moon in the center of each one.

When he inspected the camera interior, he found that the sun had actually burned a round hole through the cloth shutter curtain a week earlier when he set his camera down lens-up to the sun. *Never* leave your camera aimed at the sun.

OTHER CAMERA KILLERS

Sand and dust are more subtle camera killers. If you must go to the beach, plan in advance to protect your equipment. One grain of sand lodged in the focusing mechanics can ruin a lens. A little sand inside the camera itself can do a lot of damage, too. And you don't have to roll your camera down a sand dune for this to happen. Sand blows everywhere at the beach.

Photographers always rationalize their actions with, "I'm going to watch it like a hawk," or "I'm not going to be out there long, just long enough to grab a couple of quick shots." But of course the sand always gets to them quicker than they get to their pictures.

Don't risk it. Use one of the water-protection systems mentioned earlier, unless a $500 overhaul is of no consequence to you.

Here's another caution: Don't use a vacuum on the interior of your camera. During a sand dune photo expedition, a friend's camera was blasted by the sand. On the way home, we stopped at a car wash to vacuum the sand out of our car and clothes. Against my suggestion, Bob tried the vacuum on his new SLR, and found it did a good job on the outside, so he decided to try it on the inside. Bob opened the camera and proceeded. The next thing I saw was Bob very upset—the vacuum pulled the shutter out of the camera. I doubt if Bob will ever try this again—and hope you have learned from his mistake.

PHOTOGRAPHY BELOW FREEZING

Summer extremes may be tough on cameras, but winters

scare their owners from even attempting photography. When the first blizzard blows in from the north, most cameras "head" for the shelf and stay there all winter. Sports activities don't stop in the winter, so why cut your shooting life in half, or more—depending on where you live?

There *are* hazards with winter photography, however, and regrettably most of the scare stories you hear about film cracking and camera parts freezing are true. But before you get cold feet, here are a few tricks to help you sidestep the snares.

Horror Stories—What are some of these terrible tales that cold-weather photographers come home with? First, they say their *hands* stick to metal parts of the camera when temperatures drop below −20F (−29C). Don't laugh! My *nose* once froze to my camera while I was on the ski slopes. I had to walk back inside the lodge with the camera in place and wait for it to thaw.

Avoid sticky problems by purchasing a pair of thin nylon or silk gloves and wear them inside your mittens. Leave the gloves on when you handle metal. Put tape on the back of your camera to solve the nose problem.

You'll also hear gruesome stories about the focusing barrel getting so stiff it's hard to rotate, the shutter getting sluggish or the camera mechanics freezing up. First, *never* force frozen parts. If the equipment is not working smoothly, don't use it because your picture won't turn out anyway—and you're liable to jam it more.

Here's the solution: Any time a moving part gets stiff, warm the camera by placing it inside your parka.

Brittle Film—You may have heard about film becoming so brittle that it breaks during loading—or worse, inside the camera in the middle of a roll. Your best bet is to carry the next roll of film in

CALCULATED EXPERIMENT: A friend and I were slowly making our way up a glacier at 11,000 feet in the Swiss Alps. I was gasping for air and was in no mood to stop and set up the monopod for a picture. But I wanted one. I placed the camera in the snow, set the self-timer and skied away. It was chance that put both skiers in the frame—and to this day I wonder how it happened. If you take chances, some are bound to pay off.

your pocket to keep it warm before you load it. An easy way to test the film before loading is to pinch the end of the leader to see if it snaps. If it does, stick it back in your parka for a while.

If the film breaks inside the camera, place the camera in a film changing bag or go to a darkroom and remove the exposed portion. Put the loose portion of the film in a film canister and mark the outside with the film type. When you are ready to have the film processed, bring the canister to the lab and explain what happened. They should be able to process the film without any

problem, provided you didn't fog it or otherwise damage it when handling it.

Before you load the camera, move the film advance lever and release the shutter several times to be sure everything is operating smoothly. When you are using the camera, advance the film slowly because fast motions break cold film more easily. This is one of the reasons you should avoid using a motor drive during the winter.

The most dreadful horror story of all involves photographs in which the snow looks gray, the pictures are overexposed, or you see blue streaks of "lightning."

When snow looks gray instead of white, it is because the scene you photographed was not an "average" scene. Camera meters recommend good exposure when metering average scenes. There are several ways to overcome the problem. As mentioned earlier, one is to take a reading of your hand rather than the snow. Your hand reflects about 36% of incident light. When using this approach, keep in mind that an exposure meter is calibrated for an average subject reflectance of 18%. Because of this, you should give one more exposure step after taking a reading off your hand.

If more than half the frame is filled with objects other than bright snow, such as skiers, trees or background shadows, you shouldn't have to perform this step because the meter should average these dark areas and come up with the correct exposure. When more than half the image area is snow-filled, take a reading from your hand. Then use the memory-hold button on your camera, if it has one, or set the camera manually from your shooting position.

Another solution when there are large masses of bright snow in the picture is to *bracket*. This means taking extra shots with more and less exposure by setting the camera exposure controls manually. For color film, bracket in half-steps around the exposure the camera recommends; for b&w, full steps should be sufficient. This will give you whiter snow and better exposure on the rest of the subject. You can try this technique any time you doubt the camera meter's reading. You may use more film this way, but your chances of getting the shot you want will be increased.

Remember to put the camera back in the automatic-exposure mode after shooting. Otherwise, when the scene or lighting changes, you may waste a lot of film, and lose those sometimes irreplaceable shots.

Slow Shutter—Sometimes, pictures are overexposed as a result of the mechanical parts of the camera slowing down. This gives the film more exposure than it needs. For instance, if the shutter speed is set at 1/250 second and the curtain is sluggish, it will travel at an actual speed slower than 1/250. Thus, more light reaches the film.

When the shutter sounds slow or any moving parts feel stiff, return the camera to your warm body. If it still sounds slow when the temperature is normal, have the camera shutter mechanism checked by a camera repairman.

Lightning Streaks—When you overcome everything else, you still may have streaks on your film. This is caused by static electricity. It is the result of moving the film too rapidly through the camera when the air is cold and dry. It usually occurs during rapid rewind, so take your time advancing and rewinding the film slowly and steadily. You usually can prevent these streaks from occurring.

WHICH CAMERAS WORK BEST IN WINTER?

It may sound patronizing, but whether you like it or not, more expensive cameras generally function better at lower temperatures.

I was ski-camping with a group of people in Michigan's Upper Peninsula in 1977—a year with a winter well remembered for its Ice-Age temperatures. We should never have been there, but we were—four of us with cameras. The temperature warmed to −30F during the day. And because we were on the south shore of Lake Superior, the wind was relentless.

Each day, one of the cameras died. On the fourth day, my 1964 Nikon F was the only one left and it kept on working.

Later I found out why. In the lower-priced camera models, individual parts are often cast with greater tolerance between moving

Generally, you shouldn't touch metal camera parts with your bare skin when working in extreme cold temperatures. Here, however, the photographer is working at a high altitude where the sun keeps everything warm.

This picture is a result of an automatic camera doing what it is supposed to do—read medium gray. If you want white snow, you have to *trick* the camera meter. The easiest way is to meter on something dark in the frame, such as trees, people or any other nonwhite area, and set the lens aperture manually. Or, give 1-1/2 to 2 steps more exposure than meter dictates.

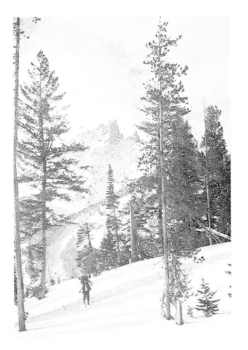

The temperature was −25F (−32C). Apparently, my camera's shutter didn't feel like moving very fast. It wasn't operating at its setting of 1/250 second, but I didn't realize it until I got home and it was too late to correct.

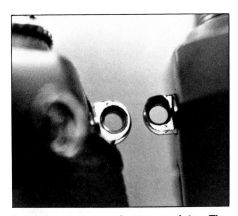

Compare these neckstrap eyelets. The one on the right once looked like the other one. Check all the telltale marks on a used camera to see how much it has been used—or abused—*before* buying it.

parts to ensure easier assembly. This gap is later filled with lubrication. Under extreme cold conditions, this lubrication solidifies. So, the more lubrication a camera has, the sooner it will seize. Top-of-the-line models have much less space between moving parts, and consequently less lubrication.

On the historic 1964 American Mount Everest ascent where wind-chill factors of −140F (−60C) were common, the Nikon F cameras on the expedition were the only ones that continued to function. More than 40,000 exposures were made without one camera malfunction. So, buy a top-of-the-line camera if you're planning to do a lot of cold-weather shooting.

Here's another factor in cold-weather photography: Older cameras are mechanical, while today's models are becoming more and more electronic. As a result, you have to consider which is better: a mechanical unit with lubricants that can freeze up, or an electronic model that depends on batteries (and some lubricants) for most or all of its functions—batteries that lose power very fast when they are cold.

So, if you can't afford the biggest and the best, not to worry. A used top-of-the-line model may be the answer for you. But watch out because buying a used camera can be as tricky as out-foxing a used car dealer.

Honest Bob—While I am on this honesty kick, I'll tell you something else. Some cameras should be *avoided* in winter. In cold weather, the first camera problem is the batteries. Then the lubrication.

So, if your camera depends on batteries, take lots of extras. Keep them in a warm, accessible place, such as your pants pocket. Electronic cameras will work under extreme cold conditions, but may require frequent battery changes. Some electronic cameras are completely useless when the batteries are dead. Others have a mechanical override that allows you to manually set the aperture to a specific shutter speed until new batteries are available.

Mechanical cameras are the best choice for winter or high altitude work if they are properly maintained for this type of shooting. So keep that in mind when deciding on what equipment to buy.

Light Meters—Built-in light me-ters are also powered by batteries. Sorry—no alternatives. Carry two extra sets of batteries and rotate them frequently. The fresh ones can be carried in a pocket next to your body where they will stay warm. Exchange them when the used ones go into hibernation. If the batteries are fresh, no need to throw them away when they stop working under these conditions. Once they warm up, you should be able to continue using them.

An alternative to this approach is to use special accessories designed for use in cold weather. For example, Nikon's DB-2 Anti-Cold Battery Pack holds two AA batteries and has a 3-1/2-foot cord that plugs into all Nikon cameras. Thus, you can carry the batteries inside your coat and keep all of the camera's electronics running properly. And for motor drives, the MC-7 Anti-Cold Cord also allows you to keep the batteries warm—this time for Nikon motor drives.

Remember, however, that just because the batteries won't die during cold-weather shooting when using these accessories, if the temperatures are extreme, you must follow the care instructions for your camera and film, too.

Buying A Used Camera—One way to find out how the owner treated the camera is to look at the telltale marks left on the camera body. Check the base plate, or bottom, to see if the camera was used in or out of a case. Professionals use cameras hard and seldom own camera cases. Non-professionals usually pamper their cameras and keep them covered most of the time. If the base plate has no scratches, it probably was well cared for.

The eyelets that hold the neck strap on a well-used camera are sometimes worn nearly through. This is an indication of heavy use.

Check the lens barrel for wear—this is like a worn clutch pedal. If the metal on the lens focusing ring is showing through,

you know it has had a lot of twisting.

Finally, *insist* on running a test roll of film through the camera before purchase.

Other Thoughts—Some photographers of cold-weather sports prefer to carry accessory handheld meters that do not depend on batteries. If you carry one in your camera bag, you can check unusual lighting situations and back up your camera's built-in meter.

Also remember that cameras with LEDs—light emitting diodes—drain batteries very fast, especially in frigid temperatures. When checking a model, see if it has a switch that automatically turns off the camera after a short amount of time if your finger is not on the shutter button. On some cameras the meter operates continuously if the shutter is cocked and you don't have the lens cap over the lens.

Wearing It Well—People who spend a lot of time outdoors in winter know that the best way to dress is in layers. This works out nicely for the photographer. Find a spot close to your body to keep the camera warm enough to function and far enough from your skin so condensation will not form. Wear the camera on your chest, and it's just a matter of unzipping your parka to get it out.

This should solve the battery problem. Unless you're dead, your body temperature will remain close to normal even if it's −98F (−37C) outside. Wearing your camera close to your skin surface is almost like keeping it in the house.

CONDENSATION

More frustrating than dead batteries is condensation. Any time you go from a cold place to a warm place, with enough temperature difference, condensation will occur. When it forms, there's nothing you can do to get rid of it. If you wipe it off, it will reappear again until the surface warms to

When you drop your camera in the snow *don't* blow the snow off. Shake the camera to remove as much as you can, and wipe the rest off.

the surrounding conditions. All you can do is wait until the air decides to cooperate. You won't have this problem if you take all your photographs outside *or* inside.

When driving in your car with the heater on and you stop to take pictures, there is no escape from this problem. You must wait until the camera cools off or keep the inside of the car the same temperature as the outside air.

STRONG LIGHT

Another thing your camera can't handle is intense light. When the sun and snow are both out, the conditions may be too intense for the camera meter to handle. For instance, 1/1000 second and *f*-16

are too slow for snow-dominant scenes with some fast films. Carry a 4X neutral-density (ND) filter in your gadget bag and you'll be able to handle almost any condition with any camera. Or, if you know what kind of conditions you'll be shooting under, load your camera with slow film, such as ASA 25 or 64.

SNOW

Some people think that just because it doesn't rain in freezing temperatures, moisture is nonexistent. Watch out. It's everywhere you think it's not. Snow melts and becomes wet, seeping through your camera bag; your breath can coat the back of the camera while in use, fogging the eyepiece and

then freezing it; snow falling on the exterior of a camera will melt if your camera is at the temperature it should be for operation. Be conscious of these and similar conditions. Carry something to dry the camera when needed.

KLUTZ

A camera dropped in the snow is not as funny as it looks. With all the thumbs we grow in winter and the clumsy clothing we wear, snowballed cameras are not an uncommon sight. When people drop their cameras in the snow, the first thing they generally do is pick it up, yell at it and proceed to blow the snow off.

Don't Do It! The first time you drop yours, pick it up if you like, blame the camera if you like, but *don't* blow the snow off. The condensation from your breath will only remove one form of moisture and coat it with another—usually worse. Just when you get all the visible snow removed, you suddenly realize you've encased the entire camera in a thin block of ice from your moist breath and the hidden snow that melted on the camera. Then you will have real cause to scream.

The best solution is to shake what snow you can from the equipment. Then use a neckerchief to "whip" the rest off. Vigorous whipping of the "ignorant" camera is also a good psychological release for hotheads.

WHAT ABOUT WINTERIZING YOUR CAMERA?

To winterize a camera, it must be completely disassembled and parts cleaned of their lubrication. Then it must be relubricated with a non-liquid graphite. The process is effective but expensive. The most important factor is not necessarily the dollar cost, however. Winterized cameras have proved themselves reliable in the most extreme temperatures.

Once a camera is winterized, it can no longer be used in warm temperatures or it will wear out prematurely—unless you "dewinterize" it again, which is also expensive.

Still, if you photograph a lot of winter sports, it may be worthwhile to convert one body to be used only in arctic temperatures. Ask your local camera dealer where you can have this winterization done.

HARD USE

Sports photographers probably use their equipment harder than most others. My cameras have been taped to the vibrating tail wing of a small airplane for four days, dragged through the mud on a caving expedition, buried in snow on the side of a mountain at 14,000 feet—and have never missed a click.

TOUGH CAMERAS

There are a few things you can do to make your cameras last longer. Start off with the toughest camera you can afford. I'm biased toward heavy cameras because I think they are more durable—and I have some 14-year-old Nikon Fs to prove it. One of them has never been in for repair work, and I can't say that I baby it.

I don't think I'm heartless with my cameras, but I do give them a workout. They rarely let me down, so I'm not afraid to use them under unusual conditions. If your camera requires too much attention, such as more than one repair in three years, I suggest that you buy another camera.

CLEANLINESS

Once you have a camera you can depend on, treat it with respect. Protect the camera body with the techniques outlined in Chapter 1, and always keep your camera clean. Use a canister of compressed air to blow air or a small battery-operated vacuum cleaner made specifically for

Rust results when moisture dries slowly. If your camera gets wet, dry it as quickly as possible. A hair dryer held at a safe distance works if you don't use extreme heat—but I can't guarantee the results.

camera interiors to clean the inside of the camera.

Dusting—Sports photographers' cameras are often exposed to dust, dirt and grime. Some individuals incorrectly think that dirt on the outside of the camera is of little concern besides appearance.

In reality, dust on the outside of the camera can cause it to jam. Any dust or dirt that is not removed from the outside will eventually work its way inside the camera where it will soak up the oil. Lack of lubrication increases friction between moving parts. This wears them down and can lead to jamming.

To remove external dust, use the compressed air canister or a stiff artist's paintbrush. *Never* use water to remove dirt. The water dries too slowly and can cause rust or corrosion. Rub the soiled area sparingly with rubbing alcohol on a lint-free tissue to remove grime.

LOOK BUT DON'T TOUCH

There are two areas on the camera you should *never* touch.

The *reflex mirror* is surface coated and is extremely sensitive. A fingerprint left on the mirror surface eventually will etch it irreparably. You can't remove the fingerprint with lens tissue because anything touching the mirror surface will scratch it. Camera repair centers clean mirrors and camera body interiors with ultrasonic baths. Any way you try to clean it yourself will cause damage.

The *shutter curtain* and *pressure plate* should never be touched either. If you are not sure where they are, check your camera manual. These must be kept clean, particularly the pressure plate, because it comes in direct contact with the film. Any dust or fragment of film on the pressure plate is sure to scratch the film, so keep the plate clean. The pressure plate can take cleaning with lens cleaning tissue, but don't use anything else.

One time, I saw an individual wearing muddy jeans walk into a camera store with a new Canon F-1. He didn't know how to unload the film for processing, so the clerk removed the film and handed the camera to him with the camera back open while he went to get a fresh roll of film.

I watched the customer pull a handkerchief out of his back pocket, slap it a couple of times on his dirt-encrusted jeans, wrap it around a finger and then start polishing the camera's pressure plate. Apparently that didn't meet his satisfaction so he licked the rag and continued working. I couldn't bear to watch, so I turned my back.

SAVING THE SHUTTER

There are different philosophies regarding when to cock the camera shutter. Should you do it right before you plan to make the exposure? Or should you recock the camera as soon as you make a shot so you will be ready for the next one?

I think you should always cock the camera shutter right *before* you take the picture, to be safe. Shutters are mechanical and spring-operated. Keeping the shutter cocked means the shutter springs are constantly in tension except for the fraction of a second when you release the shutter.

When storing the camera for an extended period—several months or more—be sure the shutter is not cocked. However, if you keep the camera handy for grab shots, or even while you are using the

equipment, there is no reason to worry about shutter-spring tension. Professional Camera Repair's Marty Forscher says that leaving the shutter cocked for extended periods *might* cause a change in tension, but this is not common.

If you think the speed of the shutter in your camera is not accurate, take your camera to a professional repair center to be checked. Inaccurate shutter speed can result in improperly exposed images.

PREVENTIVE MAINTENANCE

Most camera failures are caused by loose or worn parts. Replacing a worn part is less expensive than a major overhaul due to a jammed camera. Have your camera inspected periodically by a qualified repairman.

MAXIMUM USE FROM YOUR LENSES

Once you've learned to conquer weather threats, you can make your equipment more useful by exploiting your lens system. The first thing people think of when you mention sports photography is mammoth lenses. The stereotype of the sports photographer is the little guy carrying five motor-driven cameras with 2000mm lenses. This isn't always so.

My theory is, the shorter the lens you use and the closer you get, the greater the impact your pictures will have. Take a look at the pictures in this book. Of course, some were taken with long-focal-length lenses, but more than half were made with wide-angle lenses.

WIDE-ANGLE LENSES

My first lens choice for sports photography is the *24mm*. Although I own 13 lenses, I use this wide-angle more than any other.
Side Effects—Wide-angles have "side effects" that can become good main effects *if* you know how to take advantage of them.

These lenses cover a wider angle of view than the standard lens. As a result of their special construction, distortion can result. Generally, the center of the image looks normal but the edges are stretched out of shape.

Some people get upset about this distortion, calling it "the curse of the wide-angle lens." I think this effect is a virtue. If you keep the *distortion factor* in mind, you can make it work for you.

I was doing a story several years ago on skijoring—the sport in which sled dogs pull cross-country skiers. My subject was over six feet tall and the sled dogs were Siberian Huskies not more than two feet tall. Although the dogs had no trouble pulling the skier, it still looked rather unfair and made you feel sorry for the pups.

To "even" things up, I chose a 28mm lens, laid down in the snow, and waited for the dogs to charge toward me. From this angle, the dogs appeared larger, and the skier in the background looked smaller when the dogs sped past me.

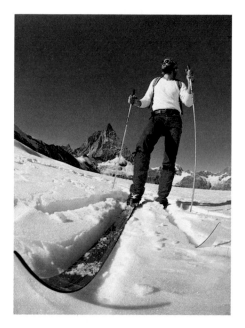

You can create impact in a photograph by taking advantage of the distortion from a wide-angle lens.

Top Left: A 50mm lens from this angle cut off some of the foreground. With a 28mm wide angle, however, I achieved the feeling of space and tranquility I wanted.

Above: There are boats racing in the background of this picture and two others about to be hoisted out of the water—but you would have never noticed if I hadn't told you. The 16mm wideangle lens gave me just the perspective I wanted to accent the subject in the foreground.

Left: I wanted the individual in the foreground to be just as sharp as the cyclists, so I took advantage of the good depth of field offered by my 28mm wide-angle lens.

Another frequent complaint about the wide-angle lens is that it diminishes the background, making everything appear to be farther away. That's not necessarily bad. One summer, when I was camped on the shore of a fjord in Norway, the sea looked as smooth as glass, without a ripple. A normal lens would not have given me the effect I wanted, so I pulled out the 28mm lens. This subdued the mountains in the background and made the water appear to stretch out for hundreds of miles. No other lens could have given it that mystical appearance.

Extending the foreground is no quality to sneeze at. One time I covered the national speedboat race at Fox Lake, Wisconsin. For one shot, I wanted to take the viewer's eyes off the action, off the mechanics, off the drivers— and simply show the elegance of the beautiful boat and the artwork on it. My 16mm lens showed the boat with the lovely lady adorning it in a way that could not be illustrated with a longer lens. The driver, his crew, the pit area, the water, are all there, but the boat is what you see.

The greater *depth of field* possible with wide-angle lenses is another asset in sports photography. As I mentioned earlier, precise focus is not as critical with a wide-angle lens. Thus, it allows shooting from the hip for "grab" shots or close-at-hand action without the need for rapid and accurate focusing. It renders several different points of interest equally sharp. And, because of its wider area of coverage, the wide-angle lens displays more detail than would ordinarily be possible. Great depth of field is an advantage everyone recognizes.

TELEPHOTO LENSES

Long-focal-length lenses do more than make the image larger in the camera viewfinder. If you only use your telephoto lens to bring the subject closer, you are short-changing yourself. Some of the effects of a telephoto lens are often of greater value to the sports photographer than enlargement of the negative.

Telephoto lenses *foreshorten* the distance between objects. This makes the elements appear closer together. If you take a picture of a row of fence posts spaced four feet apart using a standard 50mm lens, the posts appear as you usually see them. With a 300mm lens, the same section of fence looks like the posts are less than a foot apart.

You can apply this phenomenon many ways in sports photography. It heightens the impact of close-quarter action.

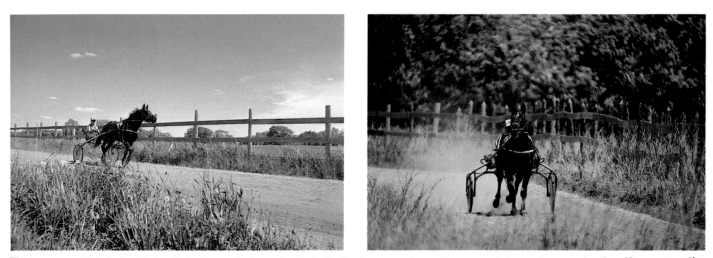

There are several similar elements in these photographs. In both, the fence posts are the same distance from each other. You can see the obvious difference between the photo at left, shot with a 28mm lens, and the one at right, shot with a 500mm. Also note the difference in foreground and background details.

For example, sailboats look as if they are on a collision course, horses look impossibly close, race-car drivers seem to have superhuman maneuvering abilities. If you want close action to look frightening, use a long-focal-length lens.

The telephoto lens makes objects look closer together, and *magnifies the background* by apparently bringing it closer to the main subject. Use this to your advantage. You can show kayakers engulfed by enormous white water, sailboats pitted against mammoth waves, and climbers can be given overwhelming walls to ascend.

This distortion effect is also a valuable tool when you want to *eliminate* a busy background. A telephoto lens of sufficient focal length will enlarge the foreground

I wouldn't want to sail as close as these boats appear, when photographed with a 200mm lens.

subject so only a small portion of the background shows.

Many inexperienced photographers dislike the short depth of field offered by telephoto lenses. Naturally, such lenses require more precise focus than shorter lenses, but this limited depth of field can be used to your advantage if you work *with* it instead of fighting it.

Framing with a long-focal-length telephoto lens is marvelously easy because you see the subject separated from its surroundings. A short-focal-length lens, particularly at small apertures, makes background arrangement crucial because so much of the area will be in sharp focus. With a long lens, however, you only have to focus and shoot—the apparent shallow depth-of-field subdues the background. If your camera has a depth-of-field preview button, use it to see what the range is before you take the picture.

Caution: The camera will probably require extra support when a long-focal-length lens is mounted on it, particularly at shutter speeds slower than 1/500 second. Rest your left elbow on a stationary surface or stabilize the lens against something solid. Such natural supports are helpful, but if the lens is longer than 400mm, I suggest using a monopod or tripod.

ZOOM LENSES

Some people disagree with my wide-angle strategy. They would pick a short-to-long-focal-length zoom lens as their first choice. I think that, for my needs, images made with a zoom lens are still not up to the quality level of those made with fixed focal-length lenses. Until I think the quality is at the level I require, I plan to stick with fixed-focal-length lenses.

Invest in a zoom lens if you do not plan to make large blowups or sell your photos for publication. Not only is it more *convenient* because it can take the place of several standard-focal-length lenses, you also get all the intermediate focal lengths.

Perhaps the best advantage of a zoom is that you can alter the

There are advantages to using a zoom lens. Here, a combination of zooming during exposure, and subject motion, makes a striking image. Photo by Candee Associates.

image in the viewfinder without having to change position or lenses. This also means you can create the image you want *in the viewfinder* instead of having to make selective enlargements in the darkroom. For example, with a zoom, one quick slide of the lens-barrel sleeve might take you from 50mm to 300mm—a change in focal length of 600%!

Special effects, like the image made by changing focal lengths while exposing the film using a slow shutter speed, cannot be duplicated with another type of lens. So, if such a lens suits your needs, the advantages are many.

CHANGING LENSES QUICKLY

The faster you can change lenses, the better off you'll be. But this speed won't help unless you know exactly where each of your spare lenses is. Rummaging through a heap of lenses in a camera bag is no way to get your shots. A *hip pouch* is handy and can carry five or six separate lenses. If you keep your lenses in specific slots, you can grab the right lens without even looking.

Know your equipment and be organized. As you make more things happen automatically, you can concentrate more on stopping the action.

Even if you take all the necessary steps to make changing a lens quick and efficient, things may not always go as planned. Once, while I was shooting skydivers, I figured I would need three cameras with motor drives. I mounted one on the wing strut, one on the tail wing and used the third in the cockpit.

To capture the skydivers exiting the plane, I needed a wide-angle lens. But after they jumped, I planned to switch to a longer lens and shoot their free-fall from the plane. I told the pilot to put the plane into a nose-dive and try to catch the divers as soon as they exited the plane. I figured I would have enough time to change to my longer lens during our descent.

As soon as he put the plane into a dive, the G-forces were so intense that when I reached for my 200mm lens, I couldn't move it. The lens felt like it weighed 80 pounds. I had to put the camera down and grab the lens with both hands just to move it. By the time I finally switched lenses, the skydivers were already on the ground.

The moral of the story is that you can never predict difficulties. Experience is the only teacher. The next time, I took an additional camera with a different focal-length lens mounted.

EXPLOITING THE MOTOR DRIVE

Many people misuse the term *motor drive.* It is not interchangeable with *autowinder* or power winder. Autowinders advance the film automatically at two to three frames per second after the exposure is made. On most models, the winder moves the film and the shutter button must be depressed for each exposure.

Motor drives can advance the film up to ten frames per second, but this is not what sets them apart. Unlike winders, in which the motor spindle is connected directly to the take-up spool, motor drives are geared into the camera's advance mechanism. This allows for *continuous exposure* by keeping the trigger depressed, *faster film transport,* and enables the use of numerous accessories.

Remote triggers are perhaps the most versatile benefit of the motor-driven camera system. This is because they allow the camera to be operated from a distance. Then you can place the camera almost anywhere.

There are different ways to trigger a camera, such as intervalometers, extension release cables, time lapse and delay switches, radio control triggers, infrared light sensors and electric-eye triggering.

You can make this convenient lens pouch for yourself in 30 minutes.

This shot shows what you can do with automation. When you have to get a shot and you can't be there to get it, use an automatic camera with motor drive and remote trigger. Professional photographers often have to use this approach. Photo courtesy Nikon Inc.

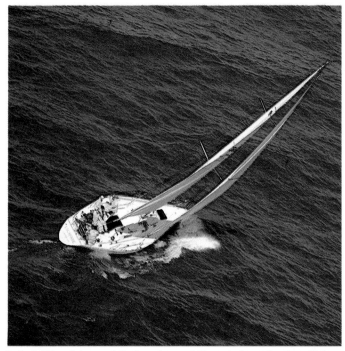

I shot this picture while hanging out the window of a low-flying plane, using a motor drive. My hands were otherwise occupied.

You can use your motor drive as a "focusing aid." For this shot, because the action was happening so fast, I held the camera exposure button down while changing the focus. This exposure made my efforts worthwhile.

In addition to these, the motor drive has other advantages. Because the motor is geared rather than direct-drive, it can operate at various speeds, both forward and backward. It can also accept different power sources, such as nicad battery packs, 510-volt external batteries and AC adapters for house current.

These features are important considerations for the sports photographer. Sometimes you can't move your finger fast enough on the shutter button to catch what you want. When I was shooting a racing yacht from the air, the plane's stalling speed was just above 100 miles per hour. Due to the direction of the sun

and the angle the yacht was traveling, I could only shoot from the left side of the plane. That was the pilot's side so I knelt on the floor behind him, opened the window and hung out. This position only offered me a narrow slot behind the wing strut through which to shoot and a fraction of a second of unobstructed view as

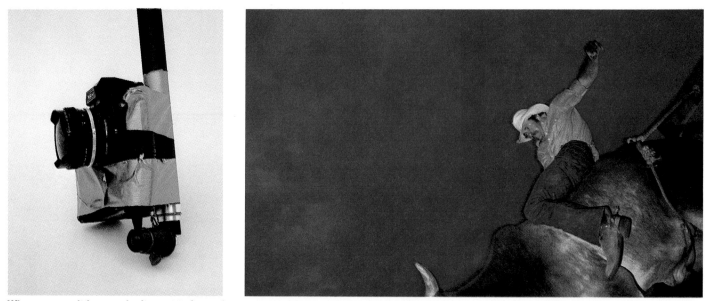

When you can't be—or don't want to be—where you want your camera, use your imagination. Here's what I did for the low-angle rodeo shot at right. I mounted the camera and motor drive to the lower end of a monopod, using gaffer's tape. The swivel head on the bottom allowed me to change the angle of the monopod and, as a result, get different angles with the camera.

Once I set up my camera for a "self-portrait" (right), all I had to do was push the trigger with my big toe—or so I thought. An entire roll was exposed while I was "positioning" my toe (see above). There was no film left by the time the action started. But eventually it all paid off. You can see one of the successful images below.

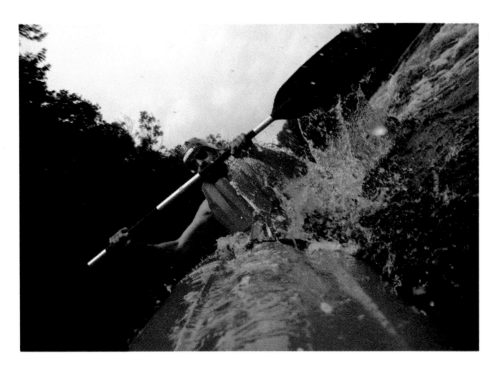

we sped past the boat.

If I had been using a manual camera or autowinder, I would not have had time to follow-focus and make more than a few exposures by moving my finger up and down. But with my motor drive set at six frames per second, I was able to make 12 exposures during our two-second pass. One frame caught the water spraying off the hull in perfect form.

Wireless triggers, external power sources and faster exposures combine to make the motor drive the better choice for sports photography. If you don't have the choice, however, all is not lost.

BENEFITS OF AUTOMATIC-ADVANCE SYSTEMS

With these differences in mind, I have good news for you. There are advantages to both systems that may not be obvious. Most people only use a fraction of a motor drive's potential. Here are some features you may never have considered.

Automatic Film Advance—When using an autowinder or motor drive, you have the advantage of continuous film advance. This means you can concentrate on what is in the viewfinder rather than thinking about advancing the film after each shot. With this accessory, you have one less mechanical function to perform.

Unmanned Camera Operation—Why would anyone want to take a picture with a camera he couldn't look through? For one thing, you may not want to stick your nose where you may be willing to stick your camera.

I thought a unique view at the rodeo would be from ground level under the stomping bull's hooves, looking up at the bull and his bouncing buddy. But I had second thoughts about lying down underneath the bull. So I mounted a swivel head on the end of my monopod, attached the camera and motor drive, and aimed the camera up at the sky. I then taped everything solidly together.

Running the remote trigger wire up the shaft of the monopod, I positioned the button on the end of the rod. Then, with this arrangement, I moved up as close to the bull as I dared, shoved the stick between his legs, and fired. I wouldn't have gotten that close, but I was glad to volunteer my camera and motor drive.

Look Mom, No Hands—There are many instances where hands-free operation can make sports photography easier. With a camera mounted on the deck of

At left is what I call a *self-exposure.* I chose this one for the book because you can see the transmitter cupped in my left hand. The remote-control receiver can be clipped into the camera hotshoe, but I sometimes just set it on top of the camera. At right is the setup I used.

my kayak, I needed a no-hands triggering method because both hands are used for paddling.

First I mounted the camera in front of the kayak in an Ikelite housing. Then I taped the wire on the underside of the kayak so it would not show, and brought it up behind the cockpit and in under the spray skirt. I ran the wire down inside the kayak to the footrest and taped the switch to the aluminum brace. As a result, I was able to push the button with my big toe, leaving my arms free to fight the current.

But I couldn't hear the camera over the noise of the river—and the sensitivity of my toe cannot reasonably be called acute. Even though my toe was pressing madly all the way through the rapids, I found out later that the camera had never been activated.

In another instance, I had a whole roll of exposures showing a friend handing me the kayak paddle next to shore; my insensitive toe thought it was just resting

above the trigger. However, with enough persistence I eventually got what I was after.

Shooting From Afar—Sometimes you just can't be everywhere at once. In soccer, the players move rapidly. There is no way a photographer can stay with the ball at all times. Not wanting to miss any action if I happened to be at the wrong end of the field at the wrong time, I set up a camera equipped with a wide-angle lens and Nikon Modulite Remote Control Unit. The transmitter is good for 200 feet, so whenever action got near my wide-angle lens at that end of the field, I merely aimed my transmitter and fired. One player, who must have heard the camera going all by itself, stopped to take a closer look between plays.

Self-Exposure—On small expeditions such as two- or three-member climbing expeditions, canoe trips with only one canoe or lone hiking excursions, it is difficult or impossible to take pictures

of the participants. Enter remote triggering.

One morning in northern Minnesota, I was camped beside a beautiful island-studded lake. The sun had just come up. I was brushing my teeth and my companion was emptying the tent when I thought, as always, "That would make a great picture." Somehow it's just not the same with only one person in a campsite. I set up the camera with the remote control unit and the pictures look as natural as Mother Nature, with both of us in them.

Problems and Solutions—One problem with remote triggering is that you cannot see through the camera viewfinder and therefore you are not always sure about framing. A wireless trigger lets you take several exposures as the subject passes by, so one of them is bound to be centered.

Another difficulty with such an arrangement is that the transmitter must be held and operated in one hand. Sometimes it takes a little

ingenuity to conceal the transmitter or to find a way of holding it while paddling a canoe. I'm still waiting for someone to come up with a remote trigger that you can hold in your mouth and activate by biting. This would solve all my remote-triggering problems.

OPERATING MORE THAN ONE CAMERA

There's another advantage of remote triggering. To shoot the finish line from five different angles for an event such as the annual Kentucky Derby, it would take you five years to get your shots. Of course, five cameras triggered remotely solves that problem.

There are many sporting events that can be covered from two or more angles simultaneously. I wanted to get the skydivers' exit from both inside the plane and from the wing strut looking back at the plane. Once the skydivers started falling toward earth, I could hardly say, "OK, get back up here, guys. Let's try one from the other side now." So I mounted a camera on the wing strut and held a second camera in the cockpit, "sandwiching" the parachutists between my two "guns." As they exited, I let them have it from both sides at once.

MOUNTING THE CAMERA

With remote capabilities, you can bolt, strap or tape the camera to almost anything that moves. This opens up a lot of exciting possibilities. You can mount a camera on the tip of a skateboard, toe of a downhill ski, helmet of a bike racer, or practically anywhere. Just devise a fastening method that will withstand the expected stress. Be sure your camera will handle the stress, too!

To mount the camera on the front hub of a bicycle, as in the picture discussed earlier, I had two aluminum plates cut to the width of the camera, padded them with foam rubber, and then bolted the camera between the two. I slipped

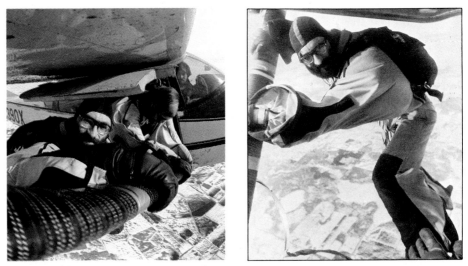

On this flight I shot from inside the cockpit with b&w film, and mounted a remote-controlled camera loaded with color film on the wing. I fired them simultaneously as the skydivers were about to fall away. One flaw in my plan: Because the cameras were facing each other—I was "caught in the crossfire."

the front axle of the bike through one of the holes in the bottom plate and tightened it to the front fork. Then I ran the wire up to the handlebars and taped the button just behind the brake lever.

UNIQUE VIEWS

Remote triggering also allows camera placement so you can obtain unusual views. For instance, no one has ever hung on the wing tip of a hang glider, looking back at the pilot and the ground below.

Many pictures of other planets from outer space are made by remotely triggered cameras. These shots could not be made even with the assistance of our largest telescopes. Some of these

cameras are similar to those you can buy at your camera dealer.

TIPS FOR REMOTE MOTOR-DRIVE SETUPS

Soon after you begin toying with remote photography, pitfalls become evident. Normally, you can't solve a problem until you have one. In remote photography, you generally don't discover malfunctions until it's too late and as a result may have to photograph the event again. This can be costly in travel and set-up time.

There is one exception, however—if someone else plays guinea pig for you and tells you where the pitfalls are. I have used remote triggering in so many weird places, it seems as if every

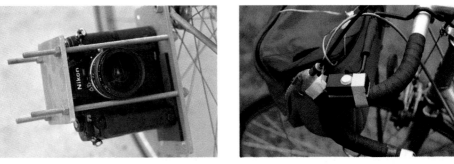

Here is the setup I used for the bicycle shot on page 5. To make that image, I padded the camera and motor drive and clamped it to the front axle of the bicycle using two aluminum plates designed for that purpose. You can have them made to your own specifications by a local metal shop. I attached the remote trigger and taped the end to the handlebars where it would not show from the camera's viewpoint. This is an important point: After you complete your assembly, always check to see if wires or tape show.

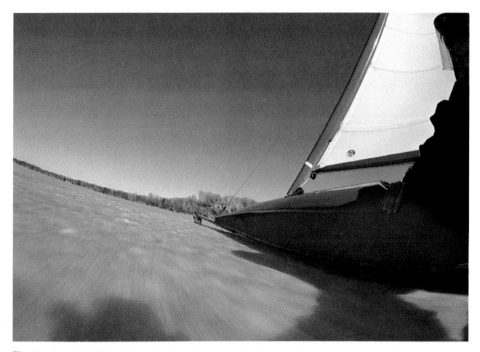

The ice boat in this picture is sharp because the boat and camera are traveling together. I used a shutter speed of 1/250 second. If I wanted to "freeze" the ice, which was whipping by at 100 mph beneath the boat, I would have had to use a much faster shutter speed.

water, on land or in the air.

180 Mile-Per-Hour Tape—Hollywood believes in the stuff. When they were filming one of Paul Newman's racing films, 35mm motion-picture cameras were taped to the hood of the race car about to travel more than 180 miles per hour—and you can be sure those cameras cost more than your average SLR. Believe in it. You can find the tape in camera shops (gaffer's) and hardware stores (duct).

SHUTTER SPEED

Whenever you tape your camera to something that moves, consider wind and mechanical vibration. Unless you want blur for effect, a good ground rule is to set your camera at 1/500 second or faster for any subject that will travel more than 20 miles an hour. If you have to guess, it's better to be high than low because you won't be able to change the setting after you leave the equipment.

Don't use an aperture-priority automatic camera unless it has a manual override for the shutter-speed selection. If you leave it up to the camera, it's bound to prove its innate poor judgment when photographing action scenes.

conceivable calamity has already happened to me. By passing on the headaches and my solutions, you should be able to avoid some of them. Here is a potpourri of precautions, prescriptions, advice, tricks, warnings and innovations. Help yourself.

HOW TO MOUNT A CAMERA ANYWHERE

There is one product all sports photographers should know about. Claude Jewell, a professional sport diver and founder of the Illinois Institute of Diving, claims without hesitation, "Man's greatest 20th-century invention was duct tape," also known as *gaffer's*

tape, silver tape and *miracle tape.* He uses it for everything, from holding ripped flippers together and repairing torn wetsuits, to underwater camera connections. One person said Claude even used this tape to attach his trailer to a van when the hitch broke!

Jewell and I became friends instantly when he tossed me a roll of *black* gaffer's tape. He'd heard of my allegiance to the product, but until then my black cameras had been covered with the silver kind.

Believe It Or Not—Gaffer's tape will secure your camera to almost anything. It's waterproof, too. I've used it to attach expensive cameras to equipment that moves in

LIGHTING CONDITIONS

When using a manual camera for remote photography, lighting can be a problem. On consistently clear or cloudy days, one aperture setting should be sufficient. But when the lighting conditions are constantly changing, you have to use one setting and expose only when the light is acceptable for that setting. Or, use an automatic camera for sports photography and leave the manual one home. If you do not already have an automatic camera, consider one with shutter-priority mode rather than aperture-priority. For sports action, you want to choose the speed to suit the subject, and let the camera set the appropriate aperture.

Gaffer's tape will attach your camera to almost anything—on both land and sea. Note that the camera is in a waterproof housing in the shot at left. On the right, the crew is mounting photo equipment to the hood of the car.

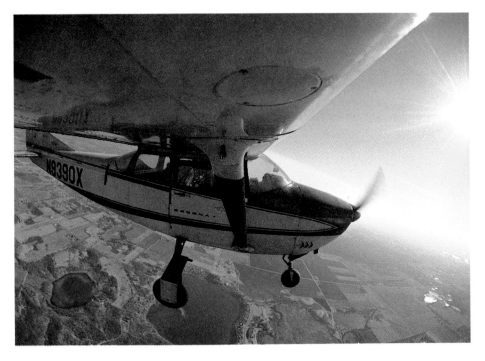

A drawback to using a manual camera in a remote setup is that it cannot adjust for different lighting—but that isn't always a problem. Automatic cameras, which can compensate for changes in light conditions, don't always make the proper settings. I was using an automatic camera on auto for these shots. Above: Because of the angle of the sun, the metering system overcompensated and underexposed the plane. When the angle of the sun changed, I got the exposure I wanted, although both are interesting photos.

Use An "Eye Patch"—When controlling an automatic-exposure camera from a distance, be sure to close the viewfinder cover. If the camera doesn't have one, block the light by taping over the viewfinder. Otherwise, light coming in through it can affect the camera's meter reading and cause the pictures to be underexposed. Normally, you have your eye up to the opening in the back of the camera so little light reaches the meter. When shooting with remote control, you are not there to block that light.

Don't tape over the eyepiece until all your adjustments are made. If you do, you won't be able to inspect the scene when you finish mounting the equipment.

THE BEST LENS

One more thing you won't be able to adjust is the focus. Therefore, the only type of lens that will work is a wide-angle lens that you've prefocused. See the section describing use of wide-angle lenses in Chapter 1.

BIG CAMERA COVER-UP

When you use a wide-angle lens, especially a super-wide an-gle, such as a 16mm, be absolutely sure that tape and wires don't show around the edges of the image area. One of the advantages of the Modulite Remote Control System is that it doesn't require wiring to operate the camera.

CAMERA PROTECTION

When you are not standing guard over the camera, there's always a chance that it can get rained on or dust-stormed, among other things. If there's a chance some nasty weather or environmental condition may "attack" your camera, protect it with an underwater housing, as discussed earlier.

CAUTIONS

When using any motor drive, remember that film is exposed rapidly. If you don't monitor use of it, you may run out long before you expect to. Under normal conditions, when you run out of film, it entails no more than an inconvenient reloading operation. But when you are separated from your camera, it means no more pictures. Don't be too trigger-happy at the beginning.

The first time I mounted cameras to a glider's wings, I was so relieved that the cameras had not been ripped off the wings by the time we were airborne, I started taking pictures while we were still in tow. When we started doing some exciting aerobatics, I discovered that I had long since finished both rolls of film.

Failsafe Insurance—The chance of electrical connections vibrating or being torn loose is a threat with many setups. The best kind of connectors for remote circuitry have locking screw caps. Other types should be checked for corrosion and cleaned with a pencil eraser.

Spread prongs slightly for a tighter fit. Connections that do not have locking screw caps should be fastened together with gaffer's tape to prevent accidental separation. *Test* all equipment before positioning it.

Testing—Make a couple of test runs from where you will be activating the camera before you leave the area. If you are too far away from the camera to hear it operate, ask a friend to stand next to it and listen, look at the lens to see if the diaphragm closes, or

This photograph would have been excellent if the tape I used to mount the camera to the board weren't showing in the upper right corner. Always try to look through the camera viewfinder before the action starts.

note the indicator lamp. Some of the more recent motor drive models, such as the Nikon MD-4, have indicator lamps that light up every time the shutter is released.

Don't Run Short—One thing many photographers don't think about ahead of time is remembering to count frames while they shoot. If you don't know how many pictures you've taken, you won't know how to pace yourself. And you may run out of film at the height of the action without even knowing it.

The best solution I have found is to take a handheld counter and keep score as I shoot. This system works great except for continuous exposures when I have to guess how many frames were expended during each burst. I usually tape the counter to the remote trigger button and push them both at once.

Film Ripper—One other precaution is the possibility of tearing film out of its cassette. Motor drives are more powerful than autowinders. Film is attached to the cartridge only by a piece of tape. Some drives can tear film off the spool if you continue to activate the advance at the end of the roll. This has never happened to me. If you're worried about it, check the instruction manual to see if the motor drive has an automatic cut-off switch. More on this later.

Don't Trust the Dials—When mounting the camera onto some-thing that moves, I tape all settings such as aperture and shutter speeds so wind or vibration will not change what I set up. This may not be necessary, but I don't want to find out the hard way that I *should* have done it.

MISCELLANEOUS TIPS

There are many different types of remote triggers available from camera manufacturers and independent companies. One wireless unit can be used from as far away as one mile. Carl & Phoebe Holzman's *How to Select & Use Photographic Gadgets,* published by HPBooks, lists a number of remote units. For more information, check with your camera dealer.

Extra-Long Film—If you are shooting b&w film, you might want to try Ilford's 72-exposure HP5 Autowinder film. Or you can purchase long rolls of b&w or color film for bulk-loading into special reusable cassettes available at your photo dealer. Some camera models also accept accessory backs for up to 750 exposures without reloading. This is a great advantage when changing film would be a major task. A photo of one of those backs appears on page 45.

Left: In an emergency, if you don't have an Ikelite or similar housing, you can use tape to protect your equipment. Here, the tape also assured me that my equipment wouldn't need a parachute. After securing the camera, I check the trigger mechanism by activating the switch and watching the shutter. This may "waste" a frame of film, but better that than coming back from a shoot and finding that the equipment didn't operate at all! Another thing to remember: Don't make the mistake of setting the camera for conditions where you mount the camera. Consider the type of conditions the equipment will encounter while you are making the exposures. Center: A good remote connector looks like this. It will have a metal locking ring that screws in place. You can use other types, but be sure to tape them so they will stay in place. Right: Clean corroded points with a pencil eraser. Don't use an ink eraser because it may scratch the polished surface of the contact points, which can cause additional corrosion.

HOMEMADE TRIGGERS

If you can't find a remote trigger for your specific needs, make your own. One camera-design engineer points out that once you understand that motor drives are activated by a simple switch that shorts the circuit, applications are limitless. Two wires plugged into the motor and crossed will activate it.

A Simple Remote Trigger— Here's how you can make a simple remote trigger. Splice a doorbell or other momentary switch to the end of a piece of wire. I use 18-gauge speaker wire that is good for about 60 feet. Maximum length for wire triggers is about 1000 feet. The length is limited because of internal resistance in wire. If you try to use two miles of speaker wire, the resistance would be so great it would short circuit itself and the camera would run non-stop. Of course, you could use a heavier gauge wire, but they all have their limits.

Purchase the standard connection cord made by your camera's manufacturer, cut the end off and splice it to the remote-control wire with the switch on it. There are other ingenious techniques for activating your camera without even using wire.

Garage-Door Opener— An item such as a household garage-door opener can be modified for use with a camera. Remove the receptor from the head on the motor and splice the output wires into the remote cord on your motor drive. Then use the wireless door opener to fire the camera. In this case, the switch stays closed until you push the button a second time, so the camera will expose in bursts rather than one frame at a time. Most remote garage-door openers are limited to about a half-block operating distance, but that is all you should need in some shooting situations.

Household Timer— Houses with light or heat timers can also provide camera switches. Again, steal the receptor from the lighting circuitry or furnace thermostat and

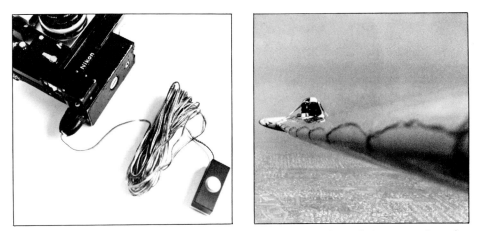

Left: This is my homemade remote trigger. I made it with 30 feet of stereo speaker wire and a doorbell switch. All connections were sealed with silicon caulking. It has worked faultlessly for several years. Right: When using a wired remote triggering system, you must remember to conceal the wire. Sometimes there's no place to hide it. In this case it didn't matter because the wire was out of the field of view of the lens.

plug it into your motor-drive wiring.

To find out which wires are the right two, connect the unit to the camera and systematically cross its wires until the switch activates. Join those two wires to the connecting prongs on your motor drive. Now the timer used to turn the lights or heat on automatically will activate your camera.

Darkroom Timer— These devices have many built-in capabilities because they have a pre-wired on/off switch. Again, locate the two key wires and attach them to your motor drive. You can use the clock to fire the camera when its time runs out or you can reverse the wires so the motor drive will run while the clock is on.

By rewiring the timer, you can set it up so the camera is triggered every time the minute hand makes a sweep, at certain settings of the hour or second hand, or in-between increments. For instance, you could have the switch closed every time the second hand passes a five-second mark.

Burglar Alarm— Burglar alarm systems can be borrowed for camera operation, too. Radio Shack sells inexpensive sonar detectors that activate an alarm system when a sonic beam is broken. You can also use an in-frared unit. Prefocus the camera in the direction of the sonic or infrared beam. The instant something interrupts the beam, the camera will fire. Such a system can be used for many sporting events in which the participants travel along prearranged courses, such as horse races or track-and-field events.

Electronic-Flash Slave— Another technique is to use an electronic-flash slave unit. Just mount the slave sensor on the camera hot shoe. Then splice the remote cord that normally connects the slave unit to the flash into the motor drive's remote cord.

There are two possible problems here. Because you use an electronic-flash unit to trigger this slave, the flash has to be directed so it won't affect the lighting of the pictures, or you should plan to take advantage of that light, along with the light emitted by the other flash units. And you must remember that the effective distance between the flash units will be reduced when using them outside or under other bright light sources. Test all setups.

These unconventional uses are only a few of the alternate switching devices you can dream up. Radio-controlled model-airplane receptors, electric-door openers,

HOMEMADE TRIGGERS

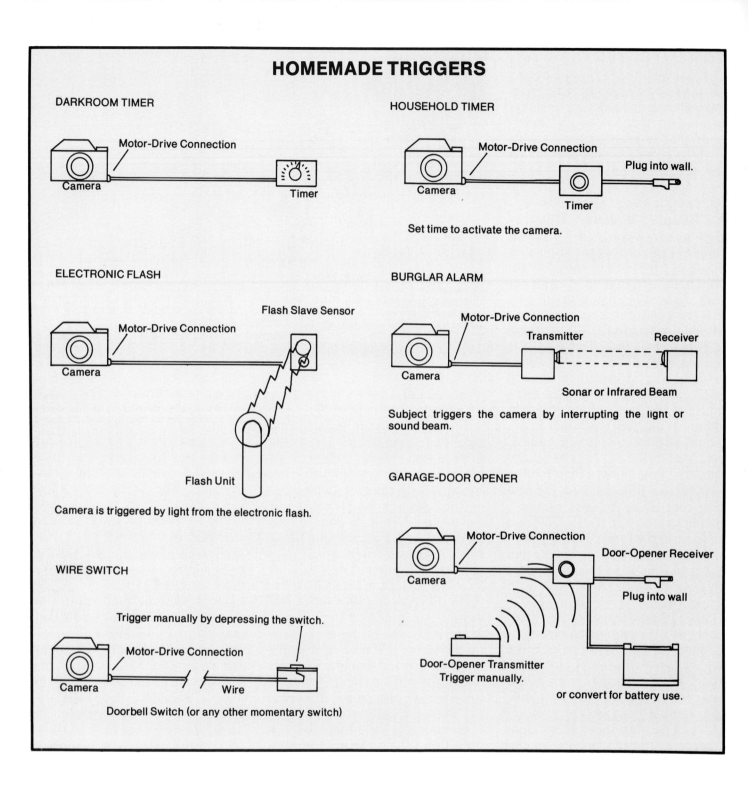

DARKROOM TIMER

Camera — Motor-Drive Connection — Timer

HOUSEHOLD TIMER

Camera — Motor-Drive Connection — Timer — Plug into wall.

Set time to activate the camera.

ELECTRONIC FLASH

Camera — Motor-Drive Connection — Flash Slave Sensor — Flash Unit

Camera is triggered by light from the electronic flash.

BURGLAR ALARM

Camera — Motor-Drive Connection — Transmitter — Receiver — Sonar or Infrared Beam

Subject triggers the camera by interrupting the light or sound beam.

GARAGE-DOOR OPENER

Camera — Motor-Drive Connection — Door-Opener Receiver — Plug into wall

Door-Opener Transmitter Trigger manually.

or convert for battery use.

WIRE SWITCH

Trigger manually by depressing the switch.

Camera — Motor-Drive Connection — Wire

Doorbell Switch (or any other momentary switch)

foot switches or even wind-up alarm clocks are other items you might try. The only requirement is that the device close a magnetic switch to complete or *short* the circuit. This entails buying the proper remote cord manufactured for your motor drive and splicing the wires into the receptor circuit of your alternative switch. You will then have a remote trigger.

Finally, these systems, at best, run on chance. It's a hit-or-miss proposition, so get ready for a lot of misses. Once in a while you'll get a hit that will make all the misses worthwhile.

A WRONG WAY TO USE A MOTOR DRIVE

Few tools are misused as consistently as motor drives. You would

not think of trying to pole vault with a bamboo ski pole, would you? Because equipment works best if it's used properly, you can get better pictures *without* a motor drive than if you are going to use that piece of equipment incorrectly. Here are some of the wrong ways to use a motor drive.

Firing Too Soon—Many people get trigger happy when they have

a motor drive in their hands. But potentially good pictures can be ruined by shooting too soon. For example, many sports move faster than the unit can handle. While filming skydivers, I set the motor drive at six frames per second and planned to shoot continuously when the divers were ready to let go. The shot I was looking for was the bodies of the three skydivers separated from the plane above 10,000 feet. I never got it.

When I looked at the processed film, frame number 4 showed the skydivers' hands letting go of the wing strut, and frame number 5 showed nothing but air. In one-fifth of a second, the divers moved completely out of view. All that was left was a blank picture of me staring out the airplane door. Even at its highest frame-per-second setting, the motor was not fast enough. But if I had slowed down my trigger finger and waited for the peak moment rather than just holding the button down, I could have stopped them in mid-air.

A week later, I went back to try again. This time I mounted the camera on the tail wing. I had learned my lesson. I shot judiciously, waiting for the moment the divers left the plane before getting the mid-flight picture I was after.

The key was taking well-placed single frames rather than machine-gunning it. Don't assume you'll automatically capture the peak action just because you fire continuously while it happens. You have to pick your shots just as much, if not more carefully, than if shooting individual frames.

OUT OF FILM

Unchecked rapid firing also results in a *film shortage*. Some motors can burn through an entire roll of film in less than four seconds. Be frugal with the exposures you make or you'll run out of film when you need it most. Those 36 frames can go by awfully

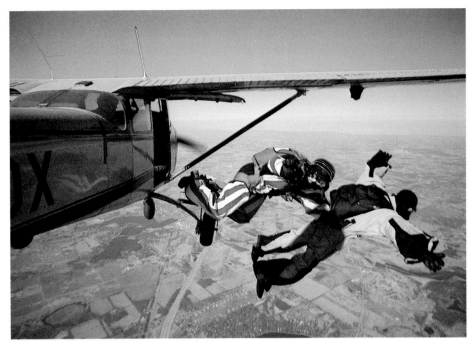

Although it can be a great asset, a motor drive is not always the answer. I was able to make the above photograph only by activating the remote on my motor-driven camera to make an exposure at the precise moment of fall-away. As you can see by the two frames below, when I depended on the motor drive to capture the full sequence at its six frame-per-second speed, it wasn't fast enough to catch the skydivers in mid air. They passed the lens between frames.

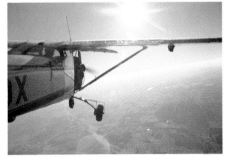

fast if you're making 10 exposures for every picture you want.

Sequence Or Viewing? — A widespread fallacy is that the foremost function of the motor drive is to make sequence exposures easier. Although the motor drive can be used effectively to capture series, its main purpose is to capture a sequence of events rather than a series of pictures depicting one event or action. If you don't make the mistake of reversing the order of importance here, your improved pictures will prove me right.

TRICKY LIGHTING

Changing light conditions trip up a lot of motor-drive users.

When the photographer swings his camera around, he is following the action and is usually intent on framing and firing, forgetting that lighting may be different when he changes viewpoint. It's easy to forget about making proper meter adjustments simultaneously, and takes a conscious effort, so think about it. In such a situation it helps to have a good automatic camera taking care of the settings for you.

BAD WINTERS

Like members of the Polar Bear Club who go swimming in the middle of winter and live to tell about it, you may get away with using your motor drive in winter.

If the temperature is above 0F (−18C), you probably won't have many problems. Below that point, watch out.

First, batteries die prematurely. Motor drives and autowinders are battery operated. Some have a remote power supply so you can keep the batteries next to your body where they stay relatively warm. With these, you run a wire out to the motor drive from the battery pack. It's also possible to have your camera modified by a camera repair center so it can accept a remote power supply.

Other problems caused by using a motor drive are static lightning streaks and film breakage. Because film becomes brittle when it is very cold, rapid transport by a motor drive may break the film inside your camera. Static electricity is generated by moving the film quickly through the camera in cold, dry weather. There are no remedies. The only solution is to leave your motor drive at home or take your chances.

When there is no way to get your pictures under arctic conditions without a motor drive, try this: Purchase a pair of electric socks and wrap them around the base of your camera. Fasten the socks together with gaffer's tape. Surround the camera back but make it so the tape can be slipped off easily for reloading of film. Although I haven't tried this technique, a friend tells me it works.

ABSURD DEVICE

Most motor drives are equipped with an automatic cut-off switch connected to the film counter. The manufacturers of this equipment believe that motor drives will rip the end of film out of its cassette without this automatic shut-off. Usually this is not so. In fact, I find this shut-off switch a big nuisance because it usually stops the film five or six frames short of the end of the roll.

To get around this, I reset the motor drive to 0 after the first five or six pictures. This "fools" the unit so it continues to advance the film until it reaches the last frame. After thousands of both commercial and bulk-loaded rolls, I have not ripped one off the cassette. As far as I am concerned, manufacturers should dispense with this worthless feature. There is no end to the trouble it causes.

Some time ago I was in Austria photographing skydivers in mid-winter. Four jumpmasters were making the attempt in the Tyrolean Alps. They all jumped at once. As they were making their approach, I noticed one chute was yellow and the other three were white. I wanted to get a shot of the yellow parachute passing in front of a giant, snow-laden peak. I had only one chance.

I checked and found that I had six frames left in my camera. No problem. I'd wait until he got into position and push the button. He came down exactly where I wanted him. I pushed the trigger and nothing happened. I knew the frame counter was the culprit, but by the time I set it back to zero, the skydiver was already on the ground. I had just one chance and the frame counter lied to me! Make sure you reset your counter early and keep a close eye on it.

FIVE-SECOND BATTERIES

Did you ever kill a brand-new set of batteries in five seconds? It's easy to do with a motor drive. Many units feature variable speeds from one to ten frames per second. Each motor-speed position is limited by camera shutter speed. If you accidentally set the shutter speed below the designated minimum, you may jam the camera.

The least damage you'll do is wear out the batteries before you finish one roll of film. Look up the specifications for your equipment and memorize them. Some photographers like to attach the chart to the back of the motor so they always have it in sight.

COMPOSITION WRECKERS

Motor drives also make great composition wreckers. Because the motor drive enables you to follow unbroken action, it's easy to forget about careful framing. The rationale is something like this: "With all these pictures, I ought to get something that looks good." When you're taking one picture at a time, the individual frame seems to carry more importance, demanding greater attention to details. If you're using your motor drive correctly, every picture should have equal importance and deserves appropriate attention.

Someone once told me a photographer is only as good as his equipment. But I prefer to believe it's what you do with what you have, more than the kind of equipment you own.

For instance, I saw some color prints that were supposed to have been taken with a 110 pocket camera. They were beautiful! I refused to believe they were made with that type of equipment. The owner explained that because pocket cameras generally have a 1/60-second shutter speed, the lack of sharpness in most pictures shot in the 110 format is due to camera motion. This is the fault of the photographer rather than the equipment.

He mounted his 110 camera on a tripod, taped a plunger to the shutter button to minimize camera shake, and held a polarizing filter in front of the lens. He made beautiful pictures that were difficult to believe.

Of course, even with superior equipment, you won't make good pictures unless you know how to get the most out of that equipment. When you learn how to exploit your camera's features and overcome its shortcomings, you'll be ahead of the crowd that just points and shoots. What's more, you'll be hot on the heels of the established pros.

4
Photographing Sports

Every athlete knows that different sports require different equipment and techniques. Some natural athletes can excel in almost any sport, but some, such as professional golfers, could probably not play professional football.

It's no different for the sports photographer. You need an assortment of equipment and different shooting techniques for different sports. Sure, it helps to be able to focus fast, but that's no guarantee you can walk in on a sport and document the best of it on film. First you have to learn the rules and pay your dues.

It takes time to learn where the optimum shooting positions are, what lenses you need, what film is best and proper use of lighting. You also pick up inside tips along the way. For example, if you want to photograph all aspects of a baseball game, you'll find that you should use three cameras with prefocused lenses.

It would take decades of hard shooting to learn the requirements of every sport and pick out the do's and don'ts on your own. I'll save you the time and exasperation by pointing out the basics and lessons I learned the hard way. The following vignettes are not meant to be exhaustive studies of the photographic requirements of each sport, but rather a guide to a better start, pointers in the right direction and some warnings.

I made this shot from the sidelines using an 85mm lens, a useful lens from this vantage point.

FOOTBALL

To photograph football, you can't just pick a spot and set up your equipment. The players cover a lot of territory. You seldom shoot from the same spot for more than a few minutes. When preparing to shoot a football game, you must select the proper equipment—not more than what you can carry and use at one time—and arrange it so you can get to it all quickly and easily.

Equipment—You need several lenses of different focal lengths. Action on the far side of the field requires at least a 200mm lens. Downfield plays require a lens in the 300mm to 400mm range. Action in the end zone calls for a short telephoto of 85mm to 135mm. Using two or three camera bodies eliminates the need to change lenses.

If you have only one camera body, you can still get good shots

With the help of a motor drive, I photographed the ball just before it reached the receiver. You don't need a motor drive for such moments, though, and sometimes you may not get the shot you want, as I mentioned last chapter. Without this accessory, you have to concentrate more, anticipate the action and release the shutter at the right time.

If you memorize jersey numbers of favorite receivers, you can anticipate who will be in the middle of the action. Here it was easy: I knew that whenever Number 34 was on the field, he would carry the ball. Remember: If you see the action you want in the viewfinder, don't shoot. Save your film because you've already missed the shot.

by predicting the plays. For instance, if it's second down with only a few yards to go and you expect the play to go right up the center, you can stand on the scrimmage line and use a 200mm lens. If a favored receiver moves to your side of the field just before the play, you can switch to the short telephoto and follow him as he breaks for the pass.

Because you'll only get one chance to get that shot as the ball reaches the receiver's hand or right before the quarterback gets hit, you have to *anticipate* the peak moment. This type of photography is a lot easier if you have a motor drive.

A monopod is a good accessory if you're using a lens with a focal length longer than 300mm. There usually isn't room or time to set up a tripod, and the monopod allows you more mobility. You can also mount the monopod to the camera and leave it there for stability during action shots.

When carrying three or more camera bodies, hang them so they're out of each other's way and yet can be brought into play easily. I like to arrange the equipment with one camera body and a short-focal-length lens carried high on my chest and a second body on a longer neck strap hanging below. I hang the third and fourth cameras on each shoulder so they don't bang against each other.

Because you can't leave gear around as you move up and down the field—unless you have a trained watchdog to stand over your unused equipment—you must devise a method of *carrying everything,* including film, filters, extra batteries, and odds and ends.

I take a small daypack and fill it with all the paraphernalia. A hip pouch is convenient for toting film and a few lenses. One of the best commercial pouches I've come across is Camp Trails' Fanny Pack, available in camping stores or from the supplier, listed in the Appendix. It has pockets for three lenses, one camera body and film. The inside compartments are removable.

Preparation—Prepare a game plan in advance. List the types of shots you want, individual players to spotlight and specific action to

Most of a football player's face is covered with protective gear. As a result, you need as much light on his face as you can get. Catch the player when he is facing the sun. Even then, you have to watch for the angle of the sun. At right, the player's helmet creates a shadow.

record. Familiarize yourself with team members so you know which carrier has the most yardage and who has the most take-downs. Memorize uniform numbers so you'll know where your subject is and can point the lens in the right direction.

Best Position—In football, where you position yourself is important. You have to understand the game to know where to stand. Your best bet in the grandstand is between the 30-yard line and the end zone, as close to the field as possible. When shooting from the grandstand, you have to wait for the action to come to you. Then you can "tackle" any play that comes to your end of the field.

Like the defensive team, you have to predict what play the offense is going to run. If you foresee a long pass, you have to move down the field away from the line of scrimmage. If it's a blockbuster, you must stay close. For a quarterback pass-off, you have to stand backfield a bit. Behind the goal post is the best place to shoot endzone action.

Lighting Tips—The sun is usually slightly to one side, depending on the layout of the field. You can shoot the whole game from one side. Occasionally, for a different effect, you may want to switch sides and shoot into the sun for a backlit image, but most of the time you'll want the sun over your shoulder.

It's hard enough seeing the players' faces behind their face masks under ideal lighting. If you "kill" your light source, it will be impossible. When the sun gets low in the afternoon, side lighting can create a much more pleasing effect than the harsh overhead light of midday.

One thing to consider: During football season, the days are relatively short. As the sun sets, it may create a dark shadow across the field. If you think this might happen, get all the pictures you need early in the game. Don't save your creative shots for the

This classic shot of Y.A. Tittle made by Morris Berman would never have been made if the photographer had been concerned exclusively with action. Remember to watch all areas around the players. Very often the most interesting shots are made away from what everyone else considers the center of activity.

last quarter. For night games, use a high-speed film such as Tri-X or Ektachrome 400.

Picture Ideas—Don't limit yourself to the stereotyped action shots everyone else makes at football games. Between plays or time outs on the field, shoot the kicker practicing his punt, a frustrated coach, the cheerleaders, a dejected player, an injured star on the bench, the excited crowd, and all the secondary action that takes place behind the sidelines.

A good place to get closeups of the individual players is in the bench area when they're discussing logistics.

When the action moves fast, you can't always plan your shots. I don't like the depth of field here. It is so great that the background is hard to separate from the foreground.

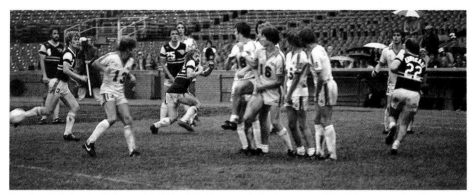

You have to know the game to shoot it. For example, for a penalty kick, no one is allowed to block the kicker. So, the best place to aim your lens is down the field where the ball will end up.

And don't forget about the cheerleaders. Whether they're leading a cheer or watching a play, shots of them will add to the story about the game.

Although it will take 1/500-second shutter speed to stop most of the action, don't be afraid to use 1/60, 1/30 or even slower to show the dramatic motions of a forceful game. For these slower speeds, I suggest you use a monopod or tripod. Take chances and use a few extra frames of film. The results may be worthwhile.

Your tendency will be to follow the ball whenever it's in motion, but there are many individual confrontations that are just as exciting as the action where the ball is. For example, isolate the linemen battling it out or a halfback holding two defensemen off the quarterback. The possibilities are endless.

SOCCER

Soccer players travel rapidly down the field, even faster than football. You have to keep all your equipment handy and arranged so each piece is easily accessible. The best preparation is to become acquainted with the sport. Know what the referees' calls mean and what happens during penalty or corner kicks.

It also helps to know what each player's responsibilities are. For instance, halfbacks and fullbacks normally get the ball out of their own territory by booting it downfield, whereas linemen generally take the ball and dribble with it, passing it back and forth. Knowing this, when you see the ball heading toward a backfield player, you know it's bound to come back to your end of the field, so there's no need to race down the sidelines after it.

Equipment—The action in a soccer game changes quicker than any other field game. It's hopeless to think you will be able to change lenses fast enough. The only solution is to carry as many different lenses as you have camera bodies and become adept at putting them into play.

Isolate individual players from the game if you want to do portraits. And while you and the goalie are waiting for the ball to come back downfield, try a different angle. Note how the horizontal lines from the goalie cage point toward the goalie. Many people think that sports and action photographers do not have to follow the rules of composition. A photograph like this one demonstrates how much planning composition actually helps the image.

Again, a motor drive will make it easier to shoot this sport. Lenses from 28mm wide angle to 400mm telephoto or longer can be put to good use.

Where to Stand—Positioning is tricky with soccer because there's no feasible way to keep up with the ball as it travels from one end of the field to the other. If both teams are evenly matched, you're in trouble.

Most of the time, however, one team will monopolize the ball and keep it at the opponent's side of the field. Stay there and concentrate on the plays that develop there. You'll need a 200mm lens to follow action to the far side of the field, and an 85mm telephoto or 28mm or 35mm medium wide angle, depending on how close the action comes.

Often the battle is between two players. Isolate them with your longer-focal-length lenses. Any time the ball comes near the end zone, and especially during corner and penalty kicks—where you get advance notice—you can move into a good position on one side of the net and catch the furious action in front of it.

When shooting from the sidelines, leave a two- or three-foot clearance so the sideline referee doesn't get a 600mm lens in his ear.

Different Shots—Like most ordinary pictures, the typical soccer photo is shot from eye level. Soccer is a foot game, so try some ground-level pictures emphasizing the game from foot level. When the ball is kicked high, figure out where it will land and prefocus on the two players, one of whom is likely to head the ball as it returns to earth.

Don't attempt to follow the ball through the air because you won't be able to release the shutter in time when the ball meets the heads. It's better to pick out the head-men. When they go for it, so can you.

For another creative angle, shoot from behind the soccer net

as a play materializes nearby. Or you can concentrate on the goalie as both of you wait for the ball to return.

Soccer entails a lot of subjective referee calls that generate hot tempers. Have your camera ready when, as always, the team captain and ref start screaming at each other.

CAR RACING

Arrive early at the racetrack and walk around the grounds. Pick out the best angles, such as the tightest curves where problems may develop, and high spots that will give you an overview of the track. Then you can decide which lenses you'll need from what positions.

An advantage is that the drivers generally are given warm-up practice time. In some of the more important races, an entire day may be spent on time trials. These trials offer you a great opportunity to test camera positions and equipment, and practice focusing skills.

Plan of Attack—The first thing to do is pick up a map of the track so you can see the layout and can pick the best locations in advance. If you arrive early enough, you may be able to walk the track like many of the race drivers do before they race on an unfamiliar track.

To find a unique angle, seek out places where none of the other photographers are standing, such as this run-out through the bales of hay. Maybe there was a reason why no other photographers were standing here?

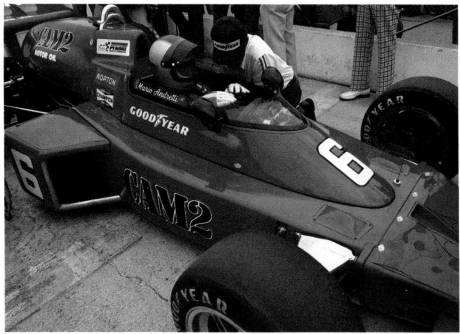

With a pit pass, you can get really close to the cars, drivers and mechanics. The best lenses to use in the pit area are an 85mm for closeups of the drivers and a 24mm wide-angle when you want to include the whole car in the frame. Although a low angle generally emphasizes the car, sometimes you may shoot down on the car to cut out unwanted background.

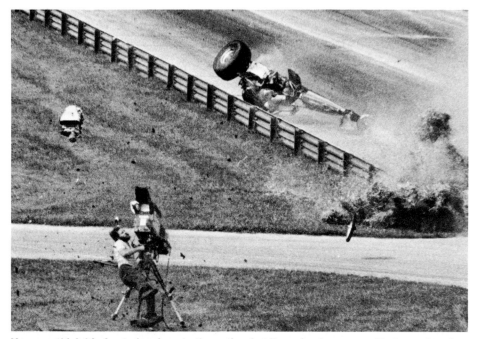

You may think it's fun to be close to the action, but it can be dangerous. Photographer Joe Rooks was killed when a 300-pound piece of a disintegrating dragster struck him while he was filming the scene for television. Be aware of everything going on around you while you are looking through your viewfinder. Photo credit: World Wide Photos.

Then check the schedule of events so you will know when each heat begins. When choosing events to photograph, give yourself time to relocate between races.

Check with track officials to see if there are restricted areas. Often you are allowed greater liberty "at your own risk" than you might expect.

Pick up a list of drivers. This will enable you to match up car numbers with race drivers when you are sorting your pictures later. Most racing events last all day, so when preparing your game plan keep in mind the sun's position as it travels across the sky. You should plan to be at a good angle for each location throughout the day.

Once the day's activities begin, the sidelines may get crowded. Have several alternate shooting locations in case you can't work your way close to the track in the middle of the race.

At some racetracks, such as drag strips, pit passes are available to anyone who pays an extra fee. This helps because you can shoot close-ups of the cars, mechanics and drivers while they are working on their machines. Get tight shots of the autos and the men who drive them—both have a unique character. It's much easier to move around the pit area during time trials because there aren't any crowds and the drivers and the teams are more relaxed.

Revving Up—When preparing for the race, take adequate protection for your cameras and yourself in case the weather turns sour. At some tracks, such as Road America in Elkhart, Wisconsin, you can drive your car on the inside track from one position to the next, so weather is of little concern. But if you have to hoof it, take along a poncho or some sort of rain gear. You never know what may happen above you.

Because all races follow a well-defined track, the action is generally repetitive and easy to predict. Simply line up the shot you want and when you and the racers get into the preplanned position, release the shutter. If you miss, you normally get a second try moments later.

Some photographers carry a spare camera body with a wide-angle lens in case some fast action explodes in front of them and they don't have time to focus or make quick adjustments. Your best bet is to keep your eyes open and be prepared.

Cautions—A racetrack can be a dangerous place. It's easy to get caught up in the excitement while looking through the camera viewfinder and lose contact with the high-speed machines out of control behind or around you.

Several years ago a press photographer made a photo sequence of a TV cameraman filming at the edge of the racetrack. A car spun out of control behind the camera operator, hit the guardrail and blew up. The tragic explosion sent a 300-pound air blower hurtling through the air toward the unsuspecting film maker. The photo sequence shows the blower flying at the photographer and knocking him down. In the last picture, the TV camera hangs motionless, aimed toward the ground; the cinematographer died.

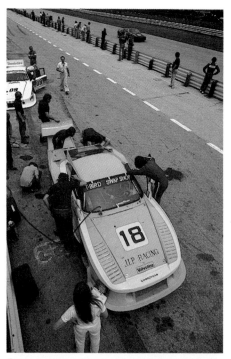

Spend some time wandering around the track so you know where the best shooting positions are. For this shot, I climbed on a roof and shot back down onto the pit to give an overview of the working area.

Racetrack filming can be risky. The best precaution is to position yourself so the action is always coming toward you rather than from behind or the side. While changing film, making camera adjustments, or when your attention will be on something other than the action around you, retreat from the firing line.

Creative Shots—Picture possibilities at the racetrack are endless. Although most photographers stay at home on rainy days, races in the rain are great for mood shots. The motocross racer, with his helmet and face covered with mud, the stunt car surrounded by a wall of water, and a roadracer coming out of a misty haze are unique breaks from the routine summer-sunshine shots everyone makes.

Try to find a different position, such as from a tree looking down on the track; shooting through the bales of hay at the end of a run-out zone; or a close-up of a driver with his hand gripping the steering wheel.

Find out in advance where accidents occur most frequently, which straightaways are the fastest, where the pile-ups begin. You can get a lot of this information from local speed shops before you even arrive at the track.

Plan your backgrounds. You have plenty of time before the race to pick out what you want to show as backdrops. A blurred time clock or green foliage can add interest to the picture or can accentuate the racers.

Shoot from different positions to use natural lighting to your advantage—such as sunlight streaking through the dust. You can set up a variety of back and side lighting conditions simply by changing your location. The racetrack has enough repeat action that you can experiment with different shutter speeds and creative angles and never run short of action or subjects.

RACQUETBALL

Racquetball is both easy and hard to photograph. With a few tips, you can overcome most of the difficulties. First, find a court with glass walls or special viewing areas—unless you want to stand inside with the players and be served a 180mph piece of rubber.

With a glass-walled court you can stand behind either side wall

Anyone can take snapshots of machines moving around the track, whether they are full-sized or sprint cars, bicycles, motorcycles. There are even plenty of opportunities at soap-box derbies and the like! Try to do what no one else has done before. Shoot from a different angle or use different equipment. Zoom in on a moving subject while the camera shutter is open, make long exposures and intentionally move the camera, or get up really close for an unusual perspective. "Creative distortion" is allowable if you are controlling it. Photos on this page by Candee Associates.

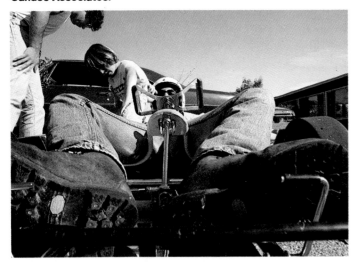

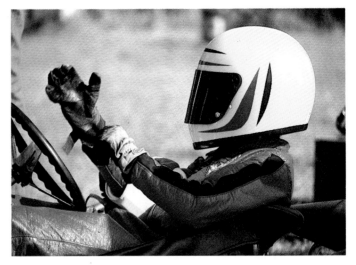

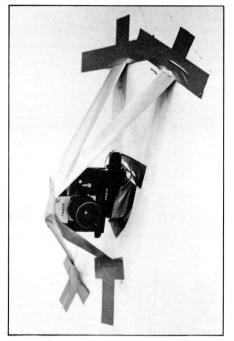

Although the easiest way to shoot racquetball is through the window on a glass court, there are alternatives. I have taped a motor-driven camera midway up the court wall and fired from a safe distance. On one occasion, the ball hit the camera, but it held firm. (You can see that trusty gaffer's tape again!) I was glad my face wasn't behind the camera. All of these racquetball photos were made under low light conditions, and enlarged. As a result, they are grainy. But they still show the action of the sport effectively.

When photographing racquetball, all you can do is pick a spot and wait for the action to look interesting. Of course, by the time it does looks interesting, you've missed the shot. I watched an excellent swing here and released the shutter—the ball is out of the shot, and the swing has been completed. As with most other action sports, you must *anticipate* the action.

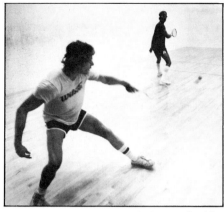

The ball is just a blurred dark spot in this picture but the blurred image is enough to give it life. I shot through a glass rear wall.

and get close-up action of both players working the ball off the walls, or behind the far wall where the players always face. The best angle is a low one, which exaggerates off-the-floor action.

Equipment—Minimal equipment is required to photograph this sport. Because racquetball is played indoors under fluorescent lighting and is a high-speed activity, fast film is a necessity—at least ASA 400. If you use daylight color film, you need an FL-D filter to balance the film with the lighting.

The other option is to use electronic flash. This will work well when you hold the camera and flash up against the glass. The light burst from the flash will freeze the action—but check with the team management and players first to make sure the light will not interfere with their play.

An 85mm lens is ideal for racquetball. You can also use a 50mm or wide-angle lens. You'll only need one lens at a time. Action is continuous enough that you can change lenses easily without missing out, so one camera body is sufficient. Multiple lenses are used for perspective variety rather than to capture different plays. You can easily carry extra lenses in a hip pouch along with film, batteries and filters.

A motor drive is helpful because peak action is fast, and keeping

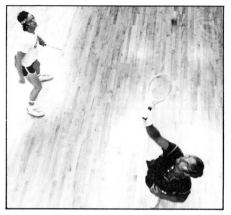

Although the balcony creates a nice change of pace for your photos, it's hard to catch both players doing something besides showing you their backs.

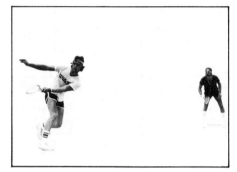

I made this shot from the front corner of the court using a 50mm lens and Tri-X film. It lacks impact because the ball is out of sight and because the two players are so far apart.

your eye to the finder is a definite asset.

Picture Ideas—Don't take your eye away from the finder when the action stops between plays. That's when emotion usually erupts. Be ready to catch the frustration or look of victory on competitors' faces.

If you wait long enough and find the right position, picture ideas will come to you. The antics that racquetball players go through while playing the game present a never-ending opportunity for fresh photo material.

One of the challenges is to catch the ball in mid-air, next to the player's racquet. The ball moves fast and you won't see it go by—but you can judge its location by the swing of the player's arm. The ball is almost always hit at right angles to the body. Hold

your fire until the arm passes midway—the ball will usually show up on film.

The most dramatic angle is when one player is in the air or close to the wall, with the other fading out of focus into the background. Experiment shooting through the side glass when players lunge toward it, reaching for the ball. Another shooting position is from the balcony looking straight down on the players.

Racquetball is a fast-moving game and you are bound to miss many of the key plays you go after, so take a lot of extra film—and use it.

BASKETBALL

Basketball is another sport in which you can't follow the ball. The best alternative is to pick the favored team and stay under their defending net. The ball usually travels rapidly without much interference until it gets under a basket.

Equipment—Planting yourself at one end of the court means you cannot take pictures at the other end, so the longest lens you will need is a short telephoto. I like an 85mm. For different shots, you may want to try a wide angle, such as a 28mm, to include the players, crowd and stadium lights above.

A motor drive is a necessity for shooting this sport. A single body is all you'll ever be able to use.

Positioning—You will miss a lot of action if you stand directly under the hoop. A position slightly off to one side allows you to get head-on shots, layups, rebounds, pass-offs and all the fast action under the net.

Lighting Conditions—Use a fast film such as Ektachrome 400 that is high-speed and balanced for

Right: If you sit on the sideline, you can get good shots of action under the baskets. Position yourself to one side of the basketball net when working close up. Otherwise, the referee standing near the basket may block your shots. Note the look of tension and anticipation on the face of every player in this shot. "Will the shot score?" Photo by Keith Olsen.

Below Left: Here, I wanted to include the playing area and its surroundings. I knew the floor would be mopped during halftime, so I waited until the beginning of the second half for this effect. A 24mm lens gave the wide field of view I wanted.

Below Right: The rule that the basketball should be included in the picture can be broken if the action or expressions are dramatic enough.

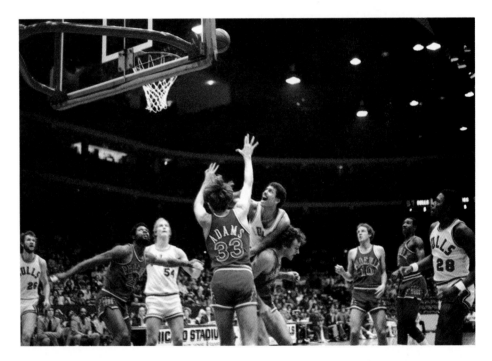

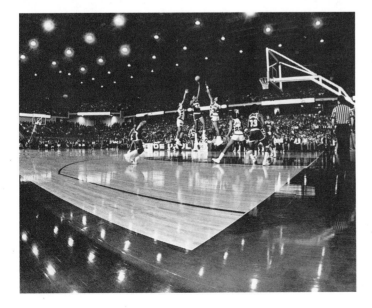

Because you'll generally be sitting at one end of the court, most floor action will come straight toward you. You must know how to *follow focus*.

Most telephoto lenses do not have a large enough aperture to be used for action sports under available light conditions. My 200mm lens, wide open and shooting at 1/125 second shutter speed, was not able to freeze this play.

tungsten lighting. This will give your photos a natural look.

Or, you may be better off with flash. Use a bracket to mount the flash unit off to one side of the camera. This creates a modeling effect. The flash will override the house lights in close-up shots, so you can use any daylight-balanced film. Check with the management of the facility before doing flash photography.

If you decide to use high-speed film and the house lights, you need a lens with a maximum aperture of at least f-2.0 to keep the

shutter speed fast enough to stop the quick action.

Techniques—When you're using a short telephoto, accurate focusing is critical. Most of the time, the players are moving toward you. Focusing on this type of action is difficult at best. Their rapid movements won't leave you much leeway for error. One thing you can do is get to the facility early and practice focusing on players doing layups and drills before the game begins.

Unique Shots—Neil Leifer once said of his well-known picture of the Boston Celtic and Chicago Bull captains shaking hands, "Good sports photography is usually the result of careful planning, good luck and good execution. This picture is a testimonial to none of the three."

Leifer had positioned himself on the catwalk directly above the basketball center court with the intention of catching the two players lunging upward for the ball at the opening of the game. When they shook hands he clicked off a few pictures just to check his focus. One of those practice pictures became more popular than the one he had intended.

For unusual pictures, find a spot in a balcony or above the basket and shoot straight down on players going for a layup. Another angle might be to use a long-focal-length lens and shoot the play coming at you from the other end of the court, with the crowd in the background.

Using your long lens, catch the grimaces that go along with flailing elbows during air-to-air combat under the net. Lie on the floor and, with a 20mm super-wide-angle lens, shoot between a player's legs as the ball flies at him.

Your reflexes are important in this sport because you generally don't want pictures without the ball showing. Push the shutter button just as the ball is released. If you're late, all you'll get is a pair of empty hands.

TRACK AND FIELD

Trying to explain track-and-field photography is like telling someone how to be a one-man band. There are so many things going on at a track-and-field meet, that each one could be a photographic specialty in itself.

For instance, you may want to use a 35mm wide-angle lens and stand directly in front of the sand trap, shooting toward the broad jumper as he hurls himself in your direction. But you may not want to use the same technique in front of the javelin thrower. Some events like the pole vault can be shot without a motor drive, but you'd get dizzy trying to figure out when the discus thrower is going to stop spinning and let 'er rip unless you have a motor drive.

The *biggest problem* is that there are always so many events going on at once. You will never be able to cover everything at one track meet. Choose those events that interest you most and cover them well. Go back again if you want to photograph other events.

Game Plan—Spend extra time on a few events, rather than trying to photograph them all. The more time you spend in one place, the more ideas you'll develop. For instance, in the hurdles, instead of shooting the typical stock photo of runners clearing the last jump, move around to the side and get a row of them arcing over one hurdle in unison.

Or, position a camera directly under a rail and use a remote-control device to fire the camera as the athlete sails over top. Or, lying on the track, shoot through the long tunnel of hurdles toward the runners coming off the blocks.

Sometimes the races are set up so the finish line is in front of the bleachers. Position yourself there and reap the ends of all races.

Beating Authority—Most track officials will work with you. Usually they will allow you to place a camera in some out-of-the-way place as long as it's not likely to

cause injury to one of the competitors. But check with an official anyway before you tape a camera to a runner's track shoe.

Some people in positions of authority are like fishermen. Among their other duties, they look for something to catch. Track officials check anything that appears unusual—innocent or not—for no other reason than because it looks different. And once they say you can't do something, it's harder to get them to change their mind than to "look the other way" at the outset.

Equipment—Depending on the events you choose to photograph, you'll need lenses ranging from 15mm to 1000mm. Use your imagination—and equipment you already own. For most events, a motor drive will help capture the peak action. If you have a remote-triggering device, take along a large roll of gaffer's tape to secure the camera to unusual locations. Remember your monopod or tripod, too. Keep all your equipment mobile because you will be moving from one place to another.

Shooting Tips—Unlike other sporting events, familiarity with each track event is not essential. Most field events are repetitive. Each contestant performs individually, and group matches are often held in heats. Once you see the first performance, you know what the next competitors in the same event will be doing.

Plenty of creative picture opportunities exist at track-and-field meets. Choose which details most accurately describe the feeling of the competition. For example, in a running event, you may want to emphasize the ground level by lying flat on your stomach and shooting up at the runners, or moving in close to get a maze of track shoes kicking dust.

At indoor meets, if there is a balcony or catwalk, position yourself directly above the participants. From such a position, you could use a telephoto lens to

focus on a high-jumper lunging upward "toward" you.

You may want to stand next to the track and, with a short telephoto, focus on the facial expressions of sprinters charging across the finish line. Remember: At track-and-field meets, you have plenty of variety. Concentrate on isolating and framing the most important moments for the best pictures.

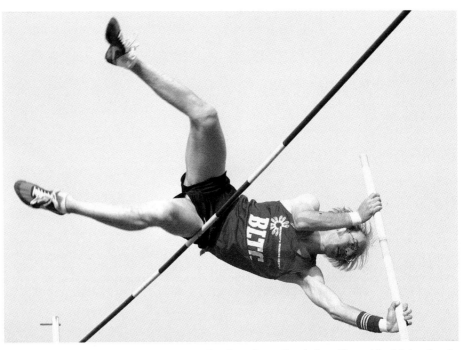

Prefocus when you can, so you are ready when the action brings the subject into view in your viewfinder. Here, I focused my 85mm lens in advance on the horizontal bar and when my subject passed over it, I released the shutter.

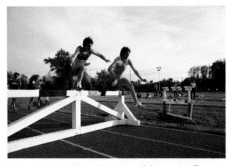

Try various shooting positions until you find one that captures the feeling of the event. Here, nothing seemed to work until I sneaked onto the track itself. One of the runners almost used me as a hurdle. I don't like the background clutter, but had no other choice at the time.

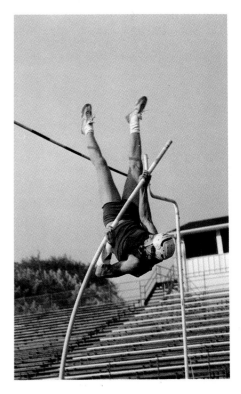

One reason pole vault is difficult to photograph is because the jumper's head is often turned or in shadow. The hardest part of getting this shot, which is part of a sequence, was keeping people from walking in front of me while my subject was making his attempt.

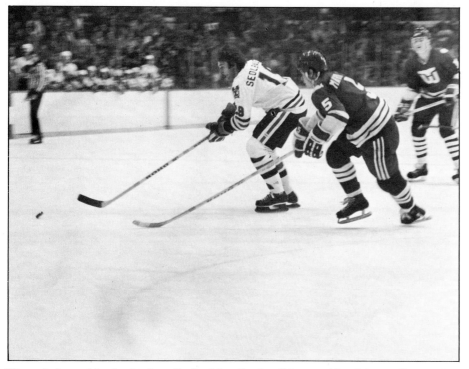

When photographing ice hockey, the best location is off to one side of the goalie cage because that's where most of the action occurs. Try to shoot from ice level so you don't have to worry about distortion or losing parts of heads. Because of the speed of the action, you'll rarely get hockey players and the puck in the same frame.

ICE HOCKEY

Hockey is a tough game to shoot. The action is fast, lighting is often tricky, shooting positions are inadequate, and you must rely on luck more than anything else to put you near the action. There is no way to predict where it will happen.

Best positioning is in seats just above the glass near one end of the rink. Most of the activity will be concentrated around the goalie net. You'll see the players' faces better from just off to the side, rather than directly behind the net. Additionally, it's easier to keep subjects moving diagonally in focus than head-on action.

Naturally, if you obtain a press pass, you can shoot from ice level. This may or may not be an advantage because you will still have to pick one spot and wait until the action comes to you.

Equipment—A motor drive is helpful but you will only need one camera body. Your location will dictate the lens focal length you need—and that's about all you'll be able to use from that position. If you can shoot from ice level, bring an extra body with a 28mm lens, in case some action occurs nearby, such as a player being checked against the glass in front of you.

If you don't have an extremely fast lens, you will need a monopod and fast film.

Lighting—Check the house lights ahead in advance to see if they are balanced to daylight film or tungsten so you can use the correct film. If you're near the ice and the players come close enough to you, you should be able to use flash with a guide number of 80 or more. However, when using flash, do not shoot through the plexiglass; the reflection of the light in the glass will appear in your picture unless the camera is against the glass.

Professional sports photographers often set up intricate lighting systems around the rink. They do the same with remote-controlled cameras.

One *Sports Illustrated* photographer talked the management of a rink into allowing him to position a camera in the back of the goalie net. It is still "off-the-record," but at one point during the game, one of the referees saw the round, black lens poking through the net on a close call and scored it a goal when the puck actually ricocheted off the outside edge of the net. It never went in. To the relief of the photographer, no one ever said anything to him about the mis-call.

Most of us will have to survive with the position we get and the lights that come with the facility.

Fresh Ideas—The face-off, with both centers trying to get to the puck first, is a good start. Keep the lens aimed at the goal box— you're bound to get frantic struggles of goalies and forwards fighting for a little piece of black rubber. The puck might be in few of your pictures, but it isn't always essential.

The excitement in hockey is the *confrontation*. Don't even try to follow the puck or the action with your lens. Your best bet is to eyeball the field and pick out isolated incidents to shoot when they are close enough. These may not coincide with the location of the puck. For example, fistfights often erupt after the puck is long gone from the area.

Keep watching the action, with the camera ready at all times. Don't forget the sidelines. If you can catch team members in the box yelling at the ref or at their own team members, you may have some great shots.

SHOOTING FROM THE GRANDSTAND

Many people think the only way to get good sports photographs is from the field. Because it is difficult to get press passes to major sporting events, many don't even try to take pictures. On the contrary, excellent sports photos can be taken from the grandstand if you are properly positioned and prepared with the right equipment.

A *monopod* is a must. You will

generally need a long telephoto lens to shoot from the grandstand, so handholding the camera is impractical—but there is not enough space in most grandstands for use of a tripod. The monopod can be used almost anywhere.

Good tickets should get you closer to the action. And sometimes you can "shoot over the shoulder of the pro."

BASEBALL

Press boxes on the baseball diamond are located opposite first and third bases. No photographers are allowed on the baseball field during play. But if you can get a seat behind either one of the boxes, you will have a vantage point similar to the pro. Another good position for shooting baseball action is directly behind home plate, in line with the umpire, batter and pitcher.

Baseball photographers prefer the 300mm lens, but 200mm, 400mm and 500mm lenses also work well. If your seat is located farther up in the grandstand, a 500mm lens is about the shortest lens you will get away with.

FOOTBALL

Get a seat as close to the sidelines as possible. Use a 300mm or longer lens. You'll have to wait for the action to come to you. Then you can tackle any play within range. Two favorite positions are on the sidelines about midfield and anywhere along the end zone.

BASKETBALL

This sport is a little tougher to photograph from the grandstand because lighting is poor and the angle from above, looking down on the players, is not the best perspective. But good shots are still possible if your seat is located near the floor. Most action occurs under the baskets. Try to sit near one corner of the floor rather than directly behind the net. Then you will have a better angle of view. From this position, a 100mm or longer lens is effective.

TENNIS

The two best positions at tennis tournaments are either parallel to the net where you can get both opponents in the frame, or behind one court. From the net, a stan-dard lens or short telephoto, such as a 90mm, is usually adequate. Shooting from back-court, a 200mm or longer lens is needed to bring in the far player.

ICE HOCKEY

Ice hockey requires a 100mm or longer lens. The action nearest you can be filmed whenever it occurs. No one position is better than another at the ice-hockey rink, so pick a spot and wait. Sometimes you can walk up the aisle and kneel down in front of the plexiglass.

Hints—When you cannot get adequate coverage from your seat, move into the aisle or near a gate where you won't block other spectators' views. Although it is not always permitted, you can often find a better position by walking to the end of an aisle or near the fence. Take advantage of it when you can.

Watch Out—There will be many eyes watching you and that "bag of gold" parked between your feet. Assume that no one is

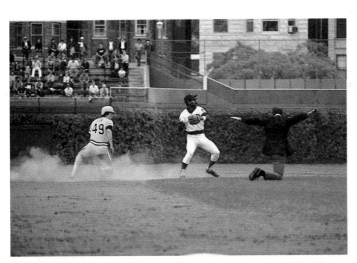

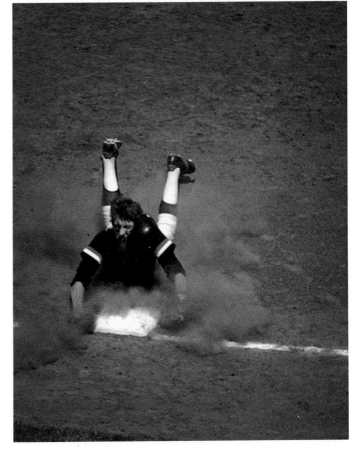

So many sports are similar when it comes to photographing them. That's why baseball is not discussed separately elsewhere in the book. As with any other sport, you should isolate the most important moment. I took the shot above from ground level. Although it shows an exciting call, it's not as dramatic as the other, which I took from the middle of the grandstand using a 500mm lens mounted on a monopod.

trustworthy. Keep all equipment zipped up in your camera bag. If you have to set something on the ground, make sure you step on the neck strap or have some contact with it so you can feel when it sprouts legs!

WILDERNESS SPORTS

Wilderness sports are different from organized sports because competition rarely exists. Usually the tension is created by man against the elements, such as climber and mountain, kayaker and whitewater, or skydiver and gravity. Not just a game, it's often a life-or-death situation. The consequences of a mistake may change more than just a scoreboard.

If a climber makes the wrong move, he falls. A skydiver who fails to pull his ripcord in time will die. These situations demand a lot of commitment to the sport—and that commitment should be obvious in your photographs.

This also requires more involvement on the photographer's part. It's not like walking across the street to the baseball diamond on a Sunday afternoon. It almost demands participation. But first let's look at some of the equipment and preparation.

EQUIPMENT

Wilderness sports require non-mechanized mobility over rough terrain for long distances. Therefore, it's important to make a selection of equipment that is light, compact, readily accessible and waterproof, as discussed earlier.

Because you'll often be traveling for several days, you'll be carrying your photographic supplies *and* camping equipment. As a result, some people prefer a lightweight camera system. I disagree with this approach. I choose the heaviest system I can find because for me, weight is synonymous with durability. When I'm out for a week—or a month—I want my equipment to keep working.

Details are important in every sport. Hands and faces are always interesting subjects.

One way to save space and weight is to carry a zoom lens in the 80mm to 200mm range to eliminate the need for several individual lenses in your pack.

A motor drive is optional. But you should carry a camera cleaning kit, a polarizing filter and lots of extra film. When photographing in town, you can run to the corner drug store or bum a roll off the photographer next to you, but on the trail, when you're out, you're out.

Always take more film than you think you will need. I'm convinced you won't unless I say it several times. In a 12-month period, nine photographers approached me at public sporting events, begging for film.

Keep It Accessible—In the wilds, most photographers lose out because they stash their equipment safe and sound, out of reach. Carry your equipment where it's easily accessible. One good place to have your camera while hiking or skiing is on your chest with an elastic band around your back. This extra band keeps the camera from bouncing around, yet allows you to stretch it up to eye level for quick use. You can find special camera straps for this purpose available at your camera dealer.

A monopod is indispensable. You might also want to bring a C-clamp. I always find a use for it. Two camera bodies are the minimum you should carry. This allows you to use one for color and one for b&w, and also provides you with a backup system if one should fail.

TECHNIQUE

Remember to pay attention to the background. Always watch for the majestic mountain peak, the delicate stream, jagged cliffs or the natural beauty that surrounds most wilderness sports. But don't just notice it. Use it in your pictures.

The background and settings for most organized sports are the same, picture after picture. But there's always a new bend in the trail, different weather and lighting conditions, and seasonal changes that can keep your wilderness pictures fresh. Nature will create her own viewpoints for you.

There must be thousands of similar shots of climbers descend-

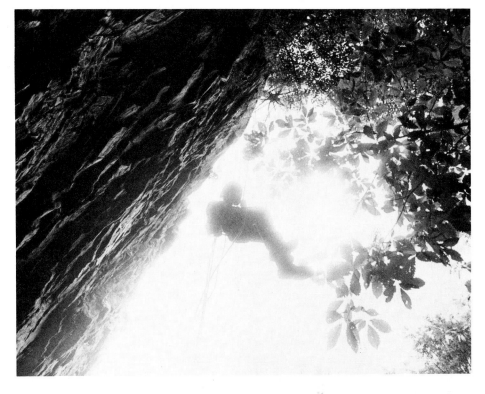

Mother Nature is constantly changing her creations. If you keep your eyes open and imagination active, you can visualize how a natural background can create a beautiful setting. Although you can set some shots up, the best way to get pictures on a wilderness trip is to scout ahead and then wait for your comrades to pass your chosen location.

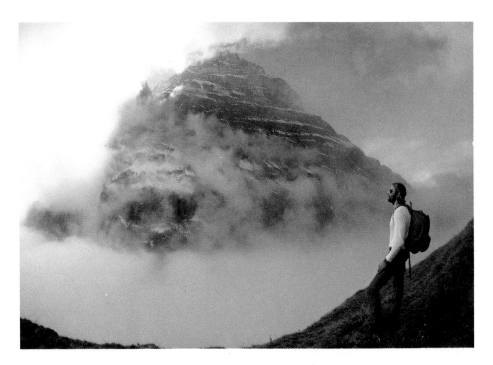

You can use your trusty C-clamp to mount your camera to almost anything.

ing a rappel rope. I have at least a hundred myself, so I didn't think I would get anything fresh at a climbing seminar held at the Cut Rock State Park in North Carolina. But I was there and I had my camera. The climbers had to descend through the tree branches at the end of the rappel.

With my back to the wall looking straight up, I saw an interesting silhouette against the overcast sun. Little did I know that the back lighting of the sun diffused the edge of the climber and gave the picture an eerie, dream-like appearance—all with simple, natural lighting. I didn't see or do anything special—the picture was given to me on a silver platter.

SHOOTING TIPS

I like to shoot things on the run during the course of events rather than asking my comrades to pose.

That's why I try to stay out front in case I have to run up a hill or canoe into a side bay to get the angle I want. Still, you can't always prearrange everything. It's nice to have comrades who will slow down for a minute or backstep once for what you promise is going to be a prize-winner.

Lighting Alternatives—You'll be surrounded by unique lighting and weather conditions, whether you like it or not. Learn to exploit them instead of complaining.

When hiking in the Alps one time, I was fuming because I couldn't get the sunny-day pictures I wanted. The sky was a thick, gray soup. Suddenly, I noticed a mountain peak peeking through the clouds behind my traveling companion. The sea of clouds below and the backlit sunlight gave me a picture I never could have gotten otherwise.

Hints—If you're camping out, try to pick a photogenic camp spot. When it's getting to be "that time of day," I start looking early so I don't miss a nice location. Don't waste evenings when shadows are long and beautiful, and don't oversleep in the morning. Sunrise is often enhanced by a morning mist that fades fast as the sun comes up.

PICTURE IDEAS

Sometimes it's easy to overindulge in the scenery surrounding the sport and miss the essential details that make the sport interesting. If you are climbing, move in close and get shots of hands at work, a foot on a narrow ledge, untangling a "rope salad."

And don't forget the faces. There's always ample opportunity to get great shots of a face bent over a campfire blowing it back to life, a frosted face on a ski trip, or the squinting face of a climber while he is trying to spider his way up a precarious pitch.

The main difference between wilderness sports and others is that there are no sidelines, no spectators. Either you're a participant or you're not. This may appear to be a disadvantage, but in

When you're camping out, try to choose a photogenic location. Stop early enough to take pictures before the sun sets, and get up early enough to take pictures around sunrise.

the long run, all it can do is ensure better pictures. Of course, it depends on how involved you get, your geographical location and your disposition.

I should warn you, however, that photographing as a participant increases the risk of the sport itself. Scuba diving requires close attention and careful planning when repetitive dives are made at depths below 30 feet. If you stay down too long, go too deep or make too many dives in one day, you can get nitrogen narcosis, which is called "rapture of the deep" by the French. Essentially, you lose your sense of reality. Although everything seems to be in order, you can drown because you "forget" where you are.

A friend of mine got "narced" on a diving trip in Florida. He had no idea why everyone was laughing at him. Lou was taking underwater movies and apparently lost track of his bottom time. When his tank ran out of air, he figured he didn't need it anymore, dropped his regulator and started swimming like a fish. Fortunately, his buddy caught up to him and shared his own air supply while getting Lou back to the surface.

Up top, Lou was still happy until he discovered the film cartridge in his camera was jammed. He claims it jammed when he loaded it, but he was still grinning when he made that claim. If you do photograph and participate, take extra precautions—just in case.

Beyond The Picture

We've all heard the saying, "There is nothing new under the sun." Many photographers have changed it to: "Everything you photograph has already been done before."

I have a surprise for you. There *are* new things under the sun and everything has *not* been photographed *from every* angle! I'll be a bit bolder and say that *nothing* has been photographed from every angle. That is where you and I come in. You have a point of view that differs slightly from all those before you, and so do I. If used properly, this viewpoint can result in photographs no one else could ever produce—except perhaps in hindsight.

CAPTURING THE UNUSUAL

The main task is to keep your mind and eyes open. Familiarity with the sport and location helps you choose an unconventional viewpoint before you get to the scene. More often, however, a unique situation or angle occurs after you arrive on the scene.

Expect the Unexpected—At the Gunflint Mail Run Dogsled race in Grand Marais, Minnesota, I planned to crouch behind the timekeepers, in the middle of the frozen lake. I thought that the mass start of the dogsleds and racers plunging past the officials' mound would make a grand opening picture. Midway through the race, storm clouds moved in and dumped loads of snow onto the lake where I was standing. Suddenly, barely discernible

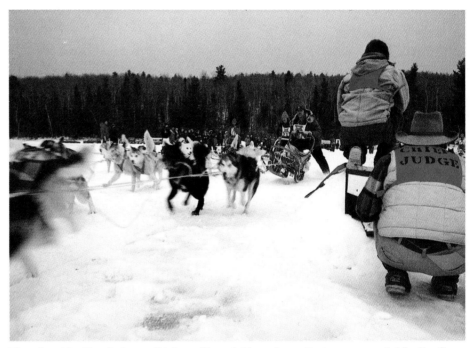

Plan ahead for the shots you think you'll need. Above is one that was on my list for the Gunflint Mail Run. Below was the unplanned shot discussed in the text.

through the whiteness, out of the snow-thick air came a dogsled racer. The shot I made at that moment was better than any I could have dreamed up.

As I mentioned, sometimes you don't even have to work for your shots:

● I was just expecting a typical shot of Barb and Bob running the eye-of-the-needle on the Chattooga River in Georgia, when suddenly Bob's paddle broke in half. Barb was in the front of the canoe, unaware of this. She kept paddling gallantly through the rapids while Bob sat helpless in the back of the canoe holding his paddle stub, not

knowing whether it would be to his advantage to tell Barb or not.

I hollered to Barb, "Don't look now, but you don't know what you're missing," and pushed the shutter button as they shot by me.

Above: If this pilot had landed his plane that way, I would have recorded it. Being prepared will get you more good pictures than you may have planned.

Left: They weren't in trouble yet because of that broken paddle in Bob's right hand, but you can sense the danger and feeling of helplessness he is experiencing at this moment. The 16mm lens I used makes the river look more treacherous than it actually is.

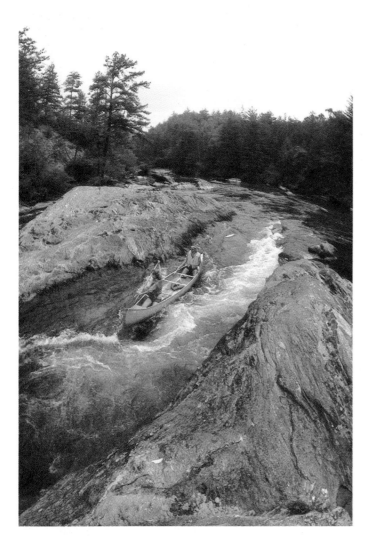

● A gambler once said, "Play for more than you can afford to lose, and you'll learn the game." I'm not sure if the fellow coming in for a landing in his biplane—upside down—was trying to apply this gambler's advice to his flying career, but I had no trouble deciding that I should make a photograph of it.

You can be sure of getting a good picture if you find an unusual angle. Of course, if the sportsman himself decides to change the angle, pray that he lives through it—and keep taking pictures.

Take Care—While you're seeking out unique angles and shooting positions, it's easy to lose track of where you are and overstep the boundaries of safety.

One time I was standing at the end of a grass runway where gliders were making continuous land-ings. I had set up my tripod and camera with a 500mm lens to film their antics in the air from ground level. As one of the glider pilots made his landing approach, I decided to lie on my back on the runway and film the plane passing directly above me.

I left the tripod standing and positioned myself in the grass approximately where I thought the plane would fly overhead. It didn't dawn on me how low the glider would pass. As it came in, I rolled to keep it in my finder and saw my friend run for cover after tipping the tripod I had left standing. The glider passed directly over her stooped head with only inches to spare. That's when I realized my folly.

Had she not foreseen the calamity and moved the tripod, the glider would certainly have hit it, possibly crashing in the process. Careless photographers can harm not only themselves and their equipment, but also their subjects if they don't take proper precautions.

Thinking Crazy Can Pay Off—More often, you will have to seek out your own new approach. The *theory* is simple: Just stand where no other photographer has stood before. The *practice* is somewhat more difficult. One approach is to think of a ridiculous angle—one that wouldn't make any sense to anyone else. I usually think of the one that makes the most sense and then consider the opposite.

At the rifle range, for instance, the guns or perhaps the squinting eyes of the gunslinger behind the barrel are the center of attention. So what would happen if you stand behind the marksman and shoot in the same direction he is shooting?

Your first inclination is, "You'd get a boring picture of a blank target and the back of the guy's head. Your score would be worse

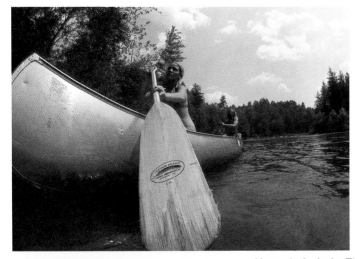

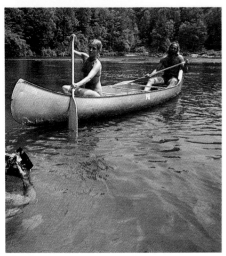

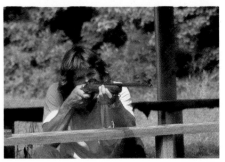

Above Left, Left: The top picture resulted when I discovered that my original concept of a fish-eye view wouldn't work. Be flexible enough to change your plan in the middle of the stream if that's what getting a good shot calls for. I used my Nikon and 24mm lens in an Ikelite housing.

Above Right, Right: Thinking about the opposite view from the one you would choose normally can often give you a fresh perspective. Make sure you have covered every angle. Too many photographers put their equipment away early.

than his.'' At this point, my reasoning is usually, ''Sounds good. Think I'll try it.'' It worked. The partially blurred head and hands give a unique perspective of what it looks like from the rifleman's viewpoint.

Be Prepared—When you come up with your new idea, be prepared with the required equipment. I had never seen a canoeing picture taken from underwater looking up at the hull of the canoe, with the paddles moving in and out of the water. I set out to photograph what no one else had thought of.

When we arrived at the river with the canoe, the models and my underwater gear, I discovered why it had never been done before. The fish's view of the typical canoe is basically that of an oblong blob—it would never work. But because I was already there, without letting anyone

know of my first intentions, I proceeded to shoot directly from the water level up at the canoe. This turned out to be better than my original idea. The point is, think crazy but be flexible, too.

Photographing Celebrities—Another easy way to give your sports pictures more zest is to photograph

the star. You can do this by design or accident.

One weekend when I was in college, a friend and I went to the Indy 500. I had borrowed a friend's camera so I could carry two and ''look professional.'' With that status, I sneaked into the pit area.

It's always nice to have photographs of stars in your collection. If the face is hidden or unrecognizable, a way to still be a "name dropper" is to show the name in the picture. Celebrities are easy to photograph because they are accustomed to the presence of cameras and don't usually shy away from them. Whether your subject is famous or not, remember that portraiture is another important part of your photographic record of sports activities.

If you can't find someone famous, look for unusual subjects to add interest to your photos. Here's one I found in the America's Marathon.

One of my speed heroes of the time was Mario Andretti. I took lots of pictures of him. After awhile, for some reason, he became very cooperative. Dozens of other photographers couldn't even get close to him. Once, in fact, he pulled up his visor, turned and looked deliberately at me from his cockpit so I had a full shot of his face.

I felt guilty at the time because I was not with a magazine and he would never see the pictures in print after all his cooperation. Nonetheless, when you get a chance to photograph someone who is well known in the sports world, don't be cheap with your film.

People Always Sell—Don't think you have to photograph big names in sports to get good portraits, however. There are always great human subjects at every sporting event.

Such was the case at the American Marathon in Chicago. With 6000 entrants, there had to be some characters. Indeed, there were people of ages 8 to 88 competing against each other. One man had wings on his headband—for extra lift I suppose. And one had a red bandana over his head, with a pair of bright yellow space goggles over his eyes and a droopy handlebar moustache hanging below that. A paraplegic in a wheelchair and a 75-year-old lady both finished the 26 miles, which is more than 1000 able-bodied men could say at the end of that day.

If you can't find a good photograph with a mix like that, you're better off in the brick-laying business. Then at least you'll have a wall to bang your head against if you don't get the results you envision.

Weather Effectiveness—Sports photographers' and weathermen's lives are built around selections of overhead conditions. Neither usually agrees with heaven's choices. I tend to like the weather events just the way they come.

For me, there is no such thing as bad weather—just different kinds of weather. I know some photographers who pack up and go home when the sun sets, and I have heard of others who don't even bother to get out of bed if they don't see the sun shining. My thinking is that when the rest of the world goes inside, it's usually a good sign that something grand is going to happen outside.

Instead of cursing the weather, use it to your advantage. Shoot in the rain or snow, or in the morning when the insomniacs are the only other creatures wandering around. When it's "too dark to shoot," shoot anyway. Weather is the one element that can set your pictures apart without changing anything else. Take pictures when it's nasty outside. But don't forget about composition, lighting, subject matter and all the other basic rules of photography.

CALCULATED EXPERIMENT: It was raining, the plastic flaps were buttoned down on the back of the boat, and all the photographers were elbowing each other for the 3-foot opening where you could shoot without getting wet. There were some pretty strange looks when I focused my lens through the plastic tarp. They really would have wondered if they had known I was focusing on the raindrops instead of the sailboats.

WINNING PHOTOS

I was once asked, "What makes an outstanding picture?" After about a minute, I replied in all sincerity, "The same thing that makes ice cream taste good." This did not go over too well. But I was serious.

Apparently, the person wanted a pat answer like, "picture impact," or "tangible emotion," or the various clichés coined over the years. It's just not like that. No one element can be singled out as *the* key ingredient for good pictures or good ice cream. It's a combination of parts that differs in every picture *and for every viewer.*

A photo critic once said, "A good picture is one the viewer looks at for more than 30 seconds." That is probably closer to a valid answer than most people realize. *Good* depends on the subjective taste of the individual. My severest critic, after flipping through a few pages of my slides, said, "The same old stuff. When are you going to shoot something new?" My response was, "What is one man's feast is another man's garbage."

Nevertheless, there are universal elements that make some pictures strong and others weak.

Isolation—This is an important element. Cropping tightly, framing with the foreground, using light creatively to isolate the subject, or using a plain background to accentuate the subject are all valid ways to present a crisp, uncluttered image.

Foreground—A friend was climbing a crack in a big rock called the Bastille outside Eldorado Springs Canyon, Colorado. Nothing else was in view. "Simple and straightforward," I thought, which turned out to be the problem. The composition was too simple.

A good rule to remember is, when you can't change the background, change the foreground. So I crossed a nearby stream, walked up the hill on the other side of the canyon and shot

Use a different vantage point to add depth and interest to the setting.

Left: One way to isolate your subject is to *crop* in the camera viewfinder. This skier was surrounded by 500 others but you would never know it because I moved in close and framed him exactly the way I wanted. Right: Don't limit your photography to just good-weather situations. Shoot in the rain, snow and foul weather. This was made in the early morning at 10,000 feet in the Austrian Alps during a four-day blizzard. Remember that snow pictures look better when fresh snow is covering the trees. Dirty snow is not very attractive.

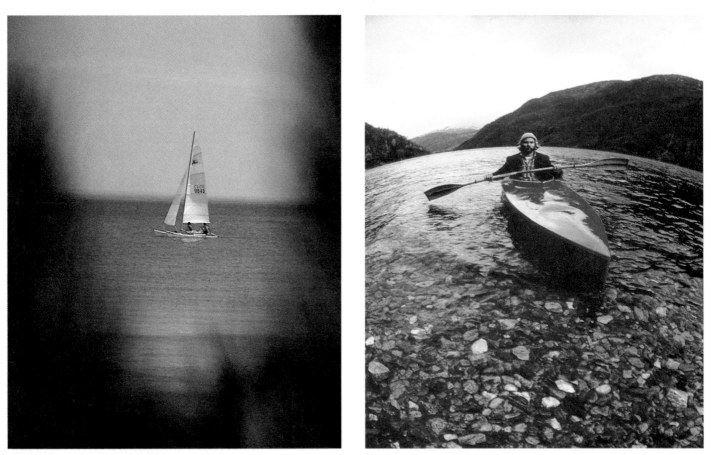

When you can find a natural frame, take advantage of it. Be aware of everything around you—not just the action you are trying to photograph. I framed the sailboat through some foliage from my shore-side vantage point. For the shot at right, I wanted to detail the foreground. I took advantage of the depth of field offered by my 16mm wide-angle lens, and held my camera a few inches above the water.

through a pine branch. I used the out-of-focus green foreground to frame the climber who was now smaller but had greater visual appeal. The surrounding colors draw the viewer to the isolated subject.

● Break up monotony by using foregrounds properly. When I saw 50 hot-air balloons inflated at a four-acre balloon port, my mind began to wander back and forth between déja vu and amnesia. With only minor variation in color, the balloons all looked the same and I was getting dizzy. So I climbed a hill on the far side and shot down at several balloons in the hollow through the tree branches. That added something—a different viewpoint—to an otherwise unspectacular scene.

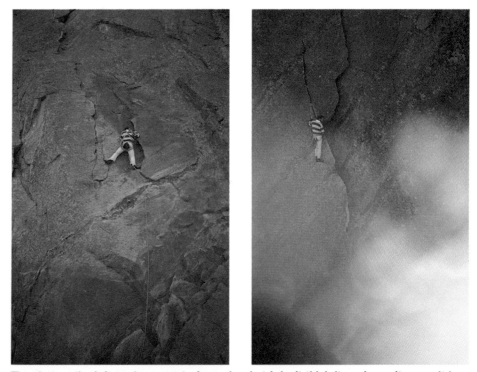

The shot on the left works as part of a series, but I don't think it works on its own. It has three major faults: The subject is centered vertically, his surroundings are too plain, and you can't see his head. It was improved when I backed up, used a longer lens, placed the subject off-center, and framed him with an out-of-focus tree branch.

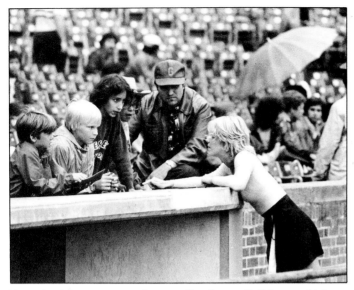

Note the intense expressions on the faces. Nothing could tear these guys away from the cheerleader.

When you can't change the camera angle to include the desired foreground, move the subject. In this case, I asked her to paddle through the weeds because there was no other way to get the two in the same shot.

• Mix elements not usually associated with the subject to modify the foreground. For example, most people think of sailboats only in terms of water and sky. Too many photographers are trapped into that same stereotype. For such a shot, I decided to back up and include a little of the shore to frame the sailboat and give the viewer a point of reference. It made the picture look a little different from all the others.

• Stretch them out by using a wide-angle lens. You can emphasize and expand the relationship between the foreground and the main subject. On a kayaking trip in Norway, I wanted to emphasize the beauty of the shoreline *under* our crafts rather than just the scenery above the water. As my partner came into shore, I lay down on the beach, held the camera next to water level and included the pebbles I had been admiring from the deck.

Foregrounds can give *mood* to any picture. I was photographing a friend paddling a canoe through a small pond, but everything looked too plain. Finally, I asked her to steer right into shore. Shooting through the tall reeds along the bank, I got the out-in-the-wilds effect I was looking for.

Suspense—One thing that will hold a person's attention without reservation is the element of suspense. With enough suspense, you can capture the attention of any audience.

Doubt it? Then try a test on yourself at the next adventure sport event you attend. Wait until a sportsman is on the verge of catastrophe: a white water canoeist swamping just above a 10-foot

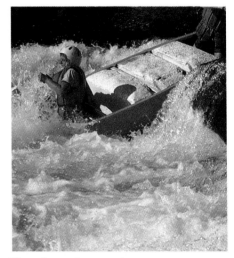

There is an element of suspense here. The shot's strength is that you do not know if she made it or not. If the subject had been riding high on the water or was already swamped, the picture would lose its impact. Always try to catch the moment before so the viewer doesn't know the outcome. Then, make a series of exposures to document the rest of the action.

waterfall; a hang glider in a stall, ready to tumble out of control; or a skydiver nearing the concrete runway and banging frantically on his unopened chute. Try to look away. You'll see that it's almost impossible to do.

Obviously, these are exaggerated examples that you may never encounter, but you can test yourself at home while watching television. Action tetering on the edge of disaster has unlimited gripping power. Suspense—that element of the unknown—is the key. Show that in your pictures. If you keep the viewer in suspense, nothing can tear him away.

Body Language—Some say that music, photography and touch are three universal languages. Whether or not you feel capable of communicating around the world, one thing you can count on is that emotion in your pictures can touch even the coldest heart.

You can find emotion by moving in close to faces. I saw one of the most captivated audiences I have ever witnessed during half-time at a Chicago Sting game. A cheerleader was leaning over the guardrail telling four youngsters something I wished I could hear. She had all of them—and an adult too—mesmerized with devoted attention. My first thought was, "Don't break the spell, but quick get a shot." Little did I know I could have waved hundred dollar bills in front of their faces and would have failed to extract a glance.

I couldn't keep myself from walking over to hear what was so entrancing. Unfortunately, the cheerleader left as I arrived, ignoring two young voices calling after her, "Do you promise? Do you promise?" If you can capture those feelings on a tiny piece of film, you know you have a winner. That's heart-to-heart communication.

Variety—Most photographers' pictures can use more variety. You can add this element to your photographs by changing lenses frequently. Don't get trapped into using the lens that happens to be on your camera. Make a *conscious effort* to pick the perspective you need and then match it with an appropriate lens.

Shooting from the deck of a 41-foot yacht, I used three different lenses. Three different types of scenes resulted.

With a 16mm lens, part of the mainsail and sheeting rope appeared in the foreground, and the back of the boat showed in the dis-

tance. Changing to a 28mm, I shot a full view of the two sailors at work in the captain's quarters. For the last shot, I used an 85mm lens and closed in on the two of them piloting their yacht, with the Chicago skyline gracing the background. Keep your lenses in motion for variety in your photographic work.

Don't stay in one place longer than you must. Several years ago I saw a fellow taking pictures at a motocross race from what must have been his favorite turn. He was sitting on a lawn chair there, aiming his camera. I ran back and forth past him all day long and he never moved an inch. There couldn't have been much variety in his pictures. Keep moving. A good photographer is never a *still* photographer.

The more you move around, the more likely you are to discover an untapped angle. I was busy photographing a skeet shoot in Northern Scotland when suddenly it dawned on me that the surrounding environment was far more photogenic than the blokes pumping their shotguns. So I quickly backed off, switched to a wide-angle lens and included the mist-enshrouded hills, lake and the stone memorial.

These three photos were taken from approximately the same position with three different lenses. At far left, the 16mm lens includes part of the mainsail. For the center shot, I backed up a few steps and used a 28mm. Above, very little of the boat shows with an 85mm lens, thus emphasizing the sailors. If you can't change your position, the best way to add variety is to change your lenses. If you can do both, you're even better off!

Don't be so distracted by the subject and action that you forget about the background. I used limited depth of field here to soften the background so it doesn't draw attention from the subject.

No, this balloon was not in outer space. I photographed it through the sunroof of the chase car.

Sometimes you'll be surprised at the great difference a slight change of perspective will bring to a scene. Earlier I mentioned The Maiden, a pinnacle of rock that has a 150-foot free-fall drop. It looked like two different parts of the country when photographed from two positions, about 50 yards apart, with the same lens. People don't believe me when I tell them the two pictures are of the same rock.

Never underestimate the impor-tance of trying new angles. I learned a long time ago—well, almost learned—not to trust my power of projection. I'm constantly deciding from where I stand, what angle will or won't work. I'm usu-ally wrong. You can't tell what something *really* looks like until you get over there and look through your viewfinder.

Keen Observation—One hurdle that may require stilts, as an ac-quaintance of mine puts it, is de-veloping your *sense of observation*.

Face it: No matter how much self-deception you engage in, you can't notice everything. The more you teach yourself to notice, the better a photographer you will become. The importance of keen observation cannot be overstated. The importance of keen observa-tion cannot be overstated.

Although I consider myself to be an observant fellow, I am con-stantly amazed at some of the details other photographers are able to scrounge out of "nothing" subjects I pass by. The key to success: Everyone sees things a little differently.

A good example I like to brag about is the shot I took of a bal-loon through the sunroof of the chase car. Every time the car stopped, other photographers would pile out. I decided to stay inside to see what I could see. The balloon passing over the sunroof was surrounded by reflections that looked like the balloon had drifted into outer space with comets whip-ping past in all directions.

Another tip to remember is to look where everyone else isn't. I'm constantly looking over my shoulder. That's how I notice the unnoticeable. You may find a better shot that way.

Such was the case at the Grand National Speedboat Races in Fox Lake, Wisconsin, where I was

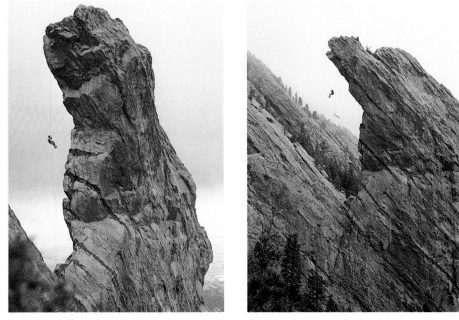

Your angle related to the subject can make a big difference in the results of your camerawork. These two pictures were made about 50 yards apart with the same lens. Which one do you like better?

To catch the unposed anxiety on this little girl's face, with my back to her, I changed lenses, set lens aperture and the approximate distance while pointing my camera in the opposite direction. Then, with everything set, I spun around, aimed quickly and released the shutter. To get this kind of shot, you sometimes have to accept a less than perfect background.

This is not your run-of-the-mill dogsled photograph. You don't always have to "manufacture" unusual shots. Sometimes you find subjects that provide such shots without prompting.

richly rewarded. When I glanced back, there "she" was, on the edge of her chair. She was no more than four feet tall and scarcely that many years old. The irony was more than I could stand—the epitomy of innocence in the midst of these firebreathing boats and men. She looked like her world would crumble if her daddy didn't bring his boat around the next turn. I knew my world would fall

apart if I didn't get it all on film. I did. How did I find it? The nervous twitch in my neck.

Document The Unusual—Whenever you see anything unusual, photograph it. John Patten, a man of many talents, is a maverick. He doesn't do things the way most people do. He couldn't just climb The Maiden. He had to sleep on the top. He didn't train his sled dogs by running them through the

woods like everyone else. He hitched them up to his van and had them pull him into town 25 miles away. Now he's into jogging, but he won't succumb to the typical 10 miles a day. No, he has to run the entire Kekakobec Trail along the border of Minnesota and Canada.

I should have expected some antics when I went dogsledding with him. He likes to ride his sled upside down, explaining that this gives him a good workout while he works his dogs. Naturally, I pounced on the opportunity to get some interesting photographs. I am certain no other photographers have dogsledding pictures quite like that—unless they know John Patten.

Many photographers forget about details. Get to know your subjects. Move in close and don't stop shooting when the action ceases.

Details—Trying to cover all the details of one sport such as climbing would easily exhaust the resources of a true Renaissance man. That phrase by the way, is not my own, but one I'd be proud to sign. Let's look at some of the more obvious details of climbing as they apply to photography.

You could show a nut, which is the wedge-shaped aluminum hexagon used to anchor a climber's rope to the rock, caught in a crack. A study of hands hauling a rope or feeling for crevices could make an essay in itself. Climbing boots, positioned precariously on a half-inch ledge, or hands testing an anchor almost out of reach would be worth a foot of film each. Just the hardware laid out on a rock before the climb could make an interesting study. You might get a close-up of a hand dipping into a bag of chalk if you climb with partners who believe in such, or you could get a close-up of the slings set up for a rappel.

Now that I've discussed some of the types of shots that can be interesting—and fun—to make, let's get into how to get them.

PICKING YOUR SHOTS

John Jerome, speaking mainly about skiing in *Outside* magazine, said, "Doing it has always been the terrific thing—learning to take a particularly cumbersome tool, the ski, and make it sing for you, make it provide you with sensory pleasure. There are not too many other sports—surfing and skateboarding come to mind—where you get so much pleasure from nothing more than the skillful manipulation of a tool."

Obviously, there are other tools we can add to his list. The camera is the first one that comes to my mind. For me, the camera provides more long-lasting pleasure than the immediate satisfaction of downhill skiing. When you are finished taking pictures, it is all over—but you have something left that is sometimes better than the memory.

Remember, however, that top shots are *made*, not discovered afterwards. There are two approaches to making pictures work—sniping and shotgunning.

The *shotgunner's* approach, recently worsened by the influx of autowinders and motor drives, is to arrive at the scene of action and start shooting in all directions. I suppose the attitude of such practitioners is much like hunters who spray the bushes with bullets and hope for a hit. "If you take enough pictures, you're bound to get a few good ones."

On the other end of the neckstrap are the *snipers*. I am a proud member of this group. We may end up taking just as many shots

as the bush-sprayers, but the main difference is that each shot is carefully planned. Shotgunners don't know what their results will be. The sniper knows exactly what he got on film. The other danger with shotgunning—the more severe one—is that it breeds imprecision. When you get used to it, you'll never be able to call your own shots. Then it's a matter of shotgunning, or hit-and-miss.

The remainder of this section is directed exclusively to snipers. If you still remain an unrepentant shotgunner, skip over this information. For the rest of us, let's talk about *knowing what you want and how to get it.*

Know It All—Here's one other thing that will help you pick shots. According to some, familiarity breeds contempt. But in photography, it can only spawn success. The better you know your equipment, the sport, the participating individuals and your own strengths and limitations, the

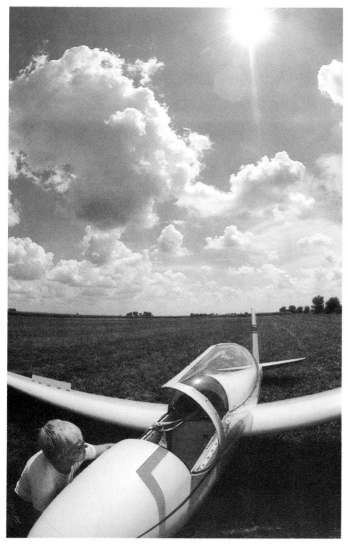

I used the sun to my advantage here. I wanted to include it in the shot, so I closed the lens aperture two steps to compensate. If you can't get close to the subject to meter directly on it, take an educated guess and bracket your shots. Write down what you did so you will know next time. You can see a "ghost image" of the lens aperture just below and to the left of the sun. This resulted from the bright sunlight reflecting inside the lens. Sometimes it can ruin a shot; I don't think it did here.

This picture was possible because I *pre-visualized* what I wanted to include and knew how to get it. With time, you will be able to judge exactly what area is covered by various lenses, and the compression or distortion each provides without having to look through the viewfinder.

more accurately you can call your shots.

For instance, while shooting sail planes, I thought it would be nice to get a shot of the sun glancing off the dome, in the same frame as the glider pilot connecting his tow cord. I knew that including the sun would overexpose the image but that closing the lens about two steps would result in proper exposure. I was right. It worked because I was familiar with the lighting conditions, how my equipment would react to them, and how to correct the situation.

An advantage of being familiar with the sport is knowing in advance which locations will and won't work. Don't count on chance to put you in the right spot because most of the time it won't. If you run around like a madman shooting from here and there, your disillusionment will only be topped by your disappointing results. Know what you want, and then figure out a way to achieve it.

When a friend rappelled over the edge of a 200-foot cliff that dropped into the north shore of Lake Superior to retrieve some

hardware, I knew he would have to climb back up the rope and I'd have a good chance to line up a shot. But I also knew it wouldn't take him long so I had to move fast. Being familiar with the area, I figured I could run around to the lookout on the opposite side, then shoot back at him working his way up the edge, with the second set of palisades behind him as a backdrop.

I got the picture I was after, just before he came up over the edge again. It never would have worked if I had to hop from one rock to

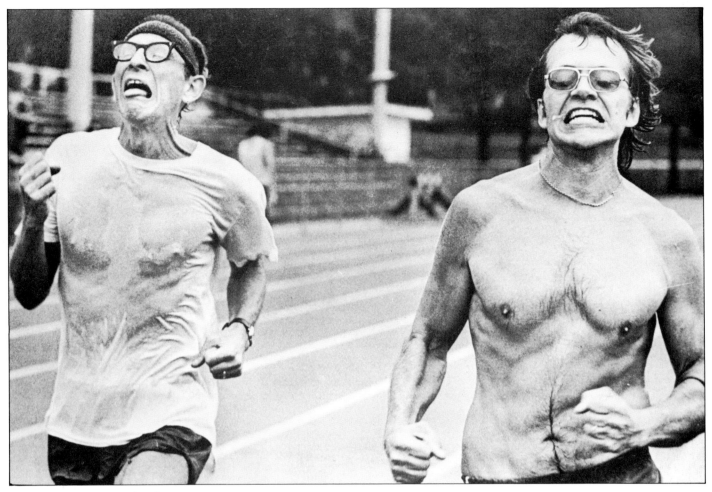

Photo by George Kochaniec Jr.

the next to "see what it looked like from there."

I can't emphasize enough that you must become as familiar as possible with the sport and the locations associated with it. Your photographic skills must also be developed well enough that you can handle your equipment without having to think about it. Then you can plan and execute exactly what you set out to do. Leave the hit-and-miss technique for the shotgunners—the ones who skipped this section.

PHOTOJOURNALISM

The best definition I can give of photojournalism is that it produces pictures that tell stories—that's all it is. Contrary to what many non-photographers believe, it does not take a mountain of photo-graphs to tell a story. A single photo without a caption can tell a complete story.

One of the best examples of this is a photo taken by George Kocha-niec Jr. of a 15,000 meter race. He framed a 20-year-old and a 60-year-old crossing the finish line together.

At the finish, they were neck to neck, fists clenched, mouths wide open, bodies soaking with sweat. The older gent's head was thrown back, veins popping in his neck, his eyes closed and his tongue sticking out like a greyhound panting for breath. It needed no caption—see above. One test for the effectiveness of a picture is how long it takes for you to forget it.

But not every story can be told in a single picture—or without words.

Sequences—Sometimes it takes a series of pictures to portray the essential information. The number of pictures required is mainly dependent on the complexity of the subject, the competence of the photographer and the cooperation of the subjects.

While filming the head instructor at Michigan Dunes Hang-Gliding School, I noticed a three-year-old getting suited with a helmet and trapeze. Sure enough, he was going for his first hang-glider ride. When he looked ready, his parents clipped him onto the hang glider behind the pilot, who promptly jumped over the edge. As the wing caught some lift and took off over Lake Michigan, the kid looked happier than a skylark. I took three pictures and they tell the entire story.

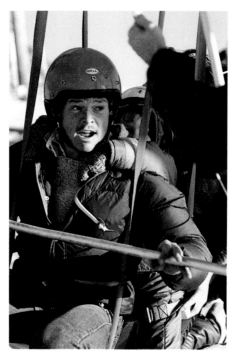

These shots show a youngster's first hang glider flight—but you already know that. If the picture series tells the story adequately, captions need only fill in the details.

But you can't always tell a story in just three pictures, either. I once did a photo story on an 11-year-old who races sled dogs. Training these animals for the racing circuit is a year-round endeavor. It would be almost impossible to show this activity in only one or two pictures.

In addition to the obvious racing shots, I needed to show how she trained the dogs using a wheeled cart in the summer; how she watered, fed and cared for the dogs, and her relationship with the lead dog. Amy and her lead dog are not just a working team— they are best friends. They play together, run together, train together, and once in a while they nap together. It's all part of the story that has to be shown.

Storytelling—Storytelling images are important. Some pictures don't tell a story. Many of the best sports pictures are packed with action, power and excitement, but they don't tell stories. The one difference that separates photojournalistic photos from all others is their ability to say more than simply "this is a skier" or "this is a car going fast."

If I can glide back over to the Michigan sand dunes for a minute: Most of the photographers I saw working there had their cameras aimed at the sky. That's where the action was—the birdmen riding the wind.

But the story was 200 feet below them at the base of the sand dunes where the hang gliders landed. It's a long hike back up to the top again every time you want another ride. I told that story by using a

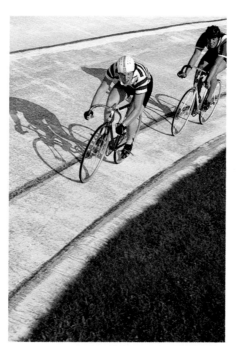

short-focal-length lens to include vast stretches of the dunes and grass around a trio slowly working their way back up for another leap.

Human Element—Photojournalism means taking pictures that tell a story. But if I were bound hand and foot, and forced to come up with a definition of "story," one word would suffice: *people*. People are interested in people. The real story behind every story is the human element. The heart of any story is people relating to situations, experiences, other people and challenges—reacting to victory, defeat, opposition and life.

For example, a photo of a runner sliding into home base is an action shot. A team captain hollering nose to nose with the

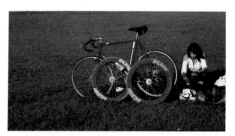

Although action photos are almost always interesting, sometimes an important part of the story does not involve the active participants.

umpire is a journalistic photo. A bike racer pulling away from the pack down the last straightaway is an action shot; his girlfriend sitting on the infield playing solitaire is the other half of his life and expresses the journalistic viewpoint.

Actionless—The great sports shots generally show action or at least one of its close relatives. As a journalist, you must sometimes

A rodeo may seem like all fun and games, but a sensitive photojournalist will go behind the scenes and show what many people never see.

deviate from the standard. You have the freedom to focus on elements that may not be directly related to the action.

At the rodeo, I saw the heart of the sport. Without the animals, there would be no rodeo. The picture I took of the horses and bulls crammed into the holding pen doesn't have any feeling of action, but it tells a deeper story that underlies what the sport is all about.

Finding The Inside Story—Come to think of it, the photojournalist probably spends most of his time with his back to the sport. He is concerned with the *inside story*—the one that most people never see. The *why* and the *how* are more important to him than pure action. Almost anyone with a camera can get action shots—the photojournalist goes deeper than that.

He doesn't want just pictures of a scuba diver blowing bubbles. He wants to show how the diver suits up, what kind of equipment he uses, how he gets in the water, any special tricks like an underwater writing pad, sign language for communication, how the diver finds the boat again, buddy-breathing when someone runs out of air.

Not enough? How about showing how tanks must be removed

to get through small openings when cave diving; inflating the bouyancy compensator to walk like spiders upside down on the ceiling of the cavern; how manatees are approached and photographed; how artifacts are raised by filling empty bags full of air; how fish are attracted and repelled.

And then you could show how inexperienced divers stir up the bottom silt so nothing is visible; how to land softly; how undersea emergencies are handled; how equipment is stored and handled on the boat—and you're still wanting more? Take your check-out dive.

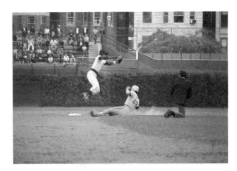

This is a good action shot, but should be part of a sequence, or picture story, to tell the complete story.

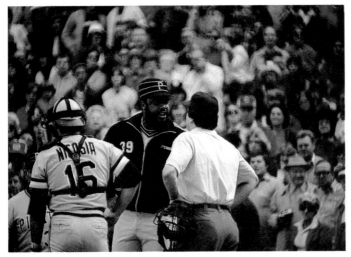

This shot illustrates what photojournalism is all about. A confrontation is usually a good source of interesting photos.

A photojournalist must notice more than just the action. He has to know how to show the full sequence of action. Here, you can see an important part of the action that many photographers miss: how hang gliders get to their launching point—through a lot of hard work.

GALLERY OF SPORTS PHOTOS

Action and faces are important in sports photos, although you don't always have to have both in the same frame. Try unusual angles and other techniques to make your photographs different from shots everyone else takes. When you can, use colors to add to the composition.

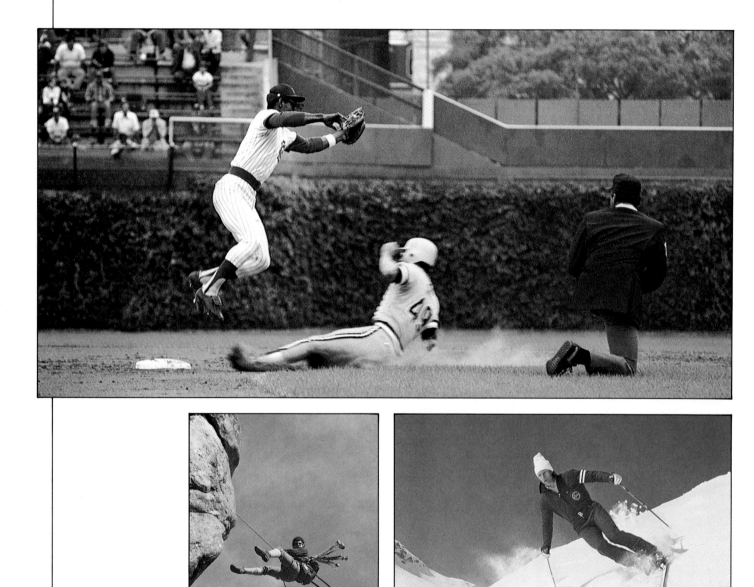

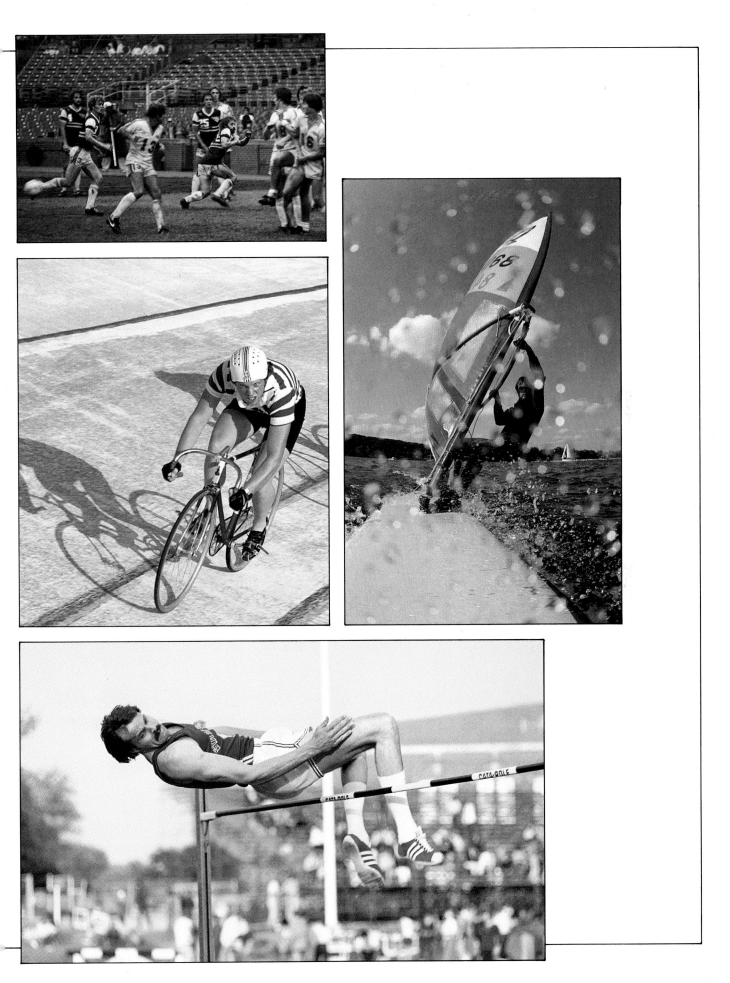

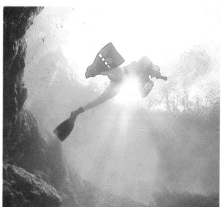

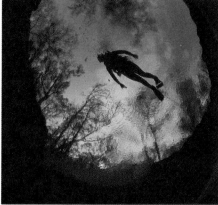

As a sports photographer, you should concentrate on the action. But as a photojournalist, you should also watch for shots that tell a story. For example, here you see several different elements from an underwater sequence. Learn to tell a complete story.

Shoot When The Others Stop— When the action stops, the photojournalist starts. The injured player is high priority for the photojournalist. What happened to the guy who's down on the ground? How did it happen? What is the outcome? Who helped him—and ignored him?

I was filming a hot soccer game at Wrigley Field during which almost every call was debated. At one point an injured player lay sprawled on the field, which apparently didn't make much difference. It looked like he might be dead, but my "journalistic eye" seemed to be the only one that noticed. First they had to take care of how the play was called. They carried the body off the field after the argument was settled. Only a picture can portray the absurdity of the situation.

Importance Of Documentation— Another journalistic responsibility is documentation of events. If any records are set, anything extraordinary or unusual, you want to have a photograph of it. But your role in documentation extends further than just to key moments. You must cover the high and low ground, everything that happens before and after, on-stage and backstage. You can't tell a story without all the parts. The photojournalist must be exhaustive in his recording of the details.

Showing a complete and accurate picture sometimes involves backing up and including the surrounding environment. It's not good enough to show the sport and the details. You must give the viewer points of reference, including the surroundings, what the place is like, where all the action takes place.

With outdoor sports, the settings are often more interesting than the sport itself. In some instances, such as backpacking, canoeing, ballooning and cross-country skiing, the scenery is the alluring factor. You shouldn't get so involved with the activity that you forget to show the surrounding elements—the very essence of the sport.

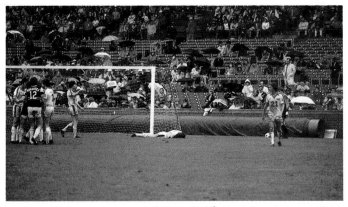

Apparently, few people were interested in the injured player. This can be shown in a picture only by including the other players.

When concentrating on action, it is often easy to forget where you are. When it is appropriate, don't forget to back up and include the surroundings to better set the scene.

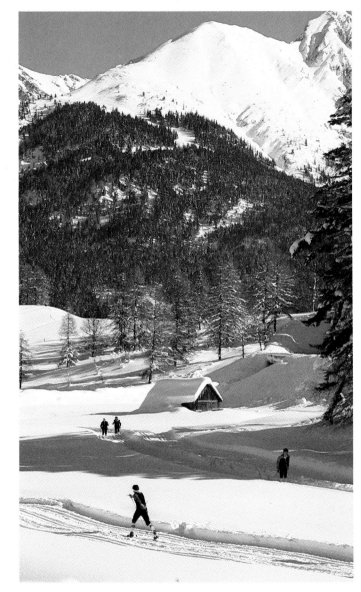

SPORT PORTRAITURE

I like sport portraiture because of its *realism*. It illustrates more than just what the person looks like. It shows the person's *being*. The sport is a part of his life, his character and, in some cases, his everything. When you photograph someone doing what he loves to do, it will be obvious to the viewer how he feels. One thing you are guaranteed is high interest level.

Action Portraits—The first question you'll have before trying to produce action portraits is how to get close enough to show faces. In most sports, it requires more than a minor miracle, considering speed, coupled with head gear or machinery surrounding the subject. Fortunately, you have a choice of methods. The first requires that the subject be in full uniform and at full gallop when you make the exposure. This is where the sportsman is at his best.

Problem 1: You may not want to stand in front of a 600mph rocket car on the salt flats, and there may not be a chase car or anything else that can keep up with it.

Problem 2: Even if there were, you wouldn't be able to see through the subject's windshield, the heatshield, the helmet and the goggles. And then, all you'd see is a pair of beady eyes likely to be watering at the corners.

Problem 3: How would you focus fast enough to get him sharp?

Solution: Why bother when there's an easier path to take?

Still Sports Portraits—When you can't photograph them on the move, do it when they stop. Don't get me wrong. I'm not advocating that you scratch action portraits from your list. But some are impossible to shoot. By all means, if there is any way to get a head shot of the athlete in action, that is my first recommendation. But when you can't keep up with the action, go for the still portrait.

Everything has a beginning and an end, and usually something in between. If you don't have two wild pilots like Ron Ridenour and Daryl Lonowski who almost touched wing-tips for me so I could get a close-up of Ron flying his glider, you can always photograph the subject while he's climbing into the cockpit, buckling into his shoulder harness, putting on his parachute, taxiing down the runway. And you have at least as many opportunities when he lands again.

Always go for the height of the action first. When that fails, go for the break in the action. I cannot think of one sport that does not have pauses in it every now and then. And I'll bet my newest SLR that you won't find one without a start and a finish. That's when you move in for the shot.

CALCULATED EXPERIMENT: Anyone can tell you the peak action of the archer is at the moment the arrow is released. If you are early or late, there's no way to stop a launched arrow. I missed the departing arrow here, and captured something better—the archer's anticipation of its arrival. As you can see, when doing sports portraits, you usually don't have to *create* interest. It's generally already there—and it's real.

Fortunately, you can usually predict where the contestants will start and finish. There are pit areas at racing machine events, runways for air sports, cliffs for leapers—and most are governed by rule or reason that you can easily predict.

Makings of a Good Portrait— Certain elements will improve portraits. Here are some to consider.

● Surroundings must be included so the object of the action is visible. If the head gear, such as a cowboy hat or a riding derby, is unique, or the immediate surroundings are especially interesting, stress these elements. But be sure to show enough to hint at the sport.

If you catch yourself explaining, "Well, they should be able to recognize . . .", they probably can't. However, if the picture is to be used in a sequence with lead-in shots providing the additional information, this is an exception.

● Lighting is an important factor. Try to position yourself to avoid unpleasant lighting angles. Then

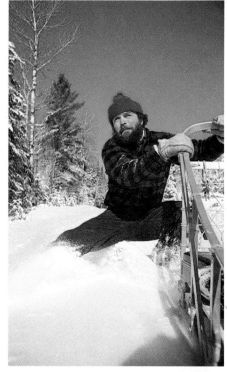

Although the best sports portraits are taken at the height of the action, if it is impossible to get the shot on the run, there's always plenty of breaks in the action that lend themselves to portraiture. This is a father-and-son team.

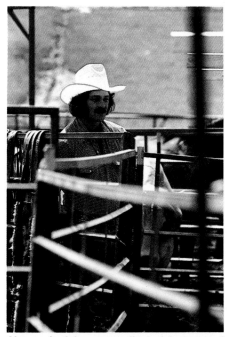

Above: A plain, uncomplicated foreground is best, but you can make a busy one work if it leads the viewer into the photo, toward the subject. Note how the lines in the fence draw you toward the cowboy. Below: I used a 200mm lens to separate this "mermaid" from a busy background.

Right, Far Right: You probably won't find the best *action* at the beginning or end of an activity, where the participants have to wait in line, for example—but this is when you can get some of the best *portraits*. One point to remember in sports portraiture is to show just enough of the subject's surroundings to identify the sport, but not so much that you will distract the viewer from the sportsman.

My first choice for a portrait is always mid-action—mid-flight in this case—but if you don't have a stunt pilot to get there, the next best thing is a shot before or after the event.

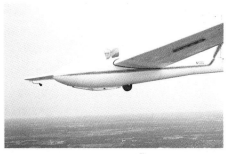

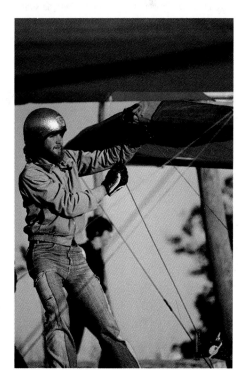

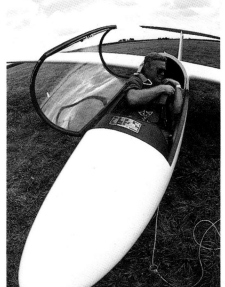

wait until the subject looks your way.

• Internal elements of the image will always emphasize or distract the viewer, depending on how you control those elements. At the DuPage Rodeo in Illinois, I took a less than spectacular picture of a cowboy—but all the internal elements work cohesively. The corral fences in front of him would ordinarily be distracting, but the way they are positioned draws attention to the center of the picture.

• Isolate your subject from the background if that background adds nothing to the subject. When I was filming scuba divers surfacing in a spring, I noticed vegetation in the background that clashed with the image I wanted. I opened the lens aperture to *f*-3.5 and the detail vanished, leaving the main subject—a pretty, drenched woman—bathed in soft color.

• Backgrounds can be modified or obliterated if natural ones aren't suitable. One method I used to

soften the background and draw the center of attention to a girl talking to her horse was to add petroleum jelly around the edge of a clear filter placed over the lens. This diffused the light entering the lens. (Never place petroleum jelly or any other substance directly on the front element of a lens.)

• Cohesion is a must when you have more than one subject. Your subjects should not compete with each other for the viewer's attention. In one shot I had a line of

Smear a bit of petroleum jelly around the outside edges of a clear filter mounted over your lens to diffuse the picture edges. This is one way to draw the viewer's attention to the center of interest.

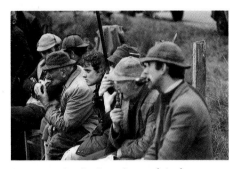

Focus selectively when picturing more than one person. I singled out the young man in the center because he stood out from his older comrades while they were watching their competitors.

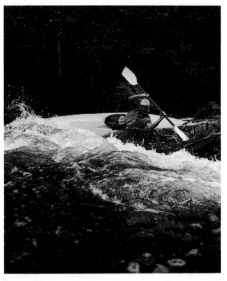

The best sports pictures show peak action, the sportsman's face and dramatic expression. You can't go wrong if you have all three.

Scottish skeet shooters eyeing their competitors, but it works because their attention is focused on one point.

● Expression on an athlete's face can be intense. It's not something you want to miss. Any time you can combine the sport, the participant, and the subject's feelings in an unposed situation, you're bound to have a winner.

The best moment to catch expressions is just after a play is completed and all the other photographers put their cameras down. Plays don't always go as planned. There can be a lot of tension built up inside an athlete who doesn't get his way. Sometimes it shows through. You should be ready to document it.

According to June Harrison, an accomplished tennis photographer, if she's sitting on a player's backhand side and notices a forehand move, she doesn't shoot. Instead, she continues focusing. If the shot is missed there's a chance to capture the disappointment or an annoyed gesture. If you're going after action portraits, keep focusing after the point is scored or lost.

● Sometimes spectators are better portrait subjects than the sportsmen. When I was photographing balloons taking off at a Wisconsin rally early one morning, the crew, team members and I all had stiff necks from keeping our heads pointed at the sky. I stopped to rub my neck and spotted a three-year-old spellbound by the "great flying beasts" around him. The picture I made of that little guy was a better portrait than any I took of the balloonists that day.

● Fido sometimes wins over his master. In many sports that involve animals, such as horse training, dog shows, dog-sled racing, the animals are the real "athletes" and deserve the attention. Animals are harder to photograph than people—they don't stand still. But this disadvantage probably results in better portraits because the good expression you do catch is spontaneous.

● Cropping often is dictated by the subject's head gear. If the head alone shows what the sportsman is doing, cut him off at the neck, so to speak. But if that doesn't tell enough, back up until a hint of the sport shows through. How much you include will vary, of course, with the subject. If you are not sure at the time, include more than you think is necessary and have the lab crop the excess out when they make the print. You can take out extra image area, but can't add it in later if you missed a key element.

● Jumping the gun might get you the portrait you're after. Many sports, such as ballooning, hang gliding or climbing, have long periods of setup time. Why wait for the formal action? This is the best time to close in on the sportsman before he gets away.

The winner's circle is not the only place to get shots showing emotion. Good *and* bad times make good photographs.

Sometimes you can get the best portraits just before or after a play. Fortunately, that's when the subject is likely to be holding still, such as during this game of field hockey.

I wanted some canoeing portraits, but the lake was one of the ugliest ones I had ever seen—it was manmade and bare around the edges. On the way to the water, I spotted a good setting with the canoe balanced over a canoeist's head as he portaged it. We didn't even have to get the canoe wet for that one.

• Angle is very important in portraits. Sometimes, raising or lowering the camera slightly will completely block out a distracting element in the foreground or background.

• Children are easier to photograph than adults in some ways. When photographing children, get down to their level. You'll capture that magical air of the big world that surrounds them.

A Piece Of My Mind—I can't stand posed pictures. I don't care if you own the most successful studio in New York City. If you sit your patrons in front of the camera and tell them to smile, I won't like your pictures. People are moving, vibrant, active creatures. It seems like such a a sin to prop them up like paper dolls and call the resulting photographs lifelike images.

Don't think for a minute that studios are the only sinners. Everywhere you go, you see tourists propping each other up and pasting cheese over their silly grins. Once in a while you even see it on the sports field.

For example, one fellow at the polo field, with a bloated waistline and matching camera satchel, waddled up to the mounted judge on the sideline. He stopped about 20 feet away, introduced himself with a whistle and a twirl of his cap. He called out, "Look this way and hooooold it right there!"

At this point he had no doubt embarrassed the horseman but at least had gained his attention. He continued to focus his lens, moving the barrel in and out, in and out for no less than five full seconds before he released the camera's shutter. Then, moving one foot slightly and bouncing up and down, he said, "Now, one more from here."

He must have sensed my admiration because as he walked past me, he stopped and said, "Ya want some tips on how to shoot polo?" I smiled politely while he droned about tripods and horses' hooves.

COMMANDING COMPOSITION

Sports photographers are notorious for assuming that composition is only for artists. I suppose they figure no one will notice that the artistic balance is amiss if there is enough action. In a sense, they are right. With the background blurred or the subject filling the frame, composition is of no essence, or at least doesn't matter too much.

The downfall, of course, is that on occasion many photographers kick the props out and drop composition altogether. From then on, a pattern is set that is seldom reversed.

I hate to be the party-pooper, but for those of you who have been gambling *action* against *composition,* I have some bad news for you: You're already losing. You'd better start picking up some of the basics.

Subject Placement—Subject location is foremost. All subjects need *room to move.* Don't get in the habit of cutting the corners so tight that the action is too great for the enclosure. Leave the subject room to move within the frame.

Subjects should usually move

A posed picture usually looks like a posed picture. Although there's a place for such photography, try to avoid it. If the subject is participating in the sport, a pose won't look artificial. The best way to get around posing is not to talk to the participants. Just aim your camera and shoot.

toward the center of the photograph rather than away from it. In other words, the tail end of your subject should be closer to the edge of the frame than his nose. Reversed, it will look like he is on his way out of the picture. This mistake is easy to make, and is one of the most common. It takes a conscious effort as you follow a rapidly moving object in your finder to keep more empty space in front of it than behind it.

Try to keep the subjects *out of the center*. Compositionally, they will have much greater emphasis if placed slightly off-center. The tried-and-true technique is to imagine that the picture frame is divided into thirds—vertically and horizontally. Place the subject at one of the four intersections.

You can't lose if you place the subject in one of these locations and have him facing toward the center. Obviously, you don't have to physically move the subject around. Just move the camera. Try taping lines to your camera's focusing screen until you become accustomed to properly framing subjects.

Conflicting Subjects—One of the gross oversights you'll find is *conflicting subjects*. Make sure the main subject is *dominant*. Either keep the secondary subject proportionately smaller, or separate the two so they do not overlap. Always focus on the main subject, whether it is the closest thing to the camera or not.

All the elements you see in the finder should work together to emphasize the main subject. If something doesn't contribute to the photograph, don't include it in the image. You can't just get the main subject in there and leave the rest to chance. Chances are the rest will come back to haunt you. Make everything in the picture work. If it doesn't, change your position, angle, lens, depth of field or any of the other options already discussed.

So what is *internal cohesion?* If there's a branch in the foreground that draws your eye away from the skier, eliminate it. But if the

branch curls around overhead and points to the skier, drawing your eye toward him, leave it in. At the same time, if there are two out-of-focus bodies framing the head of a race driver, use them to your advantage.

Watch for foreground or background objects and large dark or light areas that may distract the viewer. If they're distracting, find a way to remove them from the image area. Lines—diagonal, vertical, horizontal, zig-zag—all carry weight. Don't leave them in the picture unless they serve a purpose.

You can have too many subjects, too. As a result, none dominates. There were thousands of entries for the start of the 1980 America's Marathon in Chicago. Sure, I took a picture or two then, but it was a bit of an overkill.

Everything you include either helps or hinders the photograph. If something is a hindrance, you certainly know what to do with it: Leave it out.

Too Many Horizontals—I'm terrible with numbers and horrendous at estimations, but I would

Portraits don't have to show humans. This husky happened to be better looking than his owner, so I focused on him.

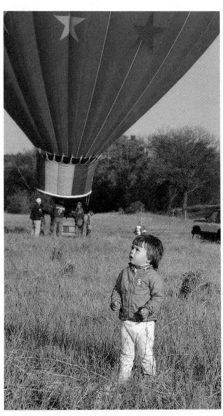

Sometimes spectators make the best portrait subjects. In order for the viewer to understand what was interesting this child, I had to move to a position that would include the balloon in the background.

Don't confine your photography just to the main action. Most sports involve setting up, organization, cleaning up and other activities. This scene provided better portrait potential than the canoeing itself.

A good rule of composition is to mentally divide the scene into vertical and horizontal thirds. Place the subject at one of the four intersecting points.

Background and foreground are important to your photographs, although you often can't control them. Above: You wouldn't believe that an ugly road was just behind the crossbow hunter. I moved around him until I found a satisfactory angle. Aside from getting rid of a distracting background, this angle also makes the subject look as if he is totally surrounded by the "wilds." Below: Compare these two pictures. In one, the branch in the foreground is too dominant and overpowers the distant skier. In the other shot, the trees frame the subject nicely without competing.

guess that 94.627 pictures out of every 100 are horizontals. The figure should be in favor of *verticals*. I think that most pictures would look better vertical than horizontal, but somehow we've gotten into the habit of holding our cameras the other way. I'm just as guilty myself.

The next time you take a horizontal picture, try it as a vertical. Many professional photographers shoot one of each so the customer has a choice.

Involve The Viewer—This is one of those "do it or else" laws. If you don't *involve* the viewer, he won't look at your pictures.

Several years ago, an editor was viewing a prominent photographer's photos. When he came to one particular image, the photographer said, "Oh geez, that's a very bad print." The editor said, "I'm not looking at the print, I'm looking at the poetry." He enjoyed the content of the picture so much that the technical imperfections went unnoticed. If you want to captivate your viewer, involve him in the picture.

Move In—This is by no means the final word on how to involve your viewer, but it has a surprisingly high batting average. Most sports photos benefit by the closer perspective. Sometimes the photographer's excuse for not moving

in close is lack of equipment. But that is just an excuse. Think *closer*.

What Is Too Close?—I've been asked how you know when you're too close. There must be a point of diminishing returns somewhere, but it's not something you need to worry about. As far as impact is concerned, *closer is always better.*

Best Expression—Strictly speaking, I should not discuss this topic here, but it does seem to fit in.

Facial expression is always a key component in any photo of a person. Dramatic expression puts

life into the deadest scenes. Without it, even the most violent action is sometimes uninteresting. Sports pictures are often repetitive, featuring the same plays, the same outfits, the same ball park. The one thing that can make your photographs different and stand out from the rest, is expression—what the sportsman is "wearing" on his face.

Keep the rules of composition in mind and catch expressions when they come your way. You'll have the combination that wins.

6
Closing The Gap With The Proper Equipment

A discussion of equipment in almost any profession will result in some kind of reasonable agreement about which are the best tools of the trade. *Not so in photography.* Carpenters have their 7-1/4-inch Skilsaws, pianists have their Steinways, doctors have their Welsh-Allyn scopes, but all photographers do is argue. There is no middle road for any of them—none agree and no one will give an inch.

Therefore, rather than tell you what is the best and worst, I will simply point out the system that *works for me* and why I chose what I did.

BARE ESSENTIALS

First, you need a camera. As mentioned earlier, I started with a Nikon F and 50mm lens. But any camera, if it's in working order, is a good one at the beginning. If you don't already own a camera, I have a few suggestions.

A 35mm single-lens-reflex (SLR) camera is best suited for sports photography. Larger or smaller format cameras are not as versatile. One reason is that there are many lenses and other accessories available for the 35mm SLR system, and lens changing is quick and easy. No other system has as many accessories and gives you as many options.

There are 35mm rangefinder cameras, but as good as they may be, you cannot change lenses on most models. And, you do not see exactly what the film is recording. This can be a disadvantage under certain shooting situations.

Warning—Do some homework before you go up to the camera counter. Have an idea of what you want before you ask the salesman

to show you something. You know what I use—but don't limit your thinking to that company's product. There are many camera lines that sell well, are reliable, have a low incidence of repair, and offer a lot of accessories.

If you want to hear worse sob stories than any marriage counselor gets, try working in camera repair. I've heard some wild tales. For example, one lady insisted her husband had left her because of a camera malfunction. I won't go any further on that one! I felt like a psychiatrist while trying to calm her down.

Consider only names and models that have a good reputation. Ask around. Get advice from friends who have experience with camera equipment. I suggest that you look through camera books such as Carl Shipman's *How to Select & Use* series that cover the SLR products available from several companies.

Camera Body—Discussions of camera bodies remind me of beach bathers' talks about the human body. Human figures have long been evaluated on a scale of 1 to 10, with 10 the best rating. Everyone has his idea of the "perfect 10." People seldom agree—on the beach *or* in the photo shop. Some connoisseurs of both varieties claim the "perfect 10" does not exist. Considerations you should keep in mind to get as

Left: This is the Nikon F3 with a motor drive. Above: These interchangeable finders are available for the Canon F-1. Other camera models have similar accessory finders. Ask your dealer for information.

Above: These are interchangeable focusing screens available for Olympus cameras. The only way to find out which works best for you is to test them out at your local dealer. Some cameras are designed so the user can change the screens; others must be changed at the manufacturer's service centers.

Right: Be sure to start with a system that allows for expansion. When photography was just a hobby for me, it didn't matter. Later, I was glad I worked from the beginning with a system that allowed me to add additional camera bodies and accessories that all work together. The equipment you see here includes automatic and manual camera bodies, an underwater housing, a tripod, lenses, filters and a remote control.

close as possible to that goal of perfection include the following:

● Shutter speed is important because a 1/500-second maximum shutter speed is limiting in the sports world. I have been in situations in which 1/2000 second was barely enough. While filming a climber at high altitude in the Swiss Alps, the reflection of the snow was so intense that with the lens stopped down to *f*-16, 1/2000 second just made for good exposure. In other events, such as polo or hockey, you'll need 1/2000 second to freeze the ball or puck.

● Interchangeable finders, such as the *sportsfinder, waist-level finder* and *illuminated finder* are useful in sports photography.

With the *sportsfinder,* you can view the full frame with your eye several inches away from the viewfinder. As a result, you can continue to view the image while advancing film. A greater advantage is that you can use both eyes to look directly through the finder or at the entire field of play. And, this finder can be used in an under-

water housing so you can see the full frame through your goggles.

The *waist-level finder* has a collapsible lid that opens much like the top of a twin-lens reflex camera. It is usually equipped with a magnifying glass to make focusing easier. You view the scene from above the camera. Such a setup allows you to shoot with the camera at ground level, for example, without having to lie on your belly and dig a hole in the ground with your chin to see through the viewfinder.

Even those systems without a waist-level finder that accept interchangeable finders can be used this way. Simply take the standard eye-level prism off and look down through the focusing screen. When scuba diving, I can look down into the top of the camera while swimming horizontally, rather than assuming a vertical position to take the pictures. Of course, the camera is in a special underwater housing.

An *illuminated finder* is handy for shooting night sports or when you can't see viewfinder settings

because of poor lighting conditions.

● Focusing screens that are interchangeable are usually available for camera bodies with removable viewfinders. Some camera manufacturers offer more than 20 different focusing screens. It's nice to have a screen that suits your preference and eyesight. There are also screens for special situations. Ask your photo dealer for more information.

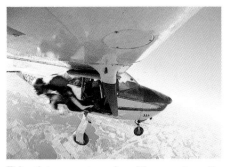

This picture was made with an automatic camera that wisely based correct settings of f-8 and 1/125 second on the lighting conditions, but was not "smart" enough to know 1/125 would never stop the action of a skydiver.

I use Nikon's standard screen, Type K. This has a split image in the center, a microprism ring and ground glass in the remaining portion. Although the split image is fast and accurate, one problem when using it with long-focal-length lenses is that half the focusing circle blacks out in dim light or when your eye is not centered in the viewfinder. Under such circumstances, I depend on the plain ground glass focusing screen that surrounds the split image area.

• Most of today's automatic-exposure camera models are electronic. I prefer non-electronic manual-exposure cameras rather than the automatic electronic cameras because many automatic cameras either stop working completely or are limited to one shutter speed if the batteries die. But you can choose whatever fulfills your needs.

Sports photography requires use of the camera for extended periods, in all kinds of weather. As a result, you'll use a lot of batteries, especially when covering cold-weather events. Even a spare set or two may not save you in the middle of a critical sequence.

Know the benefits and drawbacks of both mechanical and battery-operated cameras, and manual- and automatic-exposure models, so you can make the correct purchase decision.

Some pros like automatic cameras. One accomplished sports shooter who owns about a dozen Canon AE-1s has modified them to accept external battery sources so they can withstand his heavy use.

Although I prefer manual exposure, the automatic features are enticing. Manually operating the lens aperture, shutter speed, focus and film advance requires a lot of practice. This may never become second nature if you photograph only occasionally. You can't concentrate on the creative part of photography when you're worrying about the mechanical operation of the camera. With an automatic model, you can concentrate on adjusting what you see in the finder and leave the actual exposure up to the camera.

One thing I don't like about automatic cameras is that they let you get lazy, similar to the cruise-control feature in autos. Some people who leave everything up to their automatic cameras never realize that depth-of-field selection and shutter-speed choice should be the photographer's decision, not the camera's. Automatic functions can provide you with creative freedom or stifle it, depending on how you use them.

• Why use an autowinder or motor drive? Many of today's 35mm SLRs accept either an autowinder or motor drive. If you must skimp on accessories, don't do it here because the automatic-advance system is the one accessory sports photographers use more than any other.

The motor drive changed the face of sports photography and is still the right hand of the professional. Advantages, ranging from almost continuous viewing to stopping peak action, are outlined in Chapter 4. If you don't own an automatic-advance accessory, consider it a worthwhile investment.

When selecting a camera system, don't buy a system you may outgrow. The most common mistake is to purchase an off-brand camera, thinking you save $100 to $200 initially. Then, when you want to add an unusual lens or accessory and can't because that model doesn't accept such items, it may cost several hundred dollars to change to a system that does offer more options.

If you do not have the money to buy an expensive camera, purchase an inexpensive model in a major-brand series. Then you can trade up to a better camera body in the same series and use the accessories you bought over the years. Read all the literature you can and talk to your photo dealer.

The lens on the camera creates the image on the film. Some people think the camera body is responsible for sharp pictures. Assuming that everything connecting the lens to the body is working properly, the body of the camera, which is basically a light-tight box, has nothing to do with image quality. You are buying into a *system* and must consider every component in that system.

• Interchangeable lenses are not a feature of *all* 35mm cameras. When I talk about interchangeable lenses, I am referring only to those available for 35mm SLRs. Some models of 35mm rangefinder cameras and 110 pocket cameras offer interchangeable lens capability, but I would advise that you not use these cameras for *serious* sports photography.

An important consideration when buying a camera is that the lens system available for that body must offer the variety of focal lengths you require for the type of photographic work you'll be doing. Good lenses are available from camera manufacturers and independent lens makers.

You need the versatility of interchangeable lenses and the additional accessories available in full camera systems. Just because you don't need more than one lens now, don't assume that you never will. If you plan for the future today, you will probably save a lot of money tomorrow, when you decide you want to expand your system.

The way a lens is mounted and removed from the camera body is an important consideration. When there is fast action, you want lenses that attach and detach as quickly and smoothly as possible. Thus, the *bayonet* mount is best. Screw-mount lenses require more time to remove and mount. You want to be able to change lenses without looking, so you can keep your eyes on the action.

After the 50mm standard lens, I bought a 28mm lens and 135mm lens. These gave me creative views unattainable with the standard lens. The first time I put the 28mm wide-angle on my camera, I didn't take it off for three weeks. The advantage is obvious as soon as you look through the finder.

Don't think you must buy a camera with a 50mm lens just because the camera is generally sold that way. You can purchase a 35mm SLR camera body without *any* lens. If a dealer won't sell it that way, shop elsewhere.

Many experienced photographers don't even own a 50mm lens. A 35mm or 28mm is usually the best substitute, especially if you own a short telephoto such as an 85mm or 105mm lens.

I'd replace my 50mm standard lens with a 200mm telephoto if I had to do it over. In my opinion, the ideal system for a beginning sports photographer is a 35mm SLR camera body with a wide-angle lens in the 24mm to 28mm range, a short telephoto lens between 85mm and 135mm, and a medium telephoto lens between 180mm and 205mm. This combination offers enough variety of perspectives and angles of view for coverage of most sports.

To keep your lenses in good condition:
● Don't pick up the camera by the lens. This can put unnecessary strain on the mount. Pick up the body.
● When changing lenses, align contact points properly rather than inserting the lens and feeling for the slot.
● Always cushion the camera and lenses with foam rubber when transporting them. Better yet, if you have the space, pack the body separately from the lenses.

After the first three lenses—28mm, 135mm and 200mm—I bought a 400mm lens. Then I went to the other extreme and picked up a superwide-angle 16mm. That was followed by a 500mm mirror lens. The next addition was an 80-200mm zoom. Some would disagree and put the zoom lens at the beginning of the list, but I have already expressed my bias.

More unusual lenses are also available for use in special situations, but I prefer to rent these. For only occasional use, it is more cost effective for me to have them only when I need them. My money can then be spent on equipment I use more frequently.

EXPANDING THE CAMERA SYSTEM

Let's assume you already own a good manual camera. Now you want to increase your system's versatility. What do you buy? I suggest the automatic-exposure model in the same system. This can then be the second body and back up the rest of your camera system.

Then you can make the manual camera the workhorse and use the automatic camera for special occasions such as remote photography. With two camera bodies, you can shoot both b&w and color simultaneously or work with two different lenses.

This is the advantage of buying equipment that is part of a *system*. The system approach allows you to interchange accessories from body to body.

Next, I would suggest purchase of a motor drive for the manual body. Then another manual body. Now your automatic camera body becomes a back-up for the two workhorses or can be used with a third lens.

All You Need—This system will suffice in most situations. For many years, I completed every assignment I was given with the only equipment I owned—three used Nikon bodies and the lenses I mentioned earlier. Now I use four Nikon F bodies, which I save for underwater, aerial or other unusual assignments, and a Nikon F2AS and F3 for other jobs.

ELECTRONIC FLASH

Flashes are not strobes. Many people, even in advertising, use these terms incorrectly. Flash emits a single burst of light. A strobe produces continuous multiple bursts of light in a short time. Strobes are not used for sports photography except for special effects.

Many electronic-flash units are separated by seemingly small features. This can be a dilemma if you don't know what you're looking for. Here are some important considerations.

The *guide number* (GN) serves an important function. It refers to flash output. Using the GN, you can calculate the appropriate lens aperture setting based on the distance of the subject from the flash, and the speed of the film. Basically, you divide subject-to-flash distance into the GN to find lens aperture. For sports photography, you need a flash with a GN of at least 100 feet with

Some cameras with user-interchangeable finders can be used without any viewfinder at all. You must be very careful when using a camera this way because you are exposing internal components of the camera to the elements. This is a great advantage for tight shooting conditions or when extreme low angles are necessary.

ASA 64 film. This will adequately cover night or indoor sports over a limited distance range.

For example, if the subject is 18 feet from the flash, use an aperture of f-5.6. If it is 5.6 feet from the flash, use an aperture of f-16. This is a reasonable range of distance with a medium telephoto lens. A flash with a smaller GN will not produce enough light for you to use a telephoto lens.

Another important consideration is *recharging time*—how long it takes for the flash batteries to recharge the capacitors for another burst of light. When shopping for a flash, have the salesperson give you an actual demonstration of the unit. Time the recycling time with new batteries. You don't want a flash that takes more than *three seconds* to recharge at maximum output, or you will lose a lot of exciting shots.

You also want a flash with *both AC and DC* capability. Then you can use batteries when the flash must be portable. When such mobility isn't important, the AC adapter offers a faster recharging time. You're better off using an extension cord and AC current for photographing indoor sports not requiring much moving around on your part.

Some flash units have rechargeable battery packs that are not only economical, but well-suited to the heavy use common to sports photography. Carry three or four battery-pack replacements in a hip pocket and keep shooting with only quick battery-pack changes as needed.

Rechargeable batteries are also good because they do not diminish in power over a period of time. When they are weak, they will not function. As a result, light output and recycling time are constant. These packs use nickel cadmium (nicad) batteries that do not give you as many flashes per charge as alkaline batteries. Some flash units will not accept nicads; check the owner's manual before investing in them.

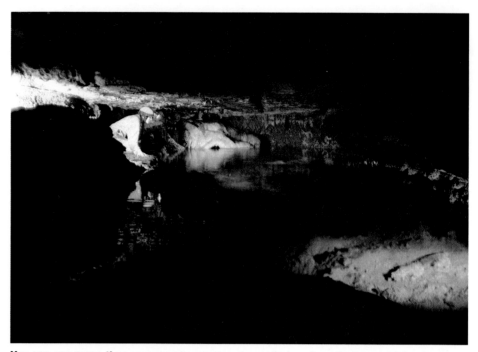

You can use more than one remote sensor, also called a *slave*, to fire multiple electronic flash units simultaneously. The dramatic effect of this underground lake and the surrounding darkness would not have been as effective if I had used a single light source from the camera. For this shot, I used two electronic flashes with long cables (to get them away from the camera) as the main light source. Three headlamp beams from cavers' helmets provided additional lighting around the edges. Exposure was 15 seconds at f-8, with one flash of the lights.

A nice feature to have on your flash unit is a *tilting head*. This allows you to bounce light off surrounding surfaces for more even, softer lighting. Some units tilt both vertically and horizontally. This provides the ultimate in utility.

The best bounce-lighting technique is to mount the flash away from the camera position. To fire the flash, use an extension sync cord (PC cord) between the camera and flash.

If using bounce lighting, remember that there is a light loss when the light is reflected from a surface. In some instances, you may have to compensate for this by moving the flash closer to the subject, increasing the light output or opening the lens aperture more. Some flash instruction manuals explain how to compensate for this. You should experiment with different lighting situations so you know in advance what to expect.

A *slave* is another way to get the electronic flash away from camera position, without having to run wires from camera to flash. However, this requires two flash units. One flash is mounted on the camera. The light-sensitive slave is attached to the off-camera flash. When you release the camera shutter, this fires the flash attached to the camera, which then creates an electrical charge within the slave, triggering the second flash. This all happens so fast that the short time lapse doesn't matter.

With slaves you can set up two or more flash units away from camera position. This has many applications for the sports photographer when the action is predictable. For example, you know that the key action in a basketball game will occur under the baskets. If you set up a tripod-mounted flash with a slave near one of the baskets, your lighting setup is ready when the players are in position.

Dedicated flash units are sold by camera manufacturers for their specific electronic camera models. These flashes tie in with the camera's electronics to give viewfinder displays and automatically set the camera at flash sync shutter speed. They also may "tell" the camera when the flash is ready to fire again.

Independent flash manufacturers also offer such units. Some have interchangeable connections so you can buy a module for a different camera. Others have multiple contacts in the foot so they can be used with a variety of camera models. This is another consideration in favor of buying a major brand of camera. Flash manufacturers only make these interchangeable units only for those models that are well established.

CAMERA SUPPORTS

All photographers try to keep the camera still enough to avoid blurred images due to camera shake. Long lenses, poor lighting and handholding for long exposures almost always yield poor results. When there is no alternative for the first two, innovative photographers come up with all sorts of solutions.

Natural Support—The most common practice is to steady the lens against a *natural support,* such as a fencepost, tabletop or guardrail. Naturally, the best support is a *tripod,* if you have the time and room to use one. It will give the camera a solid base.

Buying A Tripod—Know what you are looking for when purchasing a tripod. Look at the *legs* first. Legs with screw locks are a hassle to use and much slower than convenient flip-locks. Some tripod legs are spring-loaded—when one leg is pulled out the other two automatically open. This is handy when you have camera equipment in one hand and must open the tripod with the other. I remember the days when I used to pull two legs out with my teeth, set the tripod down and, before it fell

over, caught the third leg and pulled it out. Now I can open and set up my tripod easily with one hand.

You also want a tripod with legs that open to alternate positions, such as horizontally. This will let you set the tripod up on any terrain and keep a solid base.

I like an *all-aluminum* tripod because it's lightweight and I can set it up in water without worrying about corrosion or rust.

Another thing to look for is a *removable head.* One benefit of this type of head is that you can pull the center post out and mount it upside down, underneath the tripod for ground-level shooting. My Velbon model also has additional post lengths that can be screwed together, increasing the maximum height of the tripod.

Monopods Are Important, Too— As I mentioned earlier, a *monopod* is the next best thing to a tripod. When space limitations preclude the use of a tripod, try its single-legged relative. Basically, a monopod is one leg of a tripod with a screw mount on top.

Many sports photographers use monopods. The reason monopods are so versatile and stable is that

Some monopods are more than you think. The one I use has three "legs" that extend to make it self-standing.

most camera motion is a result of vertical movement rather than horizontal. If you support the camera properly, you can use surprisingly slow shutter speeds and long lenses effectively. Under

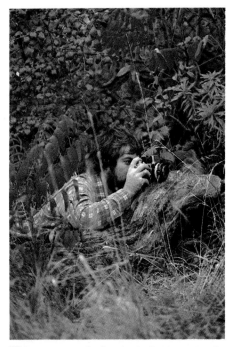
When you must shoot at shutter speeds slower than 1/60 second, stabilize the camera with anything available.

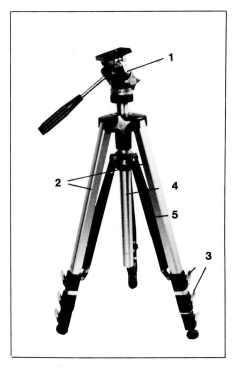
When checking out a tripod, first be sure it is made of aluminum so you don't have to worry about rust or related problems. Then consider these features: 1) Removable head; 2) Spring-loaded legs; 3) Flip locks; 4) Reversible centerpost; 5) Legs that will extend horizontally.

many circumstances, a monopod is all the support you need, and it is easier to set up and use than a tripod. Also, your two legs plus the monopod create a tripod effect.

Pistol Grip—Another popular support is the *pistol grip*. It looks like a pistol and mounts on the tripod bracket located in the center of most long telephoto lenses. This helps balance the weight of the camera with the long lens mounted on it, making it easier to hold with the right hand while focusing with the left. A shutter-release cable connects the trigger mechanism on the grip to the shutter release on the camera so you can fire from the grip.

Gyroscope—The latest camera "support" system is the *gyroscope*. It doesn't really support any-thing—it stabilizes the camera and

Whether you are shooting close-ups of flowers at 1/15 second to complete a picture story, or speedboats from a floating dock, the Kenyon Gyro Stabilizer will steady your handheld camera. You do not have to have a solid base to rest on. As a result, you can shoot from a moving object, even at a slow shutter speed and with a long-focal-length lens. The disadvantages are its cumbersome power supply and high cost. Photo by James Tallon.

lens. Used in spacecraft and submarines, gyroscopes have also been modified for use with telescopes. Recent miniaturization allows use on cameras with long

lenses. You mount it under the lens instead of a tripod, and hand hold the unit. It is bulky with its power supply—and is very expensive.

There are many other gadgets, some of them do-it-yourself ideas. They range from foot straps to bean bags to window blocks. It is most important to select a system that fits your needs and be aware of alternatives that may work better.

Quick-Release Tripod Head—This is a good accessory you can use with any stabilizing device. The traditional way to attach the camera to a tripod is with a "time-consuming" screw attach-ment. The quick-release head screws into both the camera and tripod and separates with the push of a button, allowing you instant mobility and freedom from the tripod.

SPECIALIZED EQUIPMENT

Some of the latest designs and functions of the 35mm camera have been made with the sport photographer in mind.

Bulk-Load Film Backs—Some cameras allow you to replace the standard camera back, which is basically a hinged door with a pres-sure plate, with special backs for use with longer lengths of film. These specially designed camera backs accept bulk-loaded cassettes for up to 750 exposures.

These are life savers in situa-tions such as scuba diving, where changing a roll of film would entail coming back to the surface, board-ing the boat, drying the housing, reloading, and then going back down to find whatever it was you were shooting. Even on land, the increased "mileage" per roll helps, such as in remote-control situations or when you are shoot-ing extra-long sessions. This saves a lot of valuable time that you would normally spend changing rolls, too.

The disadvantages of the long-roll film backs are the increased

There is a Nikonos on the front seat of this raft ready for use. Although it's designed for shooting underwater, it's also ideal for top-side wet sports. This shot was made with a Nikon F, safely mounted inside an Ikelite housing. Water splashed on the housing created this interesting effect.

size, bulk and weight of the equipment, and the sometimes dif-ficult loading and processing, par-ticularly if you haven't finished the roll. But generally, the value of the extra shots is worth the minor inconvenience.

Underwater Cameras—This type of equipment is not only for divers. The Nikonos is a good camera to use in wet-weather shooting, such as on a yacht, in the rain or on the beach. It is also excellent in the snow because it can be dropped, is not affected by extreme temperatures, and mois-ture from condensation will not corrode it.

An alternative to the Nikonos is an underwater housing made by Ikelite and other manufacturers. An underwater housing allows you to use your standard camera together with lenses and other ac-cessories in your existing camera system. Don't just associate under-water cameras and housings with underwater use. Waterproof cam-eras and containers also provide protection against dust and other conditions that the sports pho-tographer frequently encounters.

Sequence Camera—A sequence camera stops action when a standard camera is not fast enough to record the event. Some sequence cameras are capable of shooting at speeds up to 44,000 frames per second! You can sure use a lot of film this way. There are also models that photograph from 5 to 500 frames per second. You will probably never have a need to use such equipment, but will no doubt enjoy visualizing how sequences can be broken down into minute fragments this way.

Because this equipment is very expensive, many large photo equipment rental houses offer sequence cameras on a day-rate rental basis. When a professional

This Photo-Sonics Actionmaster 500 camera can operate at up to 500 frames per second. It was used at the 1976 Montreal Olympics. These cameras are very expensive, but can be rented from some large photographic dealers.

has a one-time need for such specialized equipment, he rents it rather than spending a lot of money purchasing it. If you want to rent any equipment—a sequence camera, a special lens or other unusual item—check with a professional equipment dealer or look in the Yellow Pages under "Photographic Equipment and Supplies."

Equipment selection will affect the quality of your photographs in the long run. Start off with wise decisions that you won't regret later. The first body you pick may dictate many of your future decisions—try to land a "10."

CARRYING IT ALL

By now you're probably wondering how you're going to carry all this equipment. The biggest mistake people make when purchasing an *equipment bag* is buying one large enough only for the equipment they presently own. Allow for more equipment. Purchase a bag larger than you think you'll need. Don't worry—you'll eventually fill all the pockets, I assure you.

Shoulder Bags—When I photograph an event that doesn't require much moving around, such as a basketball game, I carry all my equipment in an easy-to-reach shoulder bag that I can set on the floor beside me.

One thing I want in an equipment bag is plenty of *external pockets*. It's easier to reach into an outside pocket than rummage

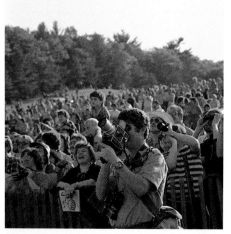

Use a shoulder bag when you don't have to do a lot of moving around. Be sure the strap is wide so it distributes the weight better. A narrow strap will cut into your shoulder.

through a large interior one to find a small accessory. Some bags have removable pockets and zippers to attach additional pockets—not a bad idea. The more compartments the bag has, the better.

Another important option is a *shoulder strap*. Sometimes you forget about an item like this until you have to use the bag. You want the option of having your hands

free while carrying your equipment bag.

Don't buy imitation leather. It won't last. Look for Cordura or real leather that will withstand heavy use and moisture without falling apart.

Rigid Cases—A hard-shell carrying case made of aluminum or fiberboard is good for traveling. It

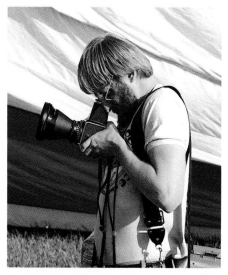

A hardshell case is useful for transporting equipment, but don't plan to carry it around while you are trying to take pictures. This photographer had trouble because he had one aluminum case on each shoulder.

provides more protection, security and accessibility than a soft bag. The best hard case you can get is the type that is filled with diced foam. Individual openings are cut for the different pieces of equipment. There are also cases that have a solid piece of foam that you can cut for your specific equipment. Or, you can get a sturdy non-photographic case, buy some thick foam and customize a case that way. Such a secure system reduces vibration on your equipment and keeps the pieces from knocking against each other.

Junkers—Choose a case with an exterior that will not attract a thief. Some photographers like to convert old suitcases rather than use the obvious aluminum camera carrying cases that say, "I've got lots of expensive equipment inside. Take me!"

HOW TO CONVERT A DAYPACK TO A CAMERA BAG

It's important that I have all my equipment with me when shooting, but I also want to be able to use both hands. A shoulder bag isn't good because it takes up valuable space for hanging a camera, and can slip off. Although good commercial packs are available from camera and backpacking stores, they are relatively expensive, so I converted a daypack for my needs.

To make your own, buy a waterproof daypack with one large compartment. It should be deep enough so 5 inches of foam in the bottom lines up flush with the zipper. Daypacks are available in large department and backpacking stores. You can find foam in fabric stores and upholstery centers.

Buy either five sheets of 1-inch-thick diced foam, which you have to glue together to make one thick sheet, or a 5-inch-thick sheet of solid foam. Follow the instructions below to convert the daypack into a camera bag.

Step 1: Trace the outline of the pack onto the foam, using a marker or soft pencil. Do this *twice*—once for the bottom, which will hold the equipment, and once for the lid of the pack. After you cut the foam, fit it into the daypack to be sure it fits tightly and doesn't move around. Remove the foam from the pack.

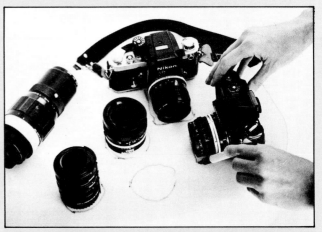

Step 2: Next, arrange your photo equipment on one piece of the foam, with the gear you use most often toward the front of the pack. Outline each piece. Be sure the lines you draw are precise. You want the pieces to fit snugly into the cutouts.

Step 3: Cut the sections with an electric knife or sharp razor blade. Be accurate. Make the cuts straight so each opening is consistent from front to back. Do not cut at an angle. The best way to cut is to move the foam, keeping the cutting blade in a vertical position.

Cut completely through the foam. Later, you can glue an uncut piece of foam to the back. Or, once you remove the individual pieces, cut each one in half and glue it back into the hole you just made. Using this approach, you can control the depth of each hole, depending on the piece of equipment it is for. Don't try cutting partway through the foam. There is no simple way of extracting part of the piece.

Step 4: After you have made all the cuts, position the foam in the pack, and then place the equipment in the appropriate openings to make sure everything fits. Then, remove everything again. If you are adding a piece to the bottom of this section for cushioning, glue this in place now. Use contact cement.

Because the foam is so porous, you'll have to apply one coat to each surface, let it dry and then add a second coat. When the second coat is tacky, press the two pieces together, being sure to *align them perfectly*. You can't separate them easily once they've made contact. Then, put glue on the bottom and sides of the pack and insert the foam. Glue the other piece of foam you cut out in Step 1 to the lid of the pack.

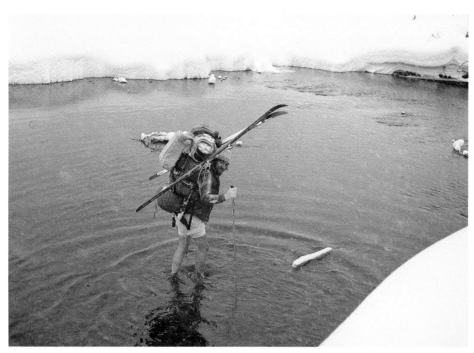

You can attach the camera pack to the back of a regular backpack. It's easy to move it around in front for easy access by pulling on the cord that holds the camera pack to the backpack.

Hip Pouches—The one disadvantage with the daypack is that it must be removed from your back to get into it. The solution is to carry a hip pouch, or fanny pack, for lenses, a camera body, film and other accessories that you may need frequently. There are many fine commercial hip pouch-

To carry equipment used most frequently I wear this hip pouch on my waist or buckled around my backpack when I'm using one. It also works well in combination with the daypack.

es. I use the Camp Trails model because it's rugged and large enough to carry the equipment I need. You can wear the hip pouch on your back, underneath the daypack, and move it to the front as needed.

Warning: Don't leave the pack open even for one picture. When you grab something out of the hip pouch, you tend to leave the pouch open. It's too easy to start shooting again and forget that you left the pack unzipped, spilling the equipment onto cement, mud or whatever.

On assignment in Austria, I was shooting cross-country skiing. When a skier high in the Alps took a plunge, I needed a long-focal-length lens to capture his fall. I pulled my pouch around, grabbed the 200mm lens and snapped it in place while raising the camera. I was still not close enough. I instinctively skied closer before making the exposure. During my descent I, too, went down but had no fear because my equipment was well protected.

About 45 minutes later, I pulled the pouch from my back to change lenses again and was horrified. Lenses and all my film were buried in snow inside my hip pouch. That's when *I* learned *my* lesson.

TAKING EQUIPMENT OVERSEAS

To avoid hassles with customs and other agents, here are several things you can do when taking your equipment overseas.

Insurance—Your gear should be insured anyway, but especially when traveling. Many insurance agents will tell you coverage is not available just for camera equipment and that you need a floater policy on your homeowner's insurance. Baloney! Ask your agent about a Schedule Personal Property (SPP). You can also ask about an Inland Marine floater for your policy. Or, check with your local camera store; they may know about policies that their customers have been happy with.

Photo Inventory—Make a photo inventory of all your equipment. This is easy. Position everything on a sheet of white background paper or other plain background. Leave space between each component. Borrow a friend's camera and take a b&w picture of all the equipment at once. Make an 8x10 print. Use a magic marker to write the *serial number* of each piece of equipment next to it on the background. Store this record in a safe-deposit box or other safe place located away from where you keep your equipment.

Some insurance companies request proof of ownership with the picture or some other way of showing the equipment was in your possession. The owner's manuals may be all you need. Even if you have the information in those manuals memorized, write the serial numbers on them and keep them around—just in case.

US Customs—When taking photo equipment overseas, you have to

fill out form 4454 at the US Customs Office to prove ownership of the equipment before re-entry into the country. Without this form, customs officials may consider it new equipment that you bought overseas and may charge you duty on your equipment when you return home. Fair or not, it happened to one of my friends.

To avoid problems, follow the rules. You can fill out the form in advance to avoid having to take the time right before departure.

Call the local customs office for information about procedures. Regardless, you must go to the customs office at the airport. When you are at the airport and ready to complete the form, you must have access to the equipment you are declaring because the serial number of every piece of equipment must be listed.

Airport Security Systems And You—A problem you will run into at all airports is security. Regardless of what the signs say, don't take any chances with X-ray machines. When you've spent considerable time and money making photographs away from home, you don't want to risk losing the images.

There are several potential problems. Most of them apply to both domestic and international air travel. If you are making many stops on your trip, and go through X-ray surveillance each time, the additive exposure to this radiation may affect your exposed and unexposed film. And, even though the *normal* short exposure to X-rays *might* not contaminate your film, damage could still occur. And, many countries do not regulate radiation levels so you never know which machines are the "killers." The best solution is to avoid X-ray machines when possible.

Security agents are required to inspect by hand if you request it. Sometimes it requires *demanding* rather than requesting, and on occasion I've had to stomp my feet and shake my fist. Insist on hand inspections for all your film, and your cameras, if they have film in them. Causing a little commotion is better than having damaged film.

Sometimes the agents do not want to inspect your equipment by hand, and will delay you. If you are late for your flight, you have to let them do what they want. Allow plenty of time for lines and inspections when adding this element to your trip.

Commercially available lead-lined bags and lead-lined sheets will help if your film does go through X-rays. Ask your photo dealer about the Sima FilmShield.

Film—Don't plan to buy film overseas. The kind you want may not be available—and if it is, it could cost up to four times more. Figure that you *will* run out of film. Then decide what you need—generously—and double that number. You won't regret it.

Some countries charge duty on film brought into the country. For instance, in Austria there is more than 100% duty on each roll over 10. These regulations are designed to discourage tourists from selling film on the black market.

You can pay the duty or try to get around it by splitting up your film and carrying it in several different cases. It also helps to take the film out of the boxes, leaving them in the plastic containers. This suggests that you don't intend to market it. Your only other alternative is to do what I said not to do: Buy film at your destination.

Don't have film processed overseas. Too many potential problems exist, such as inadequate mail services and undependable labs. *Don't mail* the film to your home in the US, planning to have it processed after your return. One friend mailed 20 rolls of Ektachrome to the US from South Africa in June 1979. It arrived at his home in December 1980! According to some sources, he was lucky the film arrived at all. Carry all the film in and carry it all out again.

And when you do have your film processed, if there is a lot of it, don't take it all in at once. If there is a problem at the lab and some film is damaged or ruined, you would like to be able to save at least some of it. This is not a common occurrence, but why take chances?

Take Only What You Need—Don't overdo it with equipment. Take only as much as you can carry. Don't ever let it out of your sight. I refuse to check my photo equipment as luggage on airline flights. And leaving photo equipment in a hotel room is about as good as handing it to a stranger and asking him to watch it for you. The only way you can be secure is to keep your equipment in your own hands.

7
Creativity

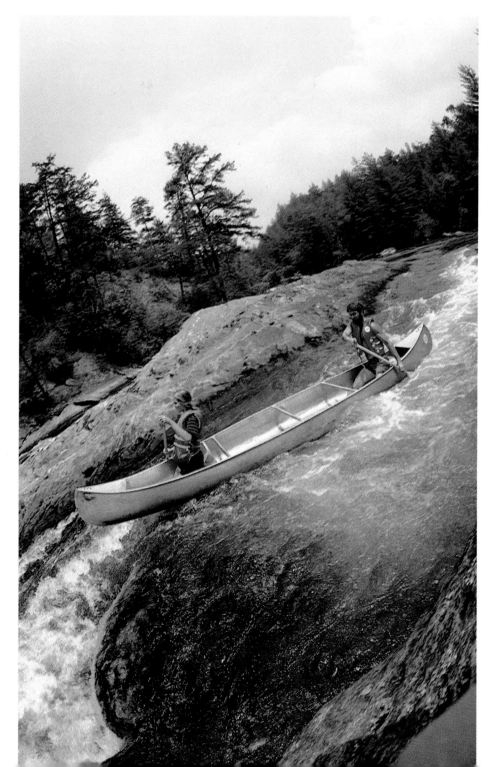

My definition of *creativity* is, *deviating slightly from the standard.* Some would say creativity must come from the photographer and has nothing to do with the camera. I mildly agree with the first half of that statement and strongly object to the second. Credit for half the pictures pegged as "creative" should be given to the capabilities of today's "smart" cameras.

WHERE TO FIND CREATIVITY

Once upon a time, you could count on the accurate rendition of a scene in a picture made with a Brownie box camera. Generally, what you saw was what you could expect to get. Today, many cameras can "see" things either too small or too fast for the human eye. They are also capable of exaggeration that would top most fish stories. Your camera will "say" anything you ask it to—sometimes more than you ask—with a perfectly "straight face."

"Creative" Equipment—To best "release your camera's creativity," first you must find out what it can do. I realize that most people don't look at an owner's instruction manual until the equipment breaks down, but I'd like you to break that tradition. You would be amazed at all the kinds of effects you can achieve with your camera if you sit down and read the manual that comes with it.

Sometimes you can lie with your camera. This picture was made using a 16mm lens that distorted the angle of the river, making it appear much steeper than it actually was. The resulting image is very dramatic.

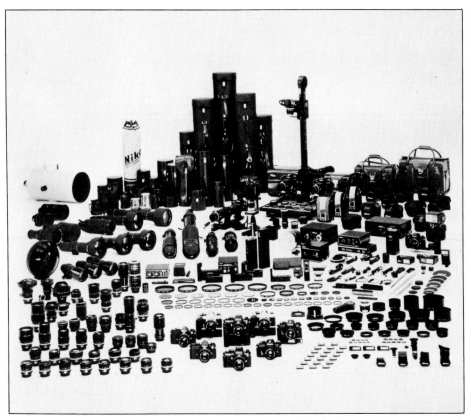

Most camera systems have numerous ingenious accessories that camera owners are not aware of. This shot includes many of the Nikon accessories. Photo courtesy of Nikon, Inc.

When I was a salesman at a photo store, I sold a camera to one fellow and loaded a free roll of film for him. More than a month later, the customer returned and handed me his new camera. Bewildered, I asked what was wrong. Although his look said, "What's wrong with *you,* mister," what he actually said was, "I finished the roll of film!" Apparently he thought it took a technician to load and unload the camera—testimony that he never bothered to open the manual.

Assuming you know how to load and operate the camera, there may still be some functions you don't know exist. I had been using Nikon FTN models for many years and figured I knew it all when I acquired my first Nikon F2AS.

Almost a year later, I was standing in a remote patch of Wisconsin woods at midnight on the second day of January, with my knees knocking and my teeth chattering.

I had a perfect picture lined up—an oil lamp burning in a trapper cabin's window and stars overhead—and needed an eight-second exposure.

I knew the camera was capable of such a long shutter speed, but I couldn't figure out how to set it. I pushed every button and turned every dial, but nothing kept the shutter open longer than a second. I felt like an idiot while my beautiful picture faded into the night.

My suggestion: Go back and read the boring parts of the manual. It may open your shutter some day.

Catalogs—When you know what your camera's capabilites are, flip through a complete catalog of accessories. Your dealer should have one, or you can write to the camera company. A quick glimpse at this catalog should reveal equipment you didn't know existed.

The first time I journeyed through one I discovered that my camera would accept a 4x5-inch

film back. There is also a wireless, remote-control shutter release that actuates the camera from 2500 feet away. There are flashing lights that hook to the end of the lens and a device that lets me write on the film. I almost expected to find an accessory that would talk back to me. And now they have some 35mm cameras that do just that!

Once you've seen what's available, go to your dealer and try the ones you're interested in. Mount a 13mm lens on your camera and see things behind your back! Or look through a long lens that picks out a loose thread in the shoestring of a man walking down the sidewalk a block away. You can test unusual equipment at large photo stores that rent photo equipment.

Gadgets—When you are familiar with all the options the manufacturer of your system offers, check out accessories from independent companies. Although you may see some items you have no use for right now, there are many problem-solvers that you may be able to put to work immediately. You'll find filters that accentuate clouds in the sky, add streaks of light through the window and turn

I was told I couldn't remotely trigger a waterproof camera. When I heard that, I decided to do it anyway. I took a standard Ikelite housing, removed the built-in battery components that are normally used to power a motor drive, took out the lever that triggers the camera shutter, and ran a 10-gauge wire through that opening. I sealed the hole with duct tape, put a camera with motor drive inside and plugged the wire into the motor drive. This contraption has been working beautifully ever since.

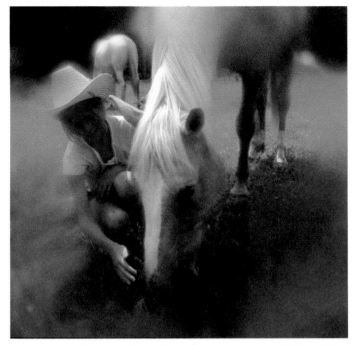

A soft-focus filter is a nice gadget—but remember that's just what it is. Gadgets should be used sparingly. Overuse can bore viewers.

I decided to make an exposure *before* this balloon was inflated to add impact and color to my shot. I used a 200mm lens to compress the layers of color for a more dramatic effect.

lights into stars. The book about gadgets I mentioned earlier features more than 350 such items.

Experiment—To learn what your camera can do, you should *experiment*. Read the camera owner's manual. However, if the manual says anything about pictures the camera cannot take, such as "when the little red light comes on it means it's too dark to take a picture," don't believe that's true under *all* circumstances. Camera manual writers are very conservative. If you accept their interpretations of what you can't do, you'll lose your spirit of adventure. Experiment, and you'll find that your camera can, indeed, perform feats that might raise the designer's eyebrows.

Breaking Habits—Continue experimenting with your equipment and subjects. My college photogra-phy professor made his students break out of the run-of-the-mill picture syndrome by having each of us expose a roll of film without looking through the camera viewfinder. He suggested that each student hold the camera over his shoulder and snap a few pictures while walking on the sidewalk; line up the desired picture and shoot from the hip; or set the camera on the ground, start the self-timer and see what the camera "captures."

I set the camera on a tripod, loosened the tripod's swivel head, set the self-timer and spun the camera. The object of this assignment was not to develop any technique skills, but to demonstrate *new perspectives in seeing*. We all develop our own way of seeing, which might be called individual style. But many of us never deviate from that style. That way of seeing may be unique to only one person, but it is still a good idea to try something new—to break that habit with a conscious effort.

One way to become aware of new approaches is to look at what other photographers are producing. You'll get a lot of good ideas from magazines. Don't limit your search to just photographic publications, however. Although some photography magazines showcase new and creative approaches more than others, I find that the best source for new angles in sports photography is the sports specialty magazine. Almost every one offers photo features, photo contests and gallery sections displaying the best each sport has to offer. Most magazines feature advertising using photography, so look at these, too.

Don't pick out the pictures you like and try to duplicate the shot.

Look at the photo on the far left and determine what you *don't* like about it. Here are my impressions: The hiker is too small and gets lost in the forest; his sweater and backpack are the same color as his surroundings. What would you have done differently? You could trade places if your clothes were brighter. You could photograph him on the near side of the river so the whitewater would make him stand out. Or, you could get closer and make him a more prominent part of the picture. At left, even though the subject is similar in size when contrasted against his surroundings, he stands out better.

That's defeating the purpose, and not very instructive. Look more at the *techniques* used to achieve the effect. Try to work these techniques into your own shooting style.

Judging—Look at the pictures and pick out the elements you like and don't like. Pinpoint what qualities attract you or which ones don't appeal to you. And don't be satisfied with the pictures. Think of ways to improve them. Most of us simply skip over the pictures we don't like, but a lot can be learned from them. Determine what makes the picture unappealing and keep a mental list of things you want to avoid.

Keep your eyes open when you're walking around—your mind's eye and your other eyes. I'm constantly looking for new settings, new subjects, anything different enough to demand my attention. I pick up new photographic ideas everywhere.

Remember, where you are right now is different from everywhere else. Some people erroneously think you have to travel to unusual spots to make good photographs. *Everyone* shoots the big events; if you go to shoot them, your pictures may look just like the next photographer's.

Your own community is one of the best places to find distinction. Learn to exploit your surroundings. I almost have to say that

under my breath because it's gotten me into a lot of trouble.

My first creative impulse had me launching my 15-foot canoe off Belmont Harbor in downtown Chicago during a small-craft weather warning. I figured a stormy Chicago skyline from the deck of a canoe about a mile out on Lake Michigan would be a fresh and exciting photo. I was halfway out when a 26-ton police boat tracked me down. I was escorted back into the harbor, issued a ticket and told I should have gotten two more. As if the loss of my picture were not enough, I had to sit in Canoe Court for three hours before paying my fine. Still, I think it would have made a grand picture. Some day I plan to sneak back out and get it.

Feeling defeated, I kept my eyes open for another good spot to photograph my flaming red canoe. I found a beautiful hidden lagoon, but had to drive my Jeep up the railroad tracks a few hundred yards to get there. Later I learned a Milwaukee Railroad employee had seen me on the tracks and called the police. Before I took the first picture, the sheriff arrived, told me the party was over, and arrested me for trespassing. It cost me $500 before I left the courtroom that time. I'm still creating photographic schemes for my little red canoe. You should be making off-the-track ideas too—but make sure yours are legal.

Retakes—I have never covered any sporting event that didn't generate new ideas while I was

shooting it. As you're shooting and when you review the results, you'll get more ideas. It's called *serendipity.* Involvement starts the process. The more you think about it, the greater your chances of developing a new approach.

If you shoot the same thing three or four times, all sorts of ideas will emerge. One thing builds upon another until soon you're coming up with wild ideas that sometimes come to life.

The first time I tried to photograph skydivers, I thought I was doing well with a few exposures of guys landing and a few more showing them packing their chutes on the runway. Next time I wanted more so I went up in the plane and shot them kneeling in the cockpit and exiting through the door.

That gave me the idea to mount the camera on the wing tip and shoot the divers falling away from the wing strut. I waited until we were over snow-covered ground and used a 16mm lens to get it all in, shooting them hanging on for dear life. Unfortunately, the camera was too close so all that shows is the plane's wing and the divers' heads. So next time I mounted the camera on the tail wing and caught them falling from the plane.

Then I decided I wanted to use a 500mm lens and shoot from the ground as the divers spread out below the plane. I also wanted a close-up of the divers landing next to my 16mm lens. After that, I

was itching to get back up in the air so I went up in a separate plane and flew beside the skydiver's plane, photographing the divers when they dropped away. That looked pretty good, so next we followed the divers down and I shot them freefalling.

By then I wanted something different from just plummeting bodies, so we lined up a four-man chute stack and I filmed it air-to-air with the rolling Wisconsin hills below. That gave me a better idea: I went back up in the drop plane and with a long lens shot down on the skydivers with the lakes and trees below them appearing frighteningly close.

My next idea is to take a step ladder to the landing point so I can get a little above ground level. From the top of it I plan to shoot the divers coming in at high speed, the grass blurred behind them. And while I'm working on that one, I'm bound to come up with another.

UTILIZING TECHNOLOGY

As I mentioned, one way to gain creativity is to buy your way out of the banal. That's not so difficult anymore with equipment getting less and less expensive. When I was in high school, I thought millionaires were an elite group. I was proud that I knew one personally. Now that one out of every 400 Americans is one, I've decided they're not so elite.

Sometimes a filter can improve an image. Most often, though, it doesn't. Before you use a filter such as this one, visualize how the photograph will look with and without the filter. Remember, if it is obvious you've used a filter, that effect is drawing attention away from the subject—unless that's your purpose.

This picture was made on my attempted journey to the private lagoon, after crossing the tracks and only minutes before I was arrested for trespassing. See the text for details.

Likewise with owning unusual photo equipment.

Not too long ago Nikon was the only manufacturer of wireless camera shutter releases and they wanted $500 for the unit. Now many companies offer them, some selling for less than $100. As a result, there's a lot of affordable technology available. While it certainly can't make you creative, this equipment opens up a new world of effects you can create—if you have the imagination and skills to use the technology.

High-Speed Motor Drive—The high-speed motor drive opens new doors to sports shooters. For example, with a fast-enough shutter speed set on your camera and with one of these motor drives, you can photograph a series of shots that "stop" a 700mph rocket-powered car in mid-flight. But you don't have to own the top-of-the-line motor drive. You can effectively use less expensive, slower units in all but the most extreme situations.

Filters—There are many filters guaranteed to "add that creative touch to your photos." In fact, Cokin, with their filter-holder

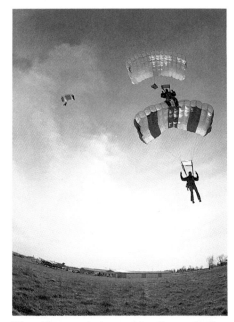
When I began photographing these skydivers, I just wanted to catch them landing. Little did I know that before I was through I'd be jumping myself. This shot shows how one idea leads to another. The more you shoot a sport and get to to know it, the more ideas you'll have.

concept, promises more than 300 image modifications.

Filters can be helpful. A useful filter for color photographs is the *polarizing* filter. Its main function is to reduce reflections and in so doing deepen color saturation. It can darken the sky, thereby making clouds look whiter. The filter is most effective on the blue sky when aimed at a 90° angle to the sun. If the sun's not out, it won't do you much good.

Another filter you can use with either color or b&w film is the *neutral-density* (ND) filter. The ND filter cuts down the light entering the lens without affecting tones or colors. So when you want to slow down shutter speed or open the aperture for less depth of field, which is not always possible with certain film and lighting combinations, this is the item you need.

You may find a *half-tone ND* filter useful. It graduates from a clear lower half to a neutral density upper half. Use this filter to darken skies when you want detail to show in the foreground. The

This is an example of the results from a lens accessory called a *rainbow refraction filter,* used just for the sake of using it.

fast, defeating the purpose of these special accessories. A good rule to remember is that use of filters should not be obvious in your photographs. The viewer generally should not be able to tell that you used a filter—unless you want the special effect to stand out and be the focal point of the photo.

Use It But Don't Abuse It—A friend once asked what I think about *2X converters.* When I told him I don't like them, he winced and said, "Well, not everybody can afford to buy big lenses—and they're better than nothing." I disagree. These converters mount between the lens and the camera body, doubling the focal length and aperture of the lens. For example, with a 2X converter, your 50mm lens set at *f*-4 will effectively be a 100mm lens shooting at *f*-8.

Few 2X converters I've used have produced sharp enough images for my needs. It's even worse when you use them as a convenience to avoid having to move closer. Most of the time you can get closer. But if you have a converter, you may not bother.

● Everyone has to use gimmick filters at the outset to get the urge out of his system. But once that's done, leave the filters home. There are filters to put stars in your model's hair, rainbows in the sky or to give three heads to a subject. Don't use the cheap tricks unless the image requires special treatment. Otherwise, the effect may overshadow your subject. If the subject needs that much help, perhaps it wasn't worth photographing in the first place.

● When writing a magazine article about how to keep your camera dry while running rivers, I received a package with a few things the magazine's editor wanted me to test and mention. One item was a plastic box that looked like a space-age gun holster and supposedly was made to hold a camera. It was approximately the size of a camera, but could hold no more

half-tone ND filter only affects the upper half of the picture, or the bottom half, depending on how it is turned.

Another half-filter you may find useful is the *split-image* filter. This one has a close-up half and a clear half. When you want both close and distant subjects sharp, it

allows greater than normal depth of field.

I could fill a book talking about types of filters and how to use them. There are many different effects. Ask your photo dealer for more information about the available brands. Remember that special effects should be used sparingly. Overuse can get boring

than one body and one lens. What good is that? Why not just carry your camera—at least then you can use it without first wrestling it out of the plastic holder.

The carrier may have had some remote functional value if it protected the camera, but I held it under the shower for two seconds and it filled with water. I carefully wrapped it and sent it back to the editor, thanking him for use of his bathtub toy.

● You'll find many *camera bags* in the stores, but if you want a good system for carrying a lot of equipment, try the daypack I describe in Chapter 5.

DOUBLE EXPOSURE: PROS AND CONS

There are two ways to achieve double exposure. You can manipulate the original film or sandwich pieces of processed film together.

Film Manipulation—This is the hardest to control. The advantage of double exposing film is that you have a sharper image requiring no special darkroom wizardry. But results are hard to predict and the double exposure is permanent.

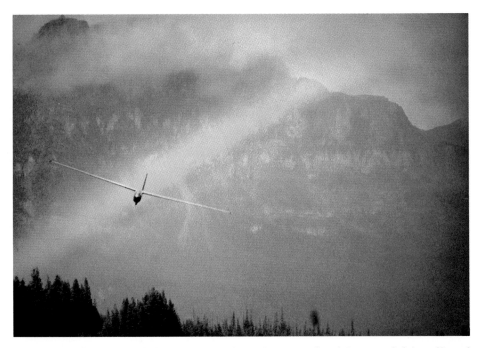

There are unlimited possibilities once you know how to make picture sandwiches. Here, I had a nice shot of a rainbow, and sandwiched it with the glider. Imagine shooting a glider and then trying to find a rainbow in front of a mountain to double expose in your camera!

An alternative I prefer is to make a sandwich, discussed later in this section.

● Some camera models have special features allowing relatively accurate registration and multiple exposures on the same frame of film. This allows you to recock the shutter without advancing the film to the next frame.

Although other cameras may not have a multiple-exposure control, such a procedure is possible if you defeat the built-in double-exposure-prevention mechanism. To make a multiple expo-

sure with this type of camera, first be sure the film-wind lever is tight. This gets the film as flat against the pressure plate as possible. Then make the first exposure. For the second exposure, push the rewind button to disengage the film advance ratchet. Recock the shutter and make the next exposure.

With other cameras, you must advance the film and then rewind it to the previous frame. Check

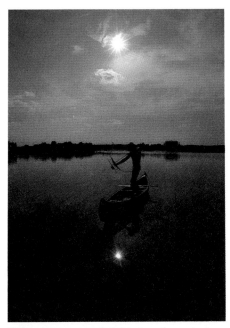

This was a very bright day. I wanted an eerie nighttime effect, so I used a neutral-density filter to cut down on light reaching the film. The small aperture and bright light created the star effect.

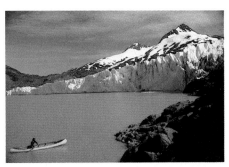

A polarizing filter cut reflections and increased color saturation to make the ice and canoe stand out better.

If you don't have a dark background when you make a double exposure, that background will be obviously overexposed, and will compete with the main subject. I made this by holding the rewind button while recocking the camera shutter using the camera's motor drive. I followed the subject and refocused as he approached my position. This was an experiment that *didn't* work.

135

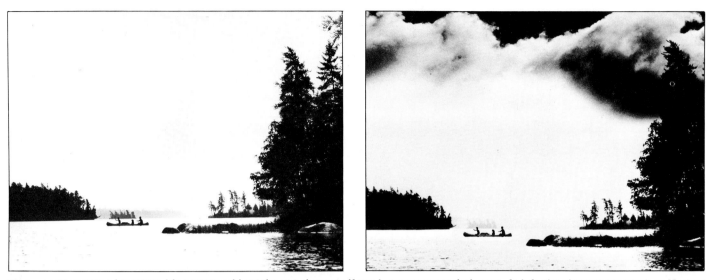

When working with b&w prints, it's easy to add or take out elements if you have your own darkroom. At left, the sky was too stark as Mother Nature offered it. In the darkroom, I added the clouds. I think the clouds make the viewer wonder what is going to happen to the people—will they encounter a storm?

the camera owner's manual. Few cameras offer precise film registration, but in most instances this is of little concern.

When using these multiple-exposure techniques, you have to compensate for the extra light hitting the film. Because light is reaching the film frame more than once when you are doing two shots on the same frame—a double exposure—you must cut the exposure in half to prevent overexposure. For example, if

I prefer sandwiching—mating two or more pieces of film together in a single mount—rather than trying to create a double image on a single frame of film. This picture would have been extremely difficult to produce on one frame. I photographed a glider against a white cloud and sandwiched it with a scenic shot that lacked a main subject but had a layer of clouds in it. The clouds make the glider stand out. Together, the shots make a stronger image.

normal exposure for two scenes of a double exposure is ƒ-4 at 1/60 second, expose each at ƒ-4 at 1/125 second. This underexposes each image by one step, half the normal exposure. They add up to one normal exposure. For a triple exposure, give each image one-third the normal exposure. Some camera models have an exposure-compensation dial for this procedure; others require use of the camera's film-speed dial.

This is a general guideline and only works if each part of the multiple exposure has approximately equal amounts of light and dark areas, and there will be an overlap of light areas.

Exposure Control—If you plan to make a multiple exposure with dominant areas of your subject overlapping, the easiest way to calculate exposure is to divide the ASA of the film you are using by the number of exposures you intend to make. To make two exposures on Tri-X film, normally rated at ASA 400, set the film-speed dial to 800 and follow the camera meter's settings. Three exposures on Kodachrome 64 should be made with the film-speed dial set to 200. Be sure to return the film-speed dial to the proper setting after completing the multiple exposure. Otherwise,

you'll get underexposed photographs on the rest of the roll.

Sandwiching—In my opinion, a better way to get double exposure is by *sandwiching*. With this technique, if you want to add a sunset or trees to a scene, you take two separate slides showing those subjects out of their mounts, place the pieces of film together and remount them in a single slide mount. Combinations are unlimited. It's easy to test the combination before you mix them by stacking the individual slides together and holding them up to a light source.

You can do the same thing with negatives by printing one on top of the other. Many of my b&w outdoor sports pictures look drab with clear, cloudless skies. I frequently change them by making the enlargement, then switching negatives and re-exposing clouds in the empty sky.

The main advantage of superimposing in the darkroom rather than on original film is that you're not locked into the combination. If you change your mind or want to rearrange things later on, you still have the original, unmodified film. Another advantage in the darkroom is that images can be shifted into their desired positions before they are exposed.

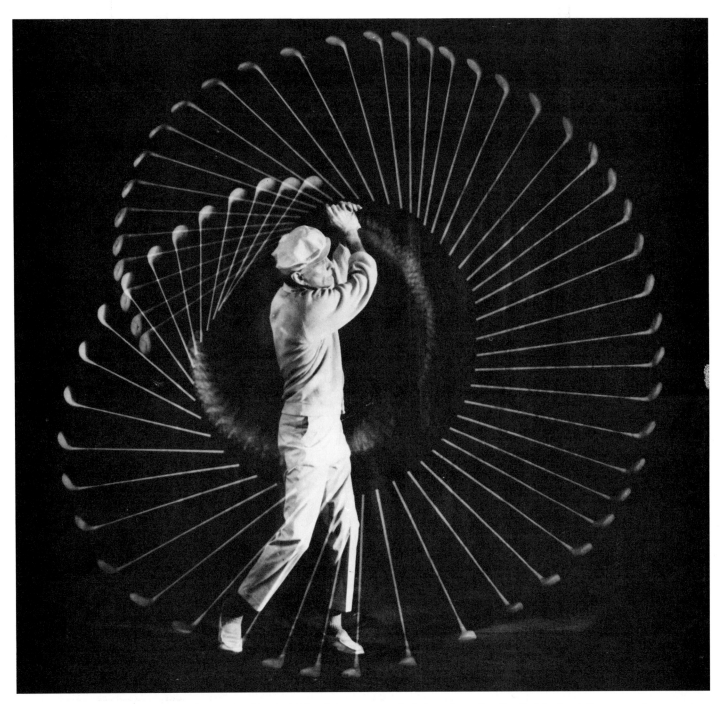

Miles Boland used a Norman Cine-Strobe for this shot. The picture was made in two steps. For the first, he kept the camera lens aperture open and fired the strobe repeatedly as the golfer, dressed in black clothing, swung. As a result, only the golf club showed up. The background was dark and there was little ambient light. For the second exposure on the same frame of film, the subject wore lighter clothing. Boland used one flash emission to illuminate the golfer's form.

I have not gone into great detail about these techniques because this is neither a book about slides nor one about the darkroom. My purpose here is to help you get the images on film. Then you can read other HP books and experiment with different ways to improve or alter those images.

When you think of *sports,* you think of action or movement. When photographing it with a 35mm SLR, you are trying to "stop" the action and document it on a piece of film. There are ways to show or imply motion on film.

Strobe—The most common method of showing action is with

repeating image—having one figure appear numerous times in the same picture. Position the moving subject against a black background. When you are ready to begin the exposure, set the camera to B. This will hold the camera shutter open. If you have a stationary object in the picture, cal-

culate exposure so the combined flashes give good exposure for it. With the shutter open and the subject moving, fire the repeating strobe light with as many pulses as you want images. Each time the light flashes, a new image appears on the film. Close the shutter when the sequence is complete. When experimenting with this technique, it is a good idea to bracket exposures.

Strobes emit multiple bursts of light. This is different from the electronic flash unit everyone is familiar with. The latter only discharges once before it has to recharge. See Chapter 6 for a more complete description of electronic flash. You can use a regular flash to create repeating images if you have the time and patience, and can control your subject's movements.

Sequence Cameras—This equipment, discussed last chapter, provides another way to achieve the same effect without a strobe light. You must disconnect the sequence camera's film advance mechanism so the film remains stationary. This is an expensive alternative. You might consider rental of the equipment.

HAVE YOU CONSIDERED EVERY POSSIBILITY?

Anyone who answered "no" should continue reading. Those who answered "yes" aren't being completely honest and should also continue reading. The first step in

your creative process is to realize there are always more possibilities. No matter how many times something has been photographed, *there is always a new angle.* That is the beauty of human perception and photography. There is no limit to what your imagination can do.

"Exhaustive" Example—I was invited by Bill Mountjoy to photograph him training his trotters at Fair Oaks, a magnificent horse estate in central Illinois.

I stationed myself beside the track while he made about six passes, during which time I changed lenses four times and made about 150 exposures. Bill thought that was a lot of pictures, and said, "I believe your camera might be faster than my horse." Actually, I had only gotten warmed up but he thought I was done and took the horse back to the stable. I thanked him and asked him if I could come back and shoot again some time.

Of course, everybody has a different idea about picture potential. Bill has no idea what he's in for the next time I show up. I plan to climb in the cart with him and shoot over his shoulder with a wide-angle lens as one of his competitors passes. Then I'll hang my camera with a bracket from the hub close to ground level and get the flying wheel, blurred horse and stationary cart all in the same shot. And then I'll hang the camera below his seat between the

two wheels, looking back at the pounding hoofs of the competitors behind him.

Next, I'll mount the camera on a specially made bracket and attach it to the horse's shoulder to fire back past his flanks at Bill driving his cart. If that works, I plan to make a U-shaped brace to hold the camera out in front of the horse's head and, with a wide-angle lens mounted on the camera, get the entire scene from the horse's nose on back. If that doesn't work, we'll take my Jeep out on the track and I'll lie down in the back bed, photographing the horse and driver at full gallop. And, while the Jeep is on the track, I'll climb on the roof and shoot down at the speeding team.

I'm making plans for a bracket to hold the camera above and to the outside of the cart, approximately where the tip of Bill's whip cracks. I'll use a superwide-angle lens to take in both Bill and the horse from the perspective of the cracking whip snaking back down to Bill's arm. I might try some detail shots, like a blurred cart-wheel and a blurred horse leg framing the driver's tack-sharp boot against the foot brace. Maybe I'll get a close-up of his hands on the reins with the shadowy image

You could use the first image as a tourist shot and send it home to Mom. It was taken the way most travelers do their photography—from the roadside, in this case in Austria. But if you want to get good shots of skiing, you've got to grab your own skis and climb the mountains with everyone else.

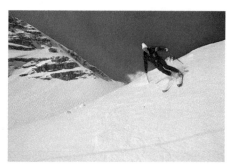

of a competitor in the background. A detail of Bill's face surrounded by dust and the horse's tail might be effective, too.

By this time you may be thinking, "That's about all you can do with trotting." Wrong again. One thing I'd like to do is dig a hole in the ground about a foot deep, plant the camera with a remote trigger and then cover the hole with a two-foot-square piece of plexiglass. Then, as the horse tromps over it, shoot up with a superwide-angle lens at the trotter from hoof level—horseshoes, tacks and dust flying in the foreground two inches from the lens with the rest of the horse and cart trailing off into the distance.

In fact, I have a better idea yet, but I'm not going to tell you—you might beat me to it.

The point is, nothing can be photographed exhaustively. When one photographer squeezes every idea he can out of a sport, the next photographer can wring 100 new ideas from it. Don't stop searching, don't stop shooting and don't ever think you're done.

Do It—I'm convinced that the best way to improve pictures of any sport is to get completely involved in the sport. I learned this lesson while trying to photograph cross-country skiing before I actually took up the sport. I figured I would just go out there and get pictures of the fellows shuffling along through the snow. The pictures turned out great, or so I thought until I got into the sport myself. Cross-country skiing is not just "shuffling along" as many people think.

Cross-country stride is an art—a rhythm of kick and glide. *Form* is of utmost importance. A person who shuffles on cross-country skis might as well shuffle on snowshoes because he won't go any faster. Pictures of shufflers don't win any admiration in the skier's world. Again, the lesson is that *the only way to learn the ins and outs of the sport is to do it.*

CALCULATED EXPERIMENT: Suicide missions sometimes work when all else fails. I had been shooting polo games all day and nothing seemed fresh. I'm not certain if my actions were legal or not—and now I'm quite convinced of my folly—but at the time it seemed like a swell idea. I mounted a 24mm lens on my camera and walked out onto the field. I crouched down behind one of the goal posts and waited for the horses to charge.

The horsemen came, all right, but a little white ball about as hard as your average rock preceded them at about 150 miles an hour. It all looked fine through my viewfinder until the ball hit the goal post beside my left ear. It could have decapitated me. But that's not the point: The ball ricocheted off the outside of the goal post and, of course, I was blamed for it not having entered. I quickly back-pedaled to the edge of the sidelines.

If you live through them, your suicide attempts may prove fruitful, but don't tell anyone I sent you.

But Not From The Road—An even more important lesson I learned is that you can't shoot cross-country skiing from the road. I found out that everyone in Austria skis *langlauf,* which is their word for cross-country skiing. You can stop your car almost anywhere and find cross-country skiers gliding through the meadow or on well-prepared tracks that line the countryside. I shot pictures of skiers in front of chalets surrounded by snow and colorful buildings, passing old barns, and dressed in traditional attire.

But the *real* ski pictures came when I put on a pair of skis and left the beaten trail. I skied into the mountains and took pictures at an altitude of 10,000 feet, with peaks jutting up on all sides. That's where I found skiers interacting with the mountains—getting into the sport—telemarking down vertical pitches, breaking trail through chest-deep powder, winding through boulder fields and mountain streams and crossing snow bridges that no man had crossed before.

You can't get those images by standing on the roof of your car with a 1000mm lens. You have to "put on" the sport yourself. Only then will you discover pictures you never imagined before. That's all it takes.

8
Competing In Your Sport

When you have a winner, keep sending it out. This photo has received a dozen awards.

WHAT JUDGES LOOK FOR

After I had received about 20 national awards, I analyzed why some of my pictures won over and over again and why others that I liked better never got anywhere. Today, when I'm asked to judge national contests, I use the criteria listed below.

Technique—One of the most important elements of a photo is its *technical quality.* If two photos have equal impact but one is slightly sharper or has better colors, the sharper one will undoubtedly win. Obvious imperfections will eliminate it immediately.

Impact—The next factor a judge looks for is *visual impact.* This includes his values, tastes and nebulous feelings—things that are subjective and often unpredictable. For instance, a judge may have a dislike for cats that will subjectively affect his judgment of cat pictures, regardless of how well the picture may have been executed.

You have little control over such bias, but other elements, such as composition, play a major role. Compositional considerations include how well the internal elements of the picture function together, the balance between dark and light areas, continuity, and the strength of the subject. The question here is, "Does the picture work?" If there are competitive elements within the picture, its impact is weakened.

Photo-contest winners receive more than a million dollars in cash, photographic equipment and paid vacations every year. Much of this goes to non-professional photographers. Unlike photos that must fulfill the specific needs of an assignment, the photos that win contests are generally *unstructured,* which means that they do not have to tell a story, show a product or illustrate a point. No one dictates the motive or message behind the picture. It is just a reflection of the photographer's feelings.

Someone *has* to win in a photo competition. If *you* don't win, someone else will because sometimes it's not necessarily a *perfect* picture that wins—just the best of what was submitted.

Regardless of *what* the picture says, it must say it loudly. That is both easy and difficult with sports shots. The disadvantage is that most sports have been photographed to death, and a picture must be fresh in order to stand out in the crowd. Action is what sports shots have going for them—it's built in. Think of an unusual perspective that emphasizes the action of the sport and you'll have a good chance of winning.

Uniqueness—Judges like to see new and fresh ideas. Regardless of how strong the image might be, if it's been done before, judges probably won't be impressed. Unlike magazine illustrations that must fulfill a need, competitions require *originality.*

Character—Some pictures have such mood or power that they don't require words or anything else to support them. Character, or the *feeling* a picture has other than the subject itself, can set the photo apart from all its competitors. Mood is strength of feeling present in the picture. Almost anything can create this, such as fog in the air, color combinations, facial expression, action—but it requires some overwhelming factor that carries the feeling of the picture. Instead of only *seeing* the image, the judge wants to *feel* it, too.

Classification—If the judge's first impression of the image is favorable, he next considers matters such as the picture's suitability to its category. Some excellent photos never make it past the preliminary screening because they don't relate to the category in which they were entered. The theme is important to the contest sponsor, so your photos should relate to the subject.

Title—One critical factor that many people overlook is the title. Because photos entered in competition generally must be titled, judges are influenced by how well the title and picture relate. The title should not simply describe the picture. It should give the

This shot has won several national and international photo awards. Aside from the execution of the image, I like to think part of the credit should go to the title, *Rebirth.*

viewer some insight or imply deeper meaning.

A good example is a picture I took of a gentle waterfall flowing mystically over a cascade of rocks, surrounded by birch trees with the changing colors of Autumn. The photo carries so much feeling that a title such as *Minnesota Waterfall* would be boring and uninteresting. Instead, I titled it *Rebirth,* which carried the feeling of dying

leaves and living water, and hinted at the greater statement it makes on life. This combination has won eight national awards and one international award. I attribute this mostly to the picture but also believe that the title plays an important role.

All of these thought processes occur simultaneously, as the judge looks at each entry. You will score higher and more predictably if you

do your homework and analyze what is expected.

FIRST IMPRESSIONS ARE LASTING

Judges are human. You can sway their emotions and decisions with a favorable first impression. Some pictures are so outstanding that regardless of how they are presented, they are bound to win—but this is not common. Other pictures may not be equal visually, but can receive similar honor through superb *presentation*.

Some Tricks—Enhance your entries by making sure they're *clean*. Never send old prints that have made the rounds. If the print looks worn, make a new one. When print margins or the mattes surrounding the prints are dirty, clean them with a pencil eraser. If this doesn't work, reprint and remount them. Make unmounted prints on doubleweight paper. Singleweight paper is not as rigid and will not withstand rough handling.

If slides are bent or damaged, remount them. Instead of scribbling your name and address on the slide mounts, order gummed labels that you can apply to the edge of the mount. They look more professional.

Emotion—Some pictures win because of their *emotional impact*. If the judge's reaction is strong enough, you've got a winning photo. It doesn't matter if the viewer feels sympathy, anger, disgust, excitement. The first time you saw the Pulitzer Prize-winning shot of the raising of the American flag at Iwo Jima, it hit hard because it drew an emotional reaction from you. And the same with another Pulitzer Prize winner, showing a mother and daughter falling from a burning building. Pictures that win don't have to be historic or tragic, but it helps if they show tension or excitement.

PITFALLS IN COMPETITION

There are several pitfalls that can put any photo out of the race, regardless of its quality.

Wrong Category—The first thing to watch is the category you are entering. If it's obvious that your choice fits the category, you're probably safe. But if you have to think why it fits, most likely it doesn't. Borderline cases may be admitted into the judging, but they'll seldom win.

Limit your submissions to those that cannot be debated. Don't enter a picture of your husky in the wildlife category just because he's not on a leash. However, if you hitch him to a sled and get a shot of him crossing the finish line in a dogsled race, it might make a fine sports-photography entry.

Missing Information—If you're supposed to include shutter speed and type of film used to make the picture, do it. If the rules ask for the date and location the picture was made, don't expect the judges to call you for the information when your picture wins—because they won't and it won't.

Late Entries—Apparently, the importance of making the *deadline* is not clear to everyone. Many people send their packages in after the closing date, regardless of how clearly the instructions stress on-time delivery. If the deadline is March 15 and your entry is postmarked the 16th, take my word that the judges won't let the entry slip through just because you were close.

Improper Entries—Some contests require each picture to be ac-companied by a separate entry form. If the rules say "one entry form per print," you can assume they mean *one entry form per print*. People who send entire packages of prints with one entry form may wonder why they're disqualified, but they shouldn't.

Entry Limits—This is another regulation that is frequently ignored. I don't understand why there is such disregard for entry limits. Undoubtedly, some people can't count, but I suspect the majority rationalize it by thinking something like, "I'll let them pick the ones they like best and just leave the others out." Wrong! The whole pile gets disqualified.

Clichés—I would say more than half the pictures entered in competition get nowhere because they're *trite*. If you have a beautiful picture of a sunset, a couple on the beach, a girl holding a flower, or any dog, cat or child picture, frame it and display it on the mantle—but don't submit it for competition. Clichés don't win photo contests.

ENTRY PREPARATION

There are a few things you can do to give your entries a "subtle edge" over your competitors.

Wider Margins—When submitting prints, stay within the size specified in the rules, but make the printed area slightly smaller to provide wider margins. Because many of the other submissions will have the standard quarter-inch

Compare these two slide mounts. Each gives a different impression of the photographer—before you would even think about looking at the image on the film mounted in it.

border, the wider edges on your entries will give them a custom appearance. If you don't do your own darkroom work, tell the lab what you want.

Extra Matte—Use the same approach if you're submitting mounted prints. Rather than using an 11x14 matte for an 8x10 print, try 13x16 or 14x15 if the rules allow it. The extra margin gives the print a classy look that may surprise even you.

Clean Slides—Mount 35mm transparencies in new slide mounts. Many labs, including Eastman Kodak, stamp the processing date on the mount. This may be a disadvantage if the slide is old. Although judges do not always see the mount, you don't know when they might look at it, so don't take any chances.

Winning Streak—Many pictures that are winners take the lead everywhere they go. The nice thing about photo competition is that when you find you have a winning photo, you may be able to use the same one to win over and over again, depending on the rules. Some rules specify that the photo entered can never have won an award in another competition. Another restriction may be that the photo can not have been published anywhere. So, if you are considering multiple uses for your photos, make your decision with these possible restrictions in mind.

Every now and then you'll get a once-in-a-lifetime grand slammer that naturally has the qualifications to win. But besides the blockbusters, there are definite types of pictures that win more frequently than others. I call them *pretty pictures, universal identity* and *high-energy.*

The waterfall on page 141 falls into the pretty picture category. In the second category, on page 140, you see an old man with long white hair, a hoary beard, and wrinkled, worn skin. He has a sparkle in his eye that everyone identifies with. It has won awards around the world.

Although the subject matter in the photograph on the left is not as interesting as that in the other one, the wider margins around the picture are attractive and may spark a judge's interest.

Sports photography rarely fits into either of the first two categories, but can easily run away with the third one. If the action looks like it's ready to break out of the two-dimensional medium, you're on the road to winning.

Increasing Your Odds—There are a few things you can do to increase your chances of winning: Keep the image simple—the photo must be clean and direct. Read the entry rules several times to be sure you don't leave anything out. Judges think they're not doing their job unless they catch the smallest omission. For example, if the rules say a maximum of six pictures, don't send two batches of four. If you are supposed to put a red dot in the upper right hand corner of your slides, don't put it on the left side.

Also remember that judges are human. Their decisions are subjective. Anything you can do to enhance the impression your picture makes will increase your chance of success. You must stay within the limits imposed by the rules, but you can always go one step further by matting your prints rather than just sending a double-weight print.

If you can intensify the colors by making a quality duplicate slide without a significant contrast increase, by all means send a dupe.

Try to find loopholes in the rules that allow you to submit a better-presented picture than the average entry. Sometimes that extra touch will get your shot into the winner's circle.

ACCURATE EVALUATION

If you're not sure that your photos rate, here are some self-evaluation techniques that may be helpful. First, a warning: *Avoid* appraisal from friends and family! Their well-meant judgments will stuff your head more than your wallet or competition portfolio.

You must evaluate your work against *other competitors.* If you were a runner, you wouldn't ask your grandmother her opinion of your abilities as your only preparation for the Boston Marathon. To get an idea of how you might place, or if you should enter at all, race against other runners—or at least ask the track coach what he thinks. Here are some ways to evaluate your potential.

Salon Catalogs—A good place to find an accurate comparison between your pictures and those that win is to order the catalogs of past

This illustrates three different ways to mount prints of about the same size. On the left is a 16x20-inch mount, in the center is 11x14 and on the right is 8x10. Which do you prefer?

winners from the photo salons and exhibitions you would like to enter.

Clubs—Join a local photo club that sponsors competitions and evaluations. There are thousands of photography clubs. You can find the ones in your area by asking at your local camera stores. There is an organization that has clubs around the world. To learn more about these groups and the international competitions they conduct, send a self-addressed, stamped envelope and a request for a listing of photo clubs to the Photographic Society of America Inc. (PSA). The group also publishes a monthly magazine, *PSA Journal.*

Teachers—You can get invaluable criticism and advice from local photography instructors.

Galleries—Some art galleries that deal with photographic images will give you free evaluations of your work. Gallery owners usually are candid and will compare your work with that of photographers whose work they handle.

Enter Competitions—Finally, the only true test of winning potential is to enter the images in contests and see what happens. Fortunately, all you have to risk is the postage and perhaps an entry fee.

CONTESTS TO AVOID

Always read the fine print on the entry forms. The most impor-tant conditions of the contest usu-ally are printed the smallest. If there are any clauses stating *exclusive rights, material will not be returned, winners must send originals, becomes property of,* don't send anything. Contest sponsors who claim exclusive rights are unethical and should not be supported. If your picture is good enough to win in their contest, it should be good enough for someone else and in the end could easily bring in more prizes or money than they would have paid in first place.

Most legitimate contests restrict entry to people not associated with the sponsor or related organiza-tions, such as the advertising agency promoting the competi-tion. If this is not stated openly, you may not have much of a chance to win.

If you doubt the integrity of the sponsoring organization, call the sponsor and ask if the prizes are backed by security bonds. Most prize money is put in a trust fund or held by an outside firm that delivers the prizes directly to the winners. If this isn't the case, enter at your own risk.

WHERE TO FIND PHOTO COMPETITIONS

There are many ways to find out about contests you can enter. You can learn about some of them by becoming active in local groups; others are announced in local or national publications.

Local—Ask about local competi-tions at your camera store or camera club. And keep your eye on local newspapers. When con-tests of local interest are announced, newspapers will gener-ally publish the information in their news or community activity columns.

National and International— These competitions are listed in numerous publications. Some may be available by mail or on newsstands. Many should be available at your library. Addresses are listed in the Appendix.

Modern Photography and *Popular Photography* are monthly maga-zines that publish news and techni-cal information of interest to photographers.

Lens, published bimonthly, is available only through photo deal-ers. It contains information of interest to photographers.

Sunshine Artists USA is a month-ly magazine for photographers, artists and craftsmen. Each issue details hundreds of shows where a photographer can sell his work, and 10,000 art festivals.

Photographer's Market and *Writ-er's Market* list competitions and exhibitions, foundations and grants and galleries.

The Photoletter includes competi-tions and sales opportunities.

Photo Insight is a monthly news-letter dealing exclusively with na-tional and international photo competitions.

How to Enter and Win Color Pho-tography Contests and *How to Enter and Win Black & White Photography Contests* are two in a series of books by Alan Gadney that list complete entry information for in-ternational contests, festivals, grants, awards, scholarships, fel-lowships and apprenticeships.

Harold Bibby, in Eastman Kodak's Public Information Department, can send details about contests conducted by Kodak.

9
Marketing Your Photographs

It's relatively easy to become a good sports photographer—just keep practicing. To *sell* your sports shots, however, you have to be more than a good photographer. Some folks think that if their pictures are good enough, they will sell automatically. Photographers who sell photos laugh at such reasoning because you also have to be a good salesman, researcher, public relations person and correspondent.

Competition is fierce because so many people have cameras today. But even though many are trying to sell photographs, the good news is that there are more markets than good photos.

If the need is so large and there are so many photographers willing to fill that need, why the gap? The answer is simple. Most photographers are looking at the wrong gaps. Sure, some magazines are willing to pay $1000 for a cover photo, and advertising agencies may pay $10,000 for the right picture, but too many photographers think these publishing markets are the only ones. That's nonsense! There are at least 15 places to sell your photos *in every community.*

LOCAL PLACES TO SELL SPORTS PHOTOS

Every town has schools that promote sports and related activities. And there are always community events, either annual or one-time, that you can attend and document. There *is* money to be made photographing them. These are the most obvious places to start practicing and getting paid for it.

When photographing events like the ones that follow, you should probably use negative film in b&w or color if you want to sell your work. Most people want prints to display, mount in photo albums or send to friends and relatives. Slides are not as useful for this type of market.

Clubs—High schools usually have a lot of clubs, such as chess, karate and motocross. You can do very well if you work with them. You should be able to obtain listings of school activities from the school's administration office. Ask for a list of student clubs and intramural teams.

Take action shots of their activities at one event or meeting and bring contact sheets next time. The key to good sales is to *isolate individuals* so they stand out from the rest of the group. They won't be able to resist a good photo.

At some schools, you'll encounter a lot of red tape. Sometimes, commercial business (that's you!) is prohibited, or they require a permit. Generally, there are few restrictions on activities conducted off school property—but call the school administration first to make sure.

Yearbooks—A teacher at a local high school called me some time ago. As the advisor for the yearbook, she was planning to use 20 pages of color pictures that year but didn't want to use her high-school photographers. She asked me to photograph the sporting events, musical groups, clubs and fights in the halls. The school supplied the film, published the pictures and then gave them back to me. Because they also paid me a fee for the full day, how could I lose?

Team Pictures—Athletic teams usually want annual team pictures—and those that don't, often can be talked into them. Taking team pictures can be lucrative for you. After all, you make one or two exposures that cost you very little, and then may sell 20 or 30 prints for $5.00 to $10 from each negative. Most of the team members want a copy so they will remember their teammates. And the parents probably want to remember their "star" member of the team, too. You can really score by scheduling all the teams at each school on the same day.

Promoting Events—Team pictures often lead to additional sports photography assignments. Many teams, such as football and wrestling, require pictures of individual players for promotion. These jobs may entail a large order of enlargements for posters. And, if the shots are used by the local paper, you'll gain additional contacts.

Tournaments—When a coach knows your name, you may be called to cover special events. I live only two blocks away from Wheaton College in Illinois, and the wrestling coach knows it. He called me when the school hosted a national invitational wrestling

tournament. He needed one exposure of each champion at the end of every round. He ordered three 8x10 prints of every picture at $5.00 each, which worked out to about $40 an hour.

Community Leagues—You can find local sports in places other than schools. Schools do not have a monopoly on local sports. I doubt if there are any towns that do not have community sports activities. Most areas have well-organized leagues and tournaments in basketball, softball, racquetball, lacrosse, rugby or bowling, to name a few.

You can take pictures at most amateur sports competitions because those groups seldom have staff photographers. Try first for team pictures.

When you finish the team pictures, photograph the action. Make contact sheets and enlarge several of the best frames onto 8x10 inch paper. Return the following week and take orders. Be sure to ask for payment *with the order* so you can be sure they come back next week. If you don't want to ask for full payment, ask for a 50% deposit. Or make the deposit at least equal to your cost for film and paper. Give the buyer a business card for a receipt—it's free advertising.

This is one of the best ways to practice shooting sports action and get paid for doing it. The team members don't have to see the shots that didn't work. As a result, you wind up learning and earning at the same time.

Special Events—Such community events as dances, rodeos, parades and band concerts are good ones to photograph because the participants don't have another chance to get pictures of the event. There are two ways to handle such activities: You can shoot them on speculation and take names as you shoot, or get a list of the performers ahead of time and make arrangements with those who would like to see proofs of your photographs.

Racing—I bet there's a race track of some kind near your home. That's a relatively safe assumption because people like to race anything that has legs, wheels or wings, or that can be pushed, pulled or conned into moving.

Local Newspapers—Once you begin shooting sports on a regular basis, you'll get show stoppers from time to time that may interest the local newspaper. Then, if you continue to supply good shots, there's a chance they may give you assignments that their staff can't cover.

Always keep local publications in mind, regardless of what you're shooting. All subjects mentioned earlier are potential newspaper illustrations. The moment of victory or defeat, activities on the sidelines, happy and sad emotions, award presentations—these are all possibilities for such publications. After you've sold the picture to the subject, a newspaper sale is an added benefit.

ADDITIONAL OUTLETS

There are other potential outlets for pictures you've already taken and sold to the subjects or publications. You can probably find some or all of these in almost every community, regardless of its size.

Art Fairs—Most communities have art fairs at which local artists display their wares. You can frame your artistic or spectacular action shots and sell them as wall art.

Public Buildings—Restaurants, banks, libraries and hotels are also possible markets for your best photos. Talk to the manager, show him some of your best work and ask if you can display it. If he asks what you plan to charge him, say, "Nothing." But *you* can make plenty selling individual prints by leaving in the corner of each frame a business card indicating price of the print.

Send out news releases for art/photography reviews and news coverage in local daily or weekly publications. And don't forget

that radio and television news and community-service departments may be looking for a good local story. Such publicity can generate more traffic for both you and the business allowing you to use its space.

Another way to get businesses to display your photographs is to suggest that they "sponsor" local artists' works and promote their generosity as a community service. They may even want to publicize the program in their advertising. An example might be, "This month, in our main lobby, local photographer John Smith's Fabulous Photography of White Water Canoeing."

Galleries—When you've established respectable sales of your work and can show evidence of public demand, you can approach art galleries and attempt to set up a show. Display of your work in art galleries will boost the price of any other work you sell.

More than 2300 listings of such outlets in 10 regions are in the *National Directory of Shops/Galleries, Shows/Fairs: Where to Exhibit and Sell Your Work.*

GETTING YOUR PHOTOS PUBLISHED

Now that you know publishing photographs is not the only way to make money, let's discuss some of the benefits unique to publication sales.

WHY PUBLISH?

Unlike most sales situations, such as when a framed enlargement changes hands, publication entails no permanent exchange of goods. Generally, you just *rent* your pictures. In a sense, the payment is pure profit because there is no overhead other than the cost of the prints or slides, and postage. And, you can sell the same picture over and over again, depending on the deal you make with the publication.

If that's not enough good news, here's more. Pictures *rented* for publication usually command higher fees than those *sold* as artwork in expensive frames. Standard payment for one-time rights for a color transparency ranges from $50 to more than $1000, depending on the photo, the publication, the market and how the photo is used.

Besides earning more money for renting your pictures, there's also a wider market for them. For example, *Ayer Directory of Publications* lists thousands of periodicals in the U.S. and Canada. The market for sports photography is realistically close to the number of magazines produced. *Writer's Market* also lists more than 3000 markets.

Obtaining Tearsheets—Everyone knows how hard it is to get started in most professions. Sometimes luck helps, but in publishing, one of the easiest ways to develop your credentials is by getting *tearsheets* from local newspapers and magazines. Tearsheets are pages literally torn from magazines. They show work you have had published.

Call The Photo Editor—This is often better than a letter. Make an appointment to see him and take a portfolio of your best photographs. When you have had some of those photos published, use the tearsheets as a stepping stone to the next plateau.

CATEGORIES OF PUBLICATIONS

In my opinion, the publishing industry can be broken down into several categories, including "slicks," general-interest, special-interest, trade and publishing houses.

Slicks—These are large-circulation magazines, like *National Geographic*, *Time*, *Life* and *Sports Illustrated*. These are not markets for beginners, but definitely future goals.

General-Interest—Such publications as *Saturday Evening Post*, *Es-*

This is a tearsheet from the annual guide, *Cross Country Skiing*, published by *Ski Magazine*. It is a good example of the kind of treatment a quality publication can give your work. I have these tearsheets laminated in plastic so they will always look fresh when I show them to potential customers.

quire and the women's magazines pay well, but don't use as many photographs as the slicks. However, they do accept more freelance material from unknowns, and frequently publish sports-oriented pictures. If you submit material to them early in your career, make sure you send them the right stuff. I'll discuss "rights" and "wrongs" later.

Another kind of general-interest publication is the *house organ*. These publications generally are produced in-house by governmental agencies, companies and educational institutions, large and small. They are distributed free to alumni, employees, stockholders, retirees and others, with the purpose of informing or entertaining.

Payment for photos is not high, but it's easier for the unknown to break in. And there is a large selection of publications and interest areas to choose from. You might also consider house organs as part

of the special-interest publication category. This market is overlooked by many photographers. It is an easy market to miss because these publications are not available at newsstands, and rarely have paid circulation. I include them here because they cover diverse topics and use many photographs each year.

Many of them accept sports-related articles and photographs, but you're better off dealing with unorganized or unconventional sports. Submissions generally must relate to the publication's sponsor or its readers' activities, so an inquiry is advisable before submitting samples.

Also keep in mind that house organs do not compete against each other for material or readership. And because an employee only works for one company at a time, there's little chance that readership will overlap. Therefore, when you have a topic

that sells to one, it may sell again and again in the same field. If you sell only one-time rights, you will be safe legally, but you may run into problems if you sell the same shots to competitive publications.

Volume 5 of *Internal Publications, Working Press of the Nation Directories* lists thousands of house organs for public and private organizations.

Special-Interest—This is the *best* market for the beginning sports photographer. There is a publication for every imaginable sport—sometimes a dozen or more for each.

Another reason special-interest magazines are good break-in markets is that you know exactly what they use. For example, *Ladies Home Journal,* a general-interest publication, might run an article on cross-country skiing for ladies, along with pieces on cuisine, the latest fashion and home decoration. With *Ski* magazine, however, you know the publication's specialty based on little more than its title.

I saved the best for last: Payment from special-interest magazines is often very high.

Publishing Houses—Unlike the other markets, you'll find multiple possibilities at publishing houses that produce several magazines, newsletters, brochures, posters or book lines. As a result, when you submit a batch of photos, they may be channeled through many different editors. For the price of one mailing, you may get multiple exposure and possibly multiple sales without extra effort.

Where To Find Them—You can find out what publications are produced near your home by looking in the Yellow Pages under "Publishers," or by calling the local Chamber of Commerce.

Here are some publications you should be able to find in the library that list possible markets for your work.

• *Photographer's Market,* the freelance photographer's bible, is a listing of magazine and book publishers that solicit freelance material. Categories are cross referenced. Most of the listings are magazines, but it also includes advertising agencies, public-relations firms, book publishers, audiovisual firms and stock-photo agencies.

• *Writer's Market,* similar to the *Photographer's Market,* contains about twice as many magazine listings. Although it is more for the writer than the photographer, most listings include photo needs.

• *Magazine Industry Market Place* lists publishers of periodicals and supporting elements of the magazine industry.

• *Ayer's Directory of Publications* is one of the most complete listings of consumer publications available. Photographic needs are not mentioned.

• *Standard Rate and Data Service (SRDS) Directories* list consumer, farm and trade publications, and newspapers. These directories include many magazines not listed elsewhere.

• *Manhattan Yellow Pages* is not your conventional magazine-source directory. But because New York City is the major publishing headquarters for many magazines, it provides a compact listing.

• *Ulrich's International Periodicals Directory* lists publications from all over the world.

Those references will tell you where the publications are and in general the type of material they use. Here are several other good publications that spell out editors' specific—and immediate—needs. Full addresses are listed in the Appendix.

• *The Photoletter* is published 22 times a year. It includes lists of editors seeking specific categories of pictures, and other information.

• *TSA Newsletter* lists the needs of photo buyers around the country in its monthly issues. It also includes articles on marketing strategy and a column discussing successful freelancers.

• *Photographer's Market Newsletter* is a monthly publication that provides current photo-marketing news, stories about photos that have sold well and articles by professional photographers.

• *The Freelance Photographer* is a bimonthly tabloid listing market needs. It features articles on different ways to make money by freelancing.

SPECIALIZE

Editors prefer to deal with specialists. Whether you concentrate on one sport or not, it may pay to pretend you do. Play up the sport you have covered most. When you send your photos, if you can't say, "I have enclosed a few tearsheets as samples of my published work," you can substitute, "I specialize in tiddly-winks photography and am enclosing some of my best material—some of which has never been published."

Whether or not they buy your photos then, you have established yourself as a likely source for tiddly-winks pictures. When they need coverage of that sport, they will contact you.

PRESS PASS

With a press pass, you'll have a lot of freedom, such as free admittance to sports events, allowing you to bypass the crowds and get better shooting positions that lead to better pictures.

Obtain credentials that will qualify you for these passes while you are still in school. When you shoot for the school paper, you will be recognized as an official photographer and usually have a free hand at any local event. Then, when you do freelance work, you will already be established.

If that option vanished more years ago than you care to admit, try the local newspaper. Because small papers are often understaffed, if you volunteer to cover an event with no obligation on their part to purchase your

photographs, they may issue you a temporary press pass.

Or, you can go directly to the management of the event you wish to photograph. Tell them you're a freelance photographer, will be trying to market your material to several magazines—name some—and need a press pass for selected dates. They usually want all the publicity they can get and, unless passes are limited, will probably issue you one.

I.D. Cards—Membership cards from photographic organizations may be sufficient credentials for some event managers to provide press privileges. Consider joining one or more of the many photography clubs or associations.

Here are the names of some of the major organizations. You'll find complete addresses in the Appendix.

• *Associated Photographers International* includes with membership a press card, a booklet called *Ninety-three Ways to Make Money with Your Camera,* a monthly newsletter about how to sell your photography, discounts on new equipment, a computer-operated photo agency and more. The organization guarantees you will publish photos and sell your work regularly. If you haven't sold anything by the end of the year, you will receive a full refund of your membership dues.

• *The Friends of Photography* is dedicated to the support and encouragement of creative photography through exhibitions, publications, workshops, grants and awards programs.

• *Photographic Society of America* has chapters around the world, conducts international photo competitions and publishes a monthly magazine, the *PSA Journal.*

• *Professional Photographers of America, Inc.* is for professional photographers and individuals enrolled in formal photographic education programs at accredited colleges and universities.

• *ASMP: The Society of Photographers in Communications* provides services to photographers who sell their work for publication. ASMP has a student membership for people attending accredited visual communications programs, and an associate membership for those who have been selling their work less than three years.

OTHER MARKETS

Besides magazines and books, photos are used in advertisements, bank checks, boxes, metal and plastic containers, bags, flyers, billboards, household items, wall coverings—almost anywhere you look. All are possible markets for your photos. Here are some common uses of sports photos in non-conventional publishing media.

Poster And Card Manufacturers—This is a large market for sports photography. The main problem with selling to these outlets is that they usually request exclusive rights. Although payment is higher than one-time rights, in my opinion it is not favorable to you because there are so many potential markets for each good sports shot. If one company wants it, it'll probably sell in another market, too. The best solution is to sell pictures to this market that you have similar shots of rather than unique ones. To locate local publishers, check the addresses on cards and posters sold in area shops.

Stock Houses—Many writers paint a rosy picture about how great it is to have your images on file in a stock house. They tell you how you receive royalty checks, with someone else doing the leg work. Be aware that *some* stock photography businesses are out to get as many pictures as they can for their stock files, throwing ethics out the window in exchange for your transparencies. When these outfits have your photos, you may never see them again—or payment, either.

Perhaps the best thing to do is to send only duplicates to stock houses. Before sending anything,

This is one type of greeting card that uses photography. The photograph is on the front and the center is blank. The back is blank except for the credits: California Scenics - Robert McKenzie, Redding, California.

however, write and ask them for a copy of their contract. Contact by mail is appropriate because unless you live in or near a large city, you probably won't find many agencies in your immediate area. Then send them samples of your work and ask if they are interested in your material. If the agency specializes in a specific topic, such as sports photography, submit only photos that apply to that area. Then sit back and wait for the results—there isn't much else you can do.

Be sure to get recommendations from people who have worked with the outfits they are recommending.

Working through an agency is advantageous because they do all the mailing and soliciting busy-work, and sell the photos over and over—if you have the right material and the right agency!

But there are some disadvantages: They keep about 50% of the fee paid for usage; they cannot give individual attention to specific photographs; and the agency generally can't spend the time to sell to a specific field. I suggest that you consider all the alternatives before you sign with a stock agency. Then proceed at your own risk.

Here are three agencies with experience in outdoor and sports photography that I can recommend: Bruce Coleman, Inc., 15 East 36th Street, NY NY 10016; Van Cleve Photography, Inc., Box 1366, Evanston IL 60204; Tom Stack and Associates, 1322 North Academy Blvd., Suite 209, Colorado Springs CO 80909.

Stock photo agencies are listed in the following publications: *Photographer's Market; Free Stock Photography Directory, Stock Photo Assignment and Source Book.*

Audiovisual Markets—Slide presentations using one or more slide projectors on one or more screens are relatively new outlets. Hundreds of companies produce and market shows using sports shots.

Because the slide shows require duplicate film, the companies usually select the images they like, copy them and return the originals to you quickly. It's always nice to have a market with quick turn-around time.

You can find audiovisual companies looking for photographic images in *Photographer's Market* or in *Audio Visual Market Place.*

Advertising—Even though advertisers are using more outdoor sports settings for their posters and advertisements today, this is generally a field for professionals only. Advertising illustration is one of the highest-paying fields in photography.

Getting work from ad agencies requires a lot of footwork. Call the agencies in your area and ask for appointments to show your portfolio. Then, if they need something in your specialty, they may call you.

BREAKING INTO PUBLISHING

Getting published the first time is rough because there are so many people trying to get their work published—and most photographers don't know how to go about it. When dealing with editors, there are standard procedures. Like trying to board a plane at the airport, if you don't follow the rules, you'll never get past the checkpoint.

You would be amazed at the kind of submissions editors receive in the mail. Here are some actual examples: loose and unprotected transparencies sent in regular letter envelopes; slides tied together with a pink ribbon; uncut, unmounted slide film. The best way to have your work published is to handle your submissions properly.

THE PROFESSIONAL SUBMISSION

There are a some things you should *never* send to an editor: negatives or color prints—unless they are requested; b&w prints smaller or larger than 8x10 inch; slides smaller than 35mm, such as 110-format or half-frame; non-standard packaging of slides, such as loose in an envelope.

You should also not send damaged materials, such as scratched slides or "worn" prints; prints without borders; prints or slides with technical flaws such as poor contrast, incorrect colors; unsharp images, or bad duplicate slides.

When you're starting out, act professional. Even if the package is the first one you've ever submitted anywhere, if you do it properly, they'll never know. Here are some hints for both b&w and color submissions.

• Standardize b&w prints to 8x10 inch. Leave a minimum 1/4-inch border around all sides and touch up dust specks or scratches. Although single-weight paper is acceptable, use double-weight or RC paper for a better appearance.

• Edit your work *ruthlessly.* Send fewer prints; limit them to your *best* work.

• Submit only the type of material the publication uses regularly or has requested. *Never* throw in a few extras hoping that because they're "spectacular," the editor will accept them. You might mention other photos in a cover letter, however, and tell the editor you will be happy to send them on speculation.

• Send your materials on time. If the magazine works six months in advance, don't even think about mailing ski pictures in November.

• Protect prints by sandwiching them between pieces of corrugated cardboard held together with rubber bands or tape. Include a short cover letter on the outside of the cardboard. Package prints in a 9x12-inch Manila envelope or cardboard photo mailer, or an ex-

hibition box if you have more than 50 prints.
- Ship slides in special slotted pages designed for the format you use. These sheets are available at your photo dealer or by mail order. Package the sheets of slides the same way as prints.
- *Always* include your return address and the editor's name and address in case the outside wrapping is damaged.
- *Always* send a self-addressed stamped envelope (SASE) large enough to contain your materials. Fold the envelope in half and insert it in the original mailer.

Remember, editors are not obligated to pay for something they didn't ask for, can't use or don't like. You want to make it as easy as possible for them to handle your valuable photographs.
- Stamp the outside of the envelope with PHOTOS: DO NOT BEND. Use typed labels for the sending and return addresses.
- Be your own strongest critic. Never send less than your best.
- Slides are the first choice for color work. If you have only color negatives, inquire first. Many magazines still require slides rather than prints.
- Most publications require 35mm format slides or larger. Two of the best slide films are Kodachrome 64 and Kodachrome 25. They enlarge with finer grain and more vibrant colors than most other films.
- Use a loupe or magnifier to make sure your slides are sharp and undamaged. Looking at projected slides or holding them up to the light is not sufficient.
- Check exposure. Do not send any slides or prints that are not well exposed.
- Send just enough—whatever that means. If you send too many slides, the editor will gloss over them all quickly. If you send too few, he won't have a wide enough selection to make a decision. Although preference varies among editors, a good starting point is

two plastic pages, about 40 35mm slides.
- Ship everything by First-Class Mail. It is fast, relatively efficient and allows your delicate photos to travel with other lightweight parcels.

Learn To Wait—When you mail the package, the best thing to do is forget about it. If you want your submission on its way back to you before you hang up the phone, call the editor and ask him where it is. Relax and wait. It's almost always returned.

A Response Card included in the package may give you some peace of mind. The one in the accompanying box shows one I suggest you use.

The card should look like a postcard when you finish. Add a postage stamp and it *will* be a postcard. Local print shops can print as many of these cards as you want. Included with your pictures, this card will usually elicit a response within a few days. At least then you know the editor's timing and interest.

THE FIRST SALE

Editors prefer to work with photographers who sell their work regularly rather than unpublished photographers—even if picture quality is equal. Sending tearsheets with your first submission always helps. But how do you make the first sale? In the beginning, deal with small-circulation magazines and local newspapers that don't pay much per photo and, as a result, are always looking for good photographs.

That first sale is often a tradeoff—an exchange of your work for a byline and a low payment, if any. An excellent way to get bylines and tearsheets is to start with religious publications or house organs.

When you have had your work published, you can either send

RESPONSE CARD

If you're impatient and don't want to wait two years for an answer about your submission, use this quick-return card. Most responsible editors will use it.

On a 4x6-inch card, or a regular pre-stamped postcard, type your address on one side and the message below on the reverse side.

Dear (your name):

() We are not interested in the photos and will be returning them soon.

() Your photos are being considered and a decision will be made by _____ (date).

() We plan to use your pictures and will contact you soon concerning their use and payment.

Sincerely,

_____ (Editor)

_____ (Publication)

tearsheets of the published work, or mention the publications in a short cover letter.

Rejection—Undoubtedly you'll receive rejection slips. These pieces of paper have messages ranging from humorous or apologetic to rude and insensitive. Worse yet, sometimes you may not even get any kind of communication when the photos are returned. In the end, they all mean the same thing: Thanks, but no thanks.

There are many ways to deal with rejection. Some people wallpaper their washrooms with these slips; others use them to start their winter fires; and some, believe it or not, put them in hope chests. It doesn't matter what you do with the slips, as long as you send those photographs off to another publication immediately. Don't let rejections intimidate you or slow you down.

The selection process at most magazines is relatively simple. First, there is a distinction between solicited and unsolicited photos. Solicited photos receive greater consideration. You can have your pictures solicited by sending queries telling the editors what you have and asking what their needs are before submitting the images.

The first photos that are rejected are those with technical faults. Weed out *everything* with mechanical faults *before* you submit. If you want the next package with your name on it to be opened, heed this warning.

Inappropriate subject matter is next. If you want to sell to sports magazines—or any other publications—study them to see what they use. If something similar has not already appeared, don't think yours will start a new trend. For specific information about a publication's photo needs, write and ask for guidelines.

Then the editors look at how appealing the image is: Does its content "jump out and grab" the viewer?

Final selection is based on many things out of your control, such as picture flow within the publication, how similar the picture is to others used in the past or even those in competitive magazines, and how well the picture relates to the text. Some photographers increase their chances by submitting both vertical and horizontal formats of each picture.

Subject and graphics are the most important, but they must look natural. If the subject looks posed, even though it may not have been formally posed, the picture *may* look fake.

Double Dollars—Consider carrying two cameras so you can shoot in both color and b&w. If there's a market for your pictures in color, there's bound to be another noncompetitive one for b&w. You *can* make b&w prints from color transparencies, but the quality is not the same as when you work from an original b&w negative.

Enhanced Submissions—To impress an editor, keep these points in mind: Low-contrast prints don't reproduce well in publications—they usually appear gray and uninteresting. Maintain good contrast. I often use a contrasty #4 paper for strong whites and blacks. When ordering b&w prints from a lab, tell them how they will be used, so they can make adjustments to their standard printing procedures if necessary.

Send clean b&w prints. Editors dislike improperly spotted prints, and dirty or otherwise imperfect prints are even worse. If you are good with a #00 brush and have a steady hand, you can touch them up with spotting dyes. Or, have them touched up professionally—you'll regain the expense in no time with increased photo sales.

Captions are important. Number slides and submit a page of appropriately keyed captions. For each b&w print, type the caption on a small piece of paper and tape it to the bottom edge of the print where it can be folded back for

viewing. Do not put tape on the front of the print. Captions should include *who, what, where* and *how*, and any additional information that's not obvious.

Keeping Your Originals—As a freelancer, you don't want your original photographs tied up. That's no problem with b&w because you keep the negatives. With color, however, you may have to wait months for slides to be returned. Here's a way to keep your transparencies in circulation.

Copy the slides in the slide sheets on a Xerox 6500 color copier and submit the copy with the original slides. Ask the editor to keep the copy on file and return the originals after he has inspected them. Then, when he wants a specific transparency, he can request that one. He knows what it looks like and has seen its quality.

Ways To Make Your Originals Last Longer—One of the biggest headaches photographers face is that color transparency film is not indestructible. One stain, scratch or accidental drop on the floor and the prize-winning original can be irreparably damaged.

You can make *quality duplicate slides* of your best work with Ektachrome Slide Duplicating Film and a slide copier so you'll have something to work with if the original is lost or damaged. Many local and national labs offer this service.

Some photographers like to coat their slides with a *protective varnish,* which works fine if you only plan to project them. However, this leaves a residue that will show up when printing. A better method to preserve the color is *proper storage.* Humidity in the air, heat and light damage film. The best place to store film is in a cool, dry, dark place. I store mine in plastic sleeves in large filing cabinets. This provides easy access and dark storage when they're not in use. Keeping them in a cool room with a dehumidifier also helps. Some slide sheets are manufactured of special materials

for archival storage. Ask your local photo dealer for more information.

Glass slide mounts are the best mounts for storage. However, the film must be removed for mailing and duplicating. *Never* mail glass mounts.

Don't think that projecting slides doesn't affect the film. Projected slides come in close contact with strong light and high heat—two things that damage them. Unfortunately, the best slides usually are viewed the longest. To save the originals, I suggest making *duplicates* for projection.

THE ART OF SELF PROMOTION

Regardless of the photographic specialty in which you market your photos, promotion plays a vital role.

Promotion of the photographer is important in this business, so make your presence known. Those who learn to make their name and photos visible sell more for higher fees. Promotion, like any advertising, is most effective when you have a unique approach rather than copying someone else's. Depending on where and to whom you sell your pictures, the technique that works best varies widely. Here are some ideas that have proved successful. Use them as a starting point.

A Creative Letterhead—A West-Coast mountaineering photographer uses one of his high-contrast photographs showing the silhouette of a photographer walking past a mountain peak. The stark image forms an unforgettable impression and depicts the type of photography he has to offer. It's a nice touch to use on your personal stationery, too.

Personalized Memos—Instead of using standard "From the desk of" notes, personalize them. Use a regular or high-contrast photo, or perhaps a light halftone shading the entire background. Any varia-

Different ways to use photography on stationery and note paper.

tion will help make your name and pictures stand out.

Brochures—One Wisconsin-based photographer periodically prints a dozen of his best photos on an 8-1/2x11 sheet of paper and mails them to potential buyers as a reminder of new images he has.

Posters—One editor showed me a large, full-color poster with a cartoon caricature of a photographer, saying "Remember me." In this case the editor did—every time he opened his door.

Reprints—Some photojournalists have reprints made of their pub-

lished photo articles and send them out to other editors as an FYI (for your information) mailing. Be sure that the publication allows reprints to be made.

Photo Lists—An Arizona-based photographer periodically sends out updated lists of photographic topics he has available to inform his clients of new material, and remind them of the old.

A Book—A printer-turned-photographer decided to print a slick book of his own photographs. The printed book helped him secure several assignments and contracts

Robert McQuilkin currently publishes in over 50 national
STUDIO PHOTOGRAPHY, PHOTO ARTIST USA, DARKROOM
MARIAH/OUTSIDE; is contributing editor
thor of Outdoor Photography, The Photo
Essay; has held six exclusive photo exhibits
al and international photo awards. He will
ly.

WILDERNESS PHOTOGRAPHY SEMINAR

Professional Filming Technique
Experiential Development Learning
How to Sell Outdoor Photography

Place: *B.W.C.A. Northern Minnesota*
Cost: *$240 all inclusive*
Time: *August 30 — September 5*

APPLICATION BLANK

MASTERCHARGE_____
VISA_____
50 Enclosed_____
lderness Photography Seminar, 1028 N. Cherry, Wheaton, IL 60187

This is part of the promotional flyer I use for my Wilderness Photography Seminar. It promotes the program I conduct and one of my photographic specialties.

elinor
stecker
productions

Sometimes your business card serves as your initial contact with a potential customer. Be sure it reflects a professional attitude.

that led to steady sales. You don't have to be a printer to do this. Read the "vanity-press" ads in *Writer's Digest* and send for information about self-publishing. But *don't sign* any contracts until you fully understand how expensive this approach may be.

Business Cards—Many people use their photos on business cards. Even if you do business by mail, you can include the card with your letter. Some people keep files of clients' cards. One photographer who uses large-format cameras uses a piece of sheet film with his photo and address printed in reverse, rather than business cards.

Published Articles—You can make more money selling photo-article packages rather than just photos. Additionally, this puts your name up with the title of the article rather than in small print near the pictures. Or, you can collaborate with a writer and share a byline.

Exhibit—Many photographers develop their reputations by organizing exhibits of their work in libraries, banks, shopping malls and other locations with heavy traffic. One sports photographer exhibits his work in the lobby of a movie theater whenever a sports-related movie is showing.

Flaunt Yourself—Make a promotional picture of yourself in action to be used along with your articles. The more you spread your name and the more easily you are recognized, the easier it will be to sell your wares.

Seminars—One good way to gain momentum in your local area is to teach photography seminars. You immediately become the town's photo authority. If you sell your work locally, it's another stepping stone. Some seminars become so popular, it's possible to acquire a second income from teaching.

TAXES ON FREELANCE WORK

You owe a cut of every dollar to the government—or do you? You must consider the tax consequences of any money earned as a photographer. If you declare yourself a business, you may be able to deduct a sizable amount of photography-related expenses from the taxes you pay on your primary occupation.

The obvious—film supplies, processing, extra equipment and the like—are not the only tax allowances. There are numerous other secondary expenses you can deduct from your income tax if you keep accurate records. Gas mileage to and from events, all expenses on trips taken exclusively to cover a sporting event—even books you purchase on the subject, such as this one. At the end of the year, your expenses may exceed your freelance income, and may give you a tax benefit. *Keep receipts for everything.* If you have questions, ask your tax accountant or the local Internal Revenue Service office.

THERE ARE MORE MARKETS

Keep in mind that most of the marketing suggestions in this chapter involve editorial photography for books, magazines and publishing houses because that's the business I'm most familiar with. However, the world market for sports photography is wide open to the enterprising individual who is willing to do his homework.

One St. Louis-based sports photographer started out selling editorial pictures to all the top sports magazines. He gradually began shifting gears and today, although he still sells $2000 of stock photos a month, his main source of income generates from shooting ads for a brewery and covering sports events for a major television network.

An expanding market for photographs is audiovisual and multi-media presentations used at business meetings, as instructional programs and product displays in the showroom. Research the market to see where the best profit area is for you. Make a list of those manufacturers to whom you would like to sell. Then obtain samples of their products and begin categorizing the types of pictures they use.

The most important lesson I have learned is that there is safety in numbers. The more markets you can find for your photos, the better. The photo marketing business is unpredictable—but has never looked better.

It's great to see your pictures *and* your name in print. The thrill never leaves. For me, it's still exciting, even after years in the business.

Appendix

This Appendix lists addresses for many of the products mentioned by name in the book. It also includes names and addresses of manufacturers of related equipment and accessories, and organizations and publications I refer to. This list is not meant to be all-inclusive. Use it as a guide only when information is not available at your local camera dealer.

PRODUCTS

Ambico filters: AIC Photo, Inc., 168 Glen Cove Rd., Carle Place NY
Camera bags: Tenba Inc., 502 Broadway, NY NY 10012; Kalt Corp., 2036 Broadway, Santa Monica CA 90404; Foto-One, 1708 Mahalo Pl., Compton CA 90220; Eastern Mountain Sports, Vose Farm Road, Peterborough NH 03458
Camp Trails Photo Fanny Pack: Johnson Camping, Inc., Box 966, Binghamton NY 13902
Canon cameras and accessories: Canon U.S.A., Inc., 10 Nevada Dr., Lake Success NY 11040
Cokin filters: Minolta Corp., 101 Williams Dr., Ramsey NJ 07446
Cook's Custom Sewing: Dan Cook, 2145 Dickens Lane, Moundsview MN 55112
EWA underwater housing: Pioneer & Company, Inc., 216 Haddon Ave., Suite 522, Westmont NJ 08108
FilmShield: Sima Products Corp., 4001 W. Devon Ave., Chicago IL 60646
FL-D filter, Hoya filters: Uniphot Corp., 61-10 34th Ave., Woodside NY 11377
Fujichrome, Fujica HD-S camera: Fuji Photo Film U.S.A., Inc., 350 Fifth Ave., NY NY 10001
Gaffer's (duct) tape, black: Kendall Inc., Boston MA 02021
Holdsteady Strap: Box 253, South Ozone Park NY 11420

Hulcher sequence cameras: Charles A. Hulcher Co., Inc., 909 "G" St., Hampton VA 23661
Hydro 35 die-cast aluminum housing: Oceanic Products, 14275 Catalina St., San Leandro CA 94577
Ikelite underwater housings: Ikelite, 3303 N. Illinois St., Indianapolis IN 46208
Ilford HP5 Autowinder film: Ilford, Inc., 70 West Century Rd., Paramus NJ 07652
Kenyon Gyro Stabilizer: Ken-Lab Inc., Box 128, Old Lyme CT 06371
Kodachrome, Ektachrome, Tri-X films: Eastman Kodak Company, Rochester NY 14650
Loupe (Agfa-Lupe): Agfa-Gevaert Inc., 275 North St., Teterboro NJ 07608
Lowe Pro Camera Packs: Lowe Alpine Systems, Box 280, Lafayette CO 80026
Minolta cameras and accessories: Minolta Corp., 101 Williams Dr., Ramsey NJ 07446
Nikon cameras, Nikkor lenses and accessories, Modulite Remote Control, Blimp, Nikonos underwater camera, SB-101 electronic flash, DB-2 Anti-Cold Battery Pack, MC-7 Anti-Cold Cord, MD-4 Motor Drive: Nikon Inc., 623 Stewart Ave., Garden City NY 11530
Novoflex grip and lens: Kalt Corp., 2036 Broadway, Santa Monica CA 90404; or Aetna Optix, Inc., 44 Alabama Ave., Island Park NY 11558

Olympus cameras and accessories: Olympus Camera Corp., Crossways Park, Woodbury NY 11797
Pentax cameras and accessories: Pentax Corp., 35 Inverness Dr. East, Englewood CO 80112
Photo-Sonics Actionmaster 500 camera: Instrumentation Marketing Corp., 820 S. Mariposa St., Burbank CA 91506
Remote-control camera triggers: Tekno, Inc., 221 W. Erie St., Chicago IL 60610
Rental camera equipment: Helix Rental Department, 325 West Huron St., Chicago IL 60610
Sequence cameras: See Photo-Sonics and Hulcher listings.
Sonar detectors: Radio Shack—ask at your local Radio Shack store or write the company at 1300 One Tandy Center, Ft. Worth TX 76102
Underwater housing for Hasselblad: Victor Hasselblad, Inc., 10 Madison Rd., Fairfield NJ 07006
Waterproof pouches: Sima Products Corp., 4001 W. Devon Ave., Chicago IL 60646
Weathermatic-A camera: Minolta Corp., 101 Williams Dr., Ramsey NJ 07446

PUBLICATIONS

Audio Visual Market Place (published annually), R.R. Bowker Company, 1180 Avenue of the Americas, NY NY 10036

Ayer Directory of Publications, IMS Press (formerly Ayer Press), One Bala Ave., Bala Cynwyd PA 19004
Free Stock Photography Directory, Infosource Business Publications, 10 East 39th St., NY NY 10016
Gebbie House Magazine Directory: See *Internal Publications, Volume 5, Working Press of the Nation Directories*
Harold Bibby, Eastman Kodak Company, Public Information Department, Rochester NY 14650
How to Enter and Win Color Photography Contests and **How to Enter and Win Black & White Photography Contests** (by Alan Gadney), Facts on File Publications, 460 Park Avenue South, NY NY 10016
Internal Publications, Volume 5, Working Press of the Nation Directories (formerly *Gebbie House Magazine Directory),* National Research Bureau, 310 South Michigan Ave., Chicago IL 60604.
Lens magazine, 645 Stewart Ave., Garden City NY 11530
Magazine Industry Market Place (updated annually), R.R. Bowker Company, 1180 Avenue of the Americas, NY NY 10036
Manhattan Yellow Pages: Call your local phone company, or contact the publisher, Reuben H. Donnelly, 466 Lexington Ave., NY NY 10017
Modern Photography magazine, 825 Seventh Ave., NY NY 10019
National Directory of Shops/Galleries, Shows/Fairs: Where to Exhibit and Sell Your Work, Writer's Digest Books, 9933 Alliance Rd., Cincinnati OH 45242
Photo Insight, Suite 2, 169-15 Jamaica Ave., Jamaica NY 11432
Photographer's Market Newsletter, Writer's Digest Books, 9933 Alliance Rd., Cincinnati OH 45242

Photographer's Market, Writer's Digest Books, 9933 Alliance Rd., Cincinnati OH 45242
The Photoletter, Rohn Engh, Publisher, Osceola WI 54020
Popular Photography magazine, 1 Park Ave., NY NY 10016
Standard Rate and Data Service (SRDS) Directories, Standard Rate & Data Service, 5201 Old Orchard Rd., Skokie IL 60076
Stock Photo Assignment and Source Book, R.R. Bowker Company, 1180 Avenue of the Americas, NY NY 10036
Sunshine Artists USA, Sun Country Enterprises, Inc., 501-503 N. Virginia Ave., Winter Park FL 32789
TSA Newsletter, 1322 North Academy Blvd., Suite 209, Colorado Springs CO 80909
Ulrich's International Periodicals Directory: R.R. Bowker Company, 1180 Avenue of the Americas, NY NY 10036
Writer's Market, Writer's Digest Books, 9933 Alliance Rd., Cincinnati OH 45242

ORGANIZATIONS

Associated Photographers International, 21822 Sherman Way, Canoga Park CA 91303
ASMP—Society of Photographers in Communications, 205 Lexington Ave., NY NY 10016
Friends of Photography, Box 500, Carmel CA 93921
Photographic Society of America (PSA), 2005 Walnut St., Philadelphia PA 19103
Pictorial Photographers of America, 211 E. 73rd St., NY NY 10021
Professional Photographers of America, Inc. (PPA), 1090 Executive Way, Des Plaines IL 60018

ACKNOWLEDGEMENTS

I am grateful to many athletes who devoted time, equipment and physical prowess so I could produce the photographs I wanted for this book. I don't have the space to tell the readers about the close calls and humorous incidents that many of them endured, but each deserves acknowledgement here.

Special thanks to: David Braddock, owner of Midwest School of Hang Gliding; Glenn Johnson, owner of Der Boathouse Windsurfing; Ron Ridenour, owner of Windy City Soaring; Jim Baron, owner of Hinkley Sky Diving; The Sky Nights Parachuting Club members; Ed Zawlocki of Underground Enterprises; and Claude Jewell, owner of Illinois Institute of Diving.

Also, for their contributions, many thanks to: Susan Campbell, Bill Mountjoy, Bob Bilthouse, Robert Lantz, Allan Badner, Ken Orchard, Darryl Lonowski, Robert Evens, Donna Wigdahl and John Patten.

Index

A

Action, 13
 confined, 11
 freezing, 38
Advertising sales, 150
Appendix, 156
Art fairs, 146
Artificial lighting, 41-43
"Auto" exposure
 with manual camera, 16-17
"Auto" focus, 10
Automatic film advance, 67
Automatic-advance systems,
 benefits, 67-69
Autowinder, 65

B

Back lighting, 30, 41
Background, controlling, 34-36
Baseball, 7, 89
Basic equipment, 20
Basketball, 85-86, 89
Batteries, 22
Batteries, five-second, 76
Bayonet mount, 120
Bean bag support, 29
Black-and-white film, 17-19
Blimp, 52
Blur, 36-37
Body language, 100
Body, camera, 118-121
Bracketing, 58
Brittle film, 57
Bulk loading, 45
Bulk-load film backs, 124

C

C-clamp, 28, 29
Camera bags, 135
Camera body, 118-121
Camera operation, unmanned, 67-68
Camera protection, 71
Camera supports, 123-124
Camera system, expanding, 121
Camera, winterizing, 61-62
Cameras, sequence, 125, 138
Cameras, underwater, 55-56, 124
Car racing, 81-83
Card manufacturers, 149
Carrying case, 19
Carrying equipment, 125-127
Caving, 21
Celebrities, photographing, 95-96
Changing lenses, 10
Clear-glass filter, 20
Clichés, 8
Club sales, 145
Clubs, 144
Color temperature, 41-42
Community league sales, 146
Competitions, 142-143, 144
Composition, 14-15, 76, 115-117

Condensation, 60
Confined action, 11
Conflicting subjects, 116
Contact sheets, 17-18
Contests to avoid, 144
Controlling background, 34-36
Converters, 2X, 134
Creativity, 129-139
Cross-country skiing, 139
Customs, US, 127-128

D

Damage, salt-air, water, 53-55
Darkroom manipulation, 48
Daypack, converting, 126
Decisive moments, 14
Dedicated electronic flash, 123
Depth of field, 23, 63
Details, 14, 103
Distortion factor, 62
Documentation, importance of, 110
Double exposures, 135-138
Double-axis pan, 39
Drama, 13
Duct tape, 19

E

Electronic flash, 121-123
Electronic-flash slave, 73-74, 122
Electronic-flash, dedicated, 123
Emotion, 13
Emotional impact, 142
Equipment, 9
Equipment, basic, 20
Equipment protection, 19-22
Experiment, 131
Exposure check, 31-32
Exposure compensation, 47
Exposure control,
 multiple-exposure, 136-137
Expressions, 117
Extra-long film, 72
Eye cup, 21
Eye fatigue, 24
Eye patch, 71
Eyelet-ring protection, 19

F

FL-D filter, 42
Film backs, bulk-load, 124
Film
 bulk loading, 45
 choice, 43-48
 color, 46-48
 extra-long, 72
 processing, 46-48
 purchasing, processing overseas, 128
Filter, polarizing, 46
Filters, 19-20, 133-134
Focus, "auto," 10
Focusing, 23-28
Focusing screens, 27, 119-120

Follow-focus, 25
Football, 77-80, 89
Footstrap, 29
Foreground, 97-99
Foreground, extending, 63
Foreshortening, 63-64
Freezing action, 38
Freezing, photography below, 56-61

G

Gadgets, 130-131
Gaffer's tape, 19, 70
Galleries, 146
General-interest publications, 147-148
Golf, 12
Grain, film, 44
Grandstand, shooting from, 89
Grips, 22
Guide number (GN), 121-122
Gyroscope, 124

H

Half-tone neutral-density filter, 133-134
Handholding, 28
Head focus, 26
Head shots, 14
Hiking, 17
Hip pouches, 127
Hockey, ice, 88-89
Horizon, 33
Horizontals, 116-117
Housings, underwater, 54
Human element, 106-107
Hyperfocal focusing, 26-27

I

I.D. cards, 149
Ice hockey, 88, 89
Ice boating, 17
Illuminated finder, 119
Impact, 140
Insurance, travel, 127
Interchangeable finders, 119
Interchangeable focusing screens, 119-120
Inventory, equipment, 127
Isolating subject, 97

J

Judging photos, 132

L

Latitude, film, 18
Lens
 changing, 10, 65
 focal length, 35
 shade, 20-21
 telephoto, 63-64
 wide-angle, 16-17, 62-63
 zoom, 64-65
Light leaks, 45
Light meters, 59
Lighting problems, 40-42
Lighting, electronic flash, 42-43

Lighting, tricky, 75
"Lightning" streaks, 57-58
Little League, 12
Local newspaper sales, 146

M
Maintenance, preventive, 62
Meter readings, 17
Monopod, 28-29, 123-124
Motocross, 17
Motor drive, 65-69
Motor drive, high speed, 133
Moving-focus, 24

N
Natural supports, 29, 123
Neutral-density filters, 133-134
Non-focus, 26

O
Observation, 101-102
Open-eye focus, 25-26
Optics, testing, 27

P
Panning, 35-36, 39-40
Parachuting, 7-8
Peak action, 38
Peak motion, 14
Photographing celebrities, 95-96
Photojournalism, 105-111
Picture ideas, 8
Pistol grip, 124
Plastic bags, 51-52
Polarizing filter, 46 47
Poncho, 51
Portraiture, 111-115
Poster manufacturers, 149
Prefocus, 26
Press pass, 148-149
Processing, film, 46-48
Promotion, 153-154
Protection against sun, 56
Protection against water, 50-56
Public building exhibitions, 146
Publications, categories of, 147-148
Publishing photos, 146-147
"Pushing" film, 18

Q
Quick focus, 15-16
Quick-release tripod head, 124

R
Racing, car, 81-83

Racquetball, 83-85
Reflex mirror, 61
Remote triggering, 65-75
Response card, 151
Retakes, 132-133
Rigid cases, 125
Rodeo, 6, 16-17

S
Salt-air damage, 53-55
Sandwiching, 136
Security systems, airport, 128
Self promotion, 153-154
Selling photos, 15-16
Sequence cameras, 125, 138
Setting up, 19-22
Sharpness, film, 44
Short-loading, 30
Short-shooting, 30
Shoulder bags, 125
Shutter curtain, 62
Shutter release, soft, 21
Shutter speed, 17, 30-31, 70
Silhouette, 30, 31
Skiing, 14
Skiing, *langlauf*, 139
Skylight filter, 20
Slave, electronic-flash, 122
Slicks, 147
Snow, 60-61
Soccer, 80-81
Soft shutter release, 21
Special event sales, 146
Special-interest publications, 148
Speed finder, 21-22
Speed, film, 18
Speed-focus, 24
Split-image filter, 134
Sports finder, 21-22, 119
Steel boxes, 52-53
Step vs. stop, 6
Stock houses, 149-150
Stopping action, 36-39
Storage, film, 44-45
Storytelling, 106
Strap, 19
Streaking, 36
Strobe, 137-138
Subject focus, 26
Subject placement, 115-116
Submissions, professional, 150-151
Sun, protection against, 56

Sunny-day settings, 32
Supports, camera, 28-29, 123-124
Suspense, 13, 99-100

T
Taxes, freelance work, 155
Team picture sales, 145
Technical quality, 140
Telephoto lenses, 63-64
Tennis, 89
Tilting head, flash, 122
Tournament sales, 145-146
Track and field, 86-87
Training, 5
Traveling with equipment, 127-128
Tricks, darkroom, 18
Triggers, homemade, 73-74
Tripod, 28, 123
Tripod head, quick-release, 124

U
US Customs, 127-128
Ultraviolet filter, 20
Umbrella, 51
Underwater cameras, 55-56, 124
Underwater housings, 54
Used cameras, buying, 59-60

V
Variable-speed pan, 40
Variety, 32-33, 100-101
Vignetting, 20-21

W
Waist-level finder, 119
Water damage, 53-55
Water, protecting equipment
 against, 50-56
Waterproof bags, 52
Wide-angle lens, 16-17, 62-63
Wilderness sports, 90-92
Winterizing camera, 61-62

X
X-ray security systems, 128

Y
Yearbook sales, 145

Z
Zone focus, 26
Zoom lenses, 64-65
Zooming, 38-39

Credits

Front Cover
 Runner—Lou Jones
 Racecars—Terry Bourcy,
 Stock Car Racing Magazine
 Football—Focus on Sports

Back Cover
 Bicyclist—Thomas Ives

8.2082682135